INTRODUCTION TO PHOTOGRAPHIC PRINCIPLES

Lewis Larmore, Ph. D.

Director, Advanced Research Laboratory
Douglas Aircraft Company, Inc.

Second Edition

DOVER PUBLICATIONS, INC., *New York*

Published in Canada by General Publishing Company, Limited, 30 Lesmill Road, Don Mills, Toronto, Ontario.
Published in the United Kingdom by Constable and Company, Limited, 10 Orange Street, London W. C. 2.

This Dover edition, first published in 1965, is a revised and corrected republication of the work first published in 1958 by Prentice-Hall, Inc.

Standard Book Number: 486-21385-4
Library of Congress Catalog Card Number: 65-20484

Manufactured in the United States of America

Dover Publications, Inc.
180 Varick Street
New York, N.Y. 10014

PREFACE TO DOVER EDITION

The arts and sciences associated with photography move forward with such a rapid pace that no one person or single book can possibly keep track of all the details. Advances in film, processing, information handling, and equipment have been applied to many varied fields ranging from undersea exploration to observations from spacecraft. However, the fundamental principles underlying photography have not changed significantly even though a few new principles have been discovered and another few known principles have been applied in different ways. The purpose of this new edition remains the same as the earlier one; namely, to give those persons interested in photography an insight into the fundamentals of science on which the art of photography is based. Many examples of processes and equipment, both old and new, have been included to help explain the more important aspects of the underlying principles. Although many practical hints are also included, the emphasis of the book still rests on those scientific aspects which are of most value to the serious photographer.

LEWIS LARMORE

May,1965

PREFACE

Photography continues to play an important role in our scientific progress as well as in our everyday life. Yet a vast number of science students receive training in their particular fields without obtaining an understanding of the basic principles of photography. Perhaps there is an even greater number of serious amateur photographers who feel that they are limited in their work because of a lack of understanding of photographic fundamentals. This book is designed to fulfill the requirements of these two groups.

Many colleges and universities offer courses in photography. However, many more should, and probably will, offer courses of a nature applicable to science curricula. This book is intended to provide a suitable text for a one semester course in photography at the lower division level. Some knowledge of physics and chemistry is helpful but not necessary, for all discussions and derivations start from basic definitions. A knowledge of trigonometry is required for an understanding of the derivations associated with lenses.

Although this book is not intended to be of the "cook book" variety, it includes a useful list of optical relationships and representative processing formulas in the Appendix. Also included are fifteen experiments that demonstrate most of the important photographic principles. The experiments require very little special equipment and can be performed in a small darkroom with limited facilities.

A book of this scope cannot include a discussion of all of the available gadgets associated with photographic practice. However, the stress on photographic principles lends itself to an understanding of the limitations and applications of many practical aids to photography.

It is a pleasure to acknowledge the valuable assistance that I have received in the preparation of this work. My wife, Mary, typed most of the manuscript and my secretary, Mary Green, typed the balance. Dr. Donald Menzel contributed many excellent suggestions during the early phases of the work both as to its content and its style. To the Prentice-Hall editorial staff I wish to express my appreciation for their patience and help during the preparation of the manuscript and the finished text.

<div align="right">LEWIS LARMORE</div>

CONTENTS

CHAPTER ONE

INTRODUCTION

We are about to concern ourselves with the scientific aspects of photography. The methods of image formation and exposure control come properly under the heading of the physics of photography. Through the chemistry of photography we will learn something about how a light-sensitive material retains an image, and we will also learn how to convert this image from a negative to a positive.

Photography is an aid to scientific and technical achievement and provides a means for artistic expression. The scope of photography today extends from the front lawn on a sunny afternoon to a spacecraft flying among the planets. Equipment, ranging from the simplest black box to the most complex camera, can record a good likeness of your maiden aunt or the image of some obscure nebula.

It is difficult to overestimate the value of photography to the various fields of science. The visual studies of astronomers have been almost completely replaced by photographic methods. Photographic observations have advantages over visual ones because of their permanency and their ability to integrate light over long periods of time. Most observatories keep permanent photographic records of the positions of the stars and planets. The planet Pluto would probably never have been discovered without these records, because the discovery was made by comparing one photograph with another.

The biological sciences also make use of photographs for illustration and records. Word pictures cannot fully describe the complex mechanisms of living things. For example, the identification of a scorpion is more vivid and complete when done with the aid of a

photograph. Photomicrography also has played an important part in the development of the biological sciences.

Photography is a valuable tool in the physicist's work with the spectrograph, an instrument which records the light energy emitted by the atom. Most of our knowledge of the atom has been obtained through the use of photography.

Let us consider briefly some of the applications of photography to modern living. Newspapers and magazines have shown us the value of the pictorial page. Photographs of disasters, sporting events, human interest material, and faces of prominent people enlighten us more vividly than long word descriptions.

Banks, libraries, and many offices which are required to keep volumes of records are turning to photographic copies of the bulky originals. Photographic film preserves many treasured family activities, presents educational material to students in the classroom, and contributes a valuable service to medicine and dentistry with x-ray. Through the medium of motion pictures shown in theaters and on television, the pleasure-seeking public enjoys still another phase of photography.

The serious work and research in the field of photography which has led up to its present-day important position began just over 100 years ago. During the sixteenth century Georgius Fabricius recorded the fact that silver chloride turned a darker color when exposed to light, but the first attempt to utilize this discovery was not made until the nineteenth century. At this time Humphry Davy and Thomas Wedgwood, son of the famous potter, were able to make prints of transparent and semitransparent objects such as leaves. However, their work was actually based on the discovery of J. H. Schulze, who accidently noticed that a solution of chalk and aqua regia to which was added a trace of silver turned to a purple color upon exposure to light.

The chief difficulty that Davy and Wedgwood encountered was their inability to "fix" the image, which faded in a short time. The first man to overcome this difficulty was Niepce, a Frenchman. His process, however, did not make use of the silver salts and it was not practical for use in a camera. In 1829 Niepce signed a partnership agreement with Daguerre, a French painter, and the two collaborated until the death of Niepce in 1833. Daguerre returned to the idea of using silver compounds and succeeded in perfecting a process

that gave direct positives. His method utilized a polished silver surface treated with iodine vapors to yield the light-sensitive surface. After exposure, the plate was treated with mercury, which attached itself to the unexposed silver iodide. The remaining silver iodide was fixed with a suitable salt solution similar to the method still used.

During this same period other investigators turned their attentions to the field of photography. Probably the most successful was Scott-Archer of England, who worked out a process to put the light-sensitive material on a glass plate. The Calotype or wet collodion process developed by Archer had the two advantages of holding the light-sensitive material rigidly on a base and also of shortening the exposure time necessary to produce a photograph. However, the process required that the collodion be used wet and necessitated a small darkroom wherever the photograph was taken.

In order to rid the photographer of the disadvantage of working with wet collodion, Dr. R.L. Maddox was able to make an emulsion of silver bromide in gelatin. When the gelatin was put on glass it was termed a "dry plate," to distinguish it from the wet collodion, and came into general use in 1873 after further experimentation. Dry plates are still used to a great extent, particularly in scientific work.

In 1884, George Eastman succeeded in making and marketing a stripping film. This film consisted of paper coated with an emulsion which was, after development, stripped from the paper and allowed to dry on glass. The paper, which was supplied in roll form, was easy to use in a camera, but the developing and stripping processes were awkward. A few years later Eastman introduced a film with the emulsion coated on a transparent base. This film was very similar to the films that we know today.

In addition to the great improvements in the physical characteristics of film which were made during the last century, the process of dye sensitizing was also discovered. H. W. Vogel in Germany discovered, almost by accident, that the introduction of a dye changed the sensitivity of the light-sensitive material. Ordinary silver salts are sensitive to blue, violet, and ultraviolet light. By using certain chemical dyes with the silver salts, he was able to extend the sensitivity into the yellow and green regions of the spectrum. Dry plates so treated were named isochromatic or

orthochromatic. Since that time much research has been done concerning the spectral sensitivity of photographic emulsions, and several types are now available. We shall return to a more complete discussion of this important subject in a later chapter.

The history of the development of photography is so interdependent with the studies of optics and chemistry that it is difficult to separate them. In order to appreciate fully the many experiments that were tried, we need to have a more complete understanding of the methods in use today. Therefore we shall discuss the remaining historical development of photography in connection with each pertinent topic.

CAMERAS

Our present-day cameras are extremely varied in both appearance and operation, but all seem to have had a common origin in the form of the camera obscura. Although no one knows just when this device was first invented, there is definite record of it as early as 350 B.C. The camera obscura consisted of a rather large room which was completely dark with the exception of a small opening in one outside wall. Inside the room was a white screen which received an image of outside objects. The camera obscura was a forerunner of the present-day pinhole camera.

The formation of an image by means of a small opening has great limitations. In order to obtain a reasonably sharp image, in the absence of a lens, the opening must be very small because the image of a point source is never smaller than the size of the aperture. On the other hand, the amount of light that enters the camera to form the image is restricted by the size of the opening, and the resulting image will not be bright. Thus one of these effects works against the other.

From the records it is difficult to tell just when the small opening in the camera obscura was replaced with a lens. Although there was very little written about lenses prior to the time of Galileo, there is some record of their having been used shortly after the birth of Christ. The use of lenses in the camera obscura overcame in part the two disadvantages of the small opening. The lens not only formed a sharper image, but also gave a brighter one because it was used with a much larger aperture.

The camera and the eye

The word camera comes from Latin and means enclosure or room. It has been carried over from camera obscura until now we think of it as a picture-taking device. Our small box cameras resemble miniature camera obscuras. The simplest camera contains a lens for forming the image, a shutter for controlling the length of time the light enters the camera, and a light-sensitive material such as the ordinary roll film.

The similarities between a camera and the eye are interesting. They each contain the three previously mentioned elements: a lens, a shutter, and a light-sensitive material. In the eye, the image is formed by a combination of the cornea, the aqueous humor, and the lens. The eyelid is actually the shutter and the retina is the light-sensitive material. Another ·similarity which exists between some cameras and the eye is the control of the image brightness by means of the iris diaphragm. The eye involuntarily controls the amount of light which enters it by opening and closing the iris. A great number of cameras control the amount of light transmitted through the lens by means of an iris diaphragm, named after the corresponding part of the eye. Figure 2-1 shows the comparison of the eye to a simple camera.

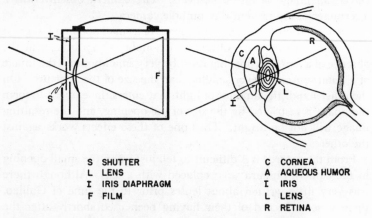

S	SHUTTER	C	CORNEA
L	LENS	A	AQUEOUS HUMOR
I	IRIS DIAPHRAGM	I	IRIS
F	FILM	L	LENS
		R	RETINA

Fig. 2-1. Comparison of a simple camera and the eye.

Shutters

Many cameras are constructed with before-the-lens shutters. The usual camera, however, has the shutter mounted between two

elements of the lens or behind the lens. In any of these three types of cameras the shutter is near the lens and is constructed of some lightweight, thin material which can be quickly opened and closed. The shutter in a box camera often contains only one leaf which passes back and forth across the lens. A shutter mounted near the lens on a more expensive camera is made of three or more leaves which open from the center and close toward it.

The blackening produced on a photographic film is actually dependent on the combination of four factors. These factors are: the length of time that the light falls on the film, the intensity of the light, the "speed" of the film, and the developing process used. Of these four factors, the first is determined by the shutter. In order to produce a good photographic negative we must simultaneously take into account the above four factors.

The main objection to a shutter near the lens is the fact that part of the time allotted for the exposure is really used to open and close the shutter. During the first part of the exposure, the shutter is not completely open and the light entering the lens is partially cut off by the unopened part. The same is true in reverse during the time that the shutter closes. For example, if the shutter is set to expose the film for $\frac{1}{100}$ of a second, it is possible that the shutter will require one-fourth of this time to open and one-fourth to close. If this is the case, the lens transmits the largest possible amount of light during only one-half of the time interval, and the shutter is approximately 75% efficient. If this same shutter were set to operate at $\frac{1}{200}$ of a second, then its efficiency would be cut to about 50%. This example, although exaggerated somewhat, shows that there is a limit to the shortness of exposure obtained with a shutter mounted near the lens. Ordinarily, $\frac{1}{500}$ of a second is the limit for this type of shutter, but some cameras provide $\frac{1}{1000}$ of a second.

Focal-plane shutters are more efficient than those located near the lens. The focal-plane shutter derives its name from the fact that it is mounted near the film, or focal plane. A common type of focal-plane shutter consists of a curtain, similar to a small window blind, in which a rectangular opening has been cut. See Fig. 2-2. The material of the shutter is wound around rollers which are mounted on a spring so that the shutter with its slit opening passes in front of the film. The length of time of exposure is controlled either by changing the tension of the spring, or by varying the size

of the opening itself. A simple table on the outside of some cameras gives the exposure time for any combination of spring tension and slit width, while other cameras accomplish the same result with a single operation. Exposure times as short as $\frac{1}{1000}$ of a second are not uncommon for focal-plane shutters.

Fig. 2-2. One type of focal-plane shutter showing four slit widths for four different exposure times.

Although the type of focal-plane shutter shown in Fig. 2-2 is more efficient than one near the lens, it suffers from two disadvantages. All parts of the film are not exposed at the same time and the photograph of a moving object will appear distorted. The classical example is the racing car which appears to lean forward because the bottom of the car was exposed before the top. The second disadvantage occurs when the shutter is used with a flashgun. This type of shutter requires a "long-peak" bulb or the result will appear as shown in top of Fig. 2-3. A comparison of the light curves of ordinary and long-peak bulbs is shown in Fig. 2-4.

In an effort to reduce the disadvantages mentioned above, most focal-plane shutters now being manufactured use a somewhat different principle. They consist of a curtain, as mentioned, but the opening begins at one side and continues until the complete film is exposed at one time. The closure takes place from the same side. Changes in the exposure time can usually be made before or after the shutter is cocked. This system lends itself to the convenient combination of simultaneous action of film advance and shutter cocking in order to eliminate the possibility of double exposures. Even with this type of focal-plane shutter, special flash bulbs combined with internal synchronization are required for satisfactory results.

Fig. 2-3. Above, example of an ordinary flash bulb used (incorrectly) with a focal-plane shutter. Below, long-peak flash bulb used with a focal-plane shutter.

Types of cameras

Modern cameras may be conveniently divided into six general classes.

1. Fixed focus cameras
2. View cameras
3. Reflex cameras
4. Miniature cameras
5. Motion picture cameras
6. Special purpose cameras

Of all the cameras in existence there are probably more of the fixed focus type than any other. This type of camera contains only the bare essentials necessary for picture taking: a lens, a shutter,

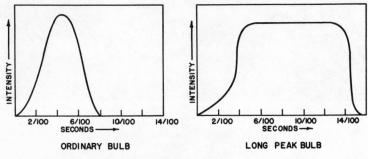

Fig. 2-4. Comparison of the light intensity vs. time curve of an ordinary flash bulb with that of a long-peak bulb.

and a film enclosed in a light-tight container. Included in this class are all the common box cameras and many folding cameras. The fixed focus cameras are adjusted in such a manner that they give satisfactory results with the subject in sunlight at distances from the camera between about 12 feet and infinity.

Many folding hand cameras are not strictly of the fixed focus type. However, they are so similar, and their focusing range is so small, that they may be included in this group. The bellows extends slightly, allowing the camera to photograph objects as close as a few feet.

The view camera is so named because it allows the photographer to view the picture on a groundglass before exposing the film. With a view camera, the photographer must open the shutter so that light passes through the lens and forms an image on the groundglass.

There is an arrangement on the camera, such as a rack and pinion gear, for focusing the image. After the photographer has suitably focused and composed his picture, he closes the shutter and adjusts it for the exposure of the film. Then he replaces the groundglass with a film or photographic plate in a light-tight holder, which is made so that the sensitive part of the film lies in the same plane that was occupied by the groundglass. Once these operations are completed, he is ready to snap the picture. Cameras of this type are often used for outdoor scenic work and for portraits.

Because of the length of time required to operate them, view cameras are sometimes modified with rangefinders. A rangefinder is a device which allows us to determine distance by viewing an object from two different locations. It operates on the same principle as the stereoscopic vision of our eyes. That is, when an object is viewed from two different points, the direction of the object changes. When we use our eyes we learn from experience how to estimate distance in a manner based on this principle. With a camera rangefinder, an object is viewed simultaneously by means of a system of mirrors from two points which are about one to four inches apart. Two images of the object are seen unless the two lines of sight are brought into coincidence by rotating one of the mirrors. A rangefinder is calibrated in such a way that when the two images are brought into coincidence, a scale reads the distance to the object.

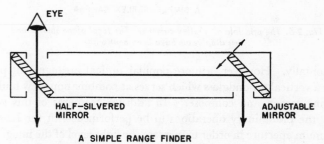

Fig. 2-5. A rangefinder in its simplest form. The adjustable mirror position is calibrated by means of a scale which reads distance directly.

It is possible to couple a rangefinder directly to a view camera (or most others which have focusing arrangements) so that when the images in the rangefinder are in coincidence, the image is in

focus on the film. This gives the photographer the advantage of not having to focus the image on a groundglass, and thus shortens the time of operation of the camera. However, it does not allow the photographer to compose the picture on the ground-glass. For this reason view cameras equipped with rangefinders are used when time of operation is more important than the composition of the resulting photographs.

A reflex camera incorporates a combination of mirror and ground-glass in such a way that when the shutter is tripped, the mirror moves out of the way and the image is then formed on the film. Figure 2-6 illustrates the principle of a reflex camera and shows the optical arrangement associated with the type in which the groundglass lies

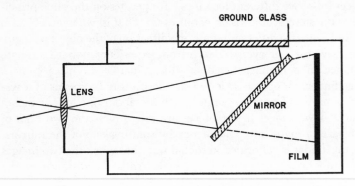

A SIMPLE REFLEX CAMERA

Fig. 2-6. The principle of a reflex camera. The focal-plane shutter and iris diaphragm have been omitted.

horizontally. However, a more popular optical arrangement provides a vertical groundglass which serves as combination view finder, focusing target, and composer. In addition, cameras of this type allow the preliminary operations to be performed with the lens at maximum aperture in order to increase the light level of the image on the groundglass. At the instant of shutter release, the iris diaphragm returns to a preset opening and the mirror flips out of the light path. Reflex cameras have been made in sizes as large as 5 × 7 inches, but their most popular form now uses 35 mm roll film. Thus, we have here an interesting combination of the reflex and the miniature camera which has proven to be extremely versatile and easy to use.

The many attachments available increase the application of these cameras to such fields as astronomical photography and photomicrography. The fact that the same lens is used for both the focusing and picture taking operations enhances the usefulness of reflex cameras into fields of science which were previously the domain of special purpose cameras.

The twin lens reflex camera is operated similarly to the reflex camera. Two lenses, which are coupled together, are mounted on the twin lens reflex. The upper lens forms an image on a horizontal groundglass and the lower lens provides the image on the film. Since the upper lens requires no shutter or iris diaphragm, this lens gives a bright image on the groundglass continually before, during, and after the photographer exposes his picture. A shutter mounted between the elements of the lower lens may be operated at any time. This camera is satisfactory for many purposes since it can be rapidly operated, the picture may be composed on a groundglass, and it is easily adapted for flash work. However, it has two disadvantages. First of these is the fact that the top lens does not "see" the same picture as the bottom lens because it is viewing the object from a slightly higher position. This is serious only when the object is close to the camera. In this case the top lens will see the top of the object while the picture will be of a lower part. This effect is called parallax. Some of the more expensive twin lens reflex cameras have means for correcting parallax on the top lens systems to allow for the different viewing position. Because of the necessity of two lenses on a twin lens reflex, the camera is rather large for the size of picture. This fact limits them to the smaller sizes, and they are generally made for $2\frac{1}{4} \times 2\frac{1}{4}$ inch negatives.

Miniature cameras are the delight of the candid camera fan. Because of their convenience of handling and their excellent quality of workmanship, they have become very popular during the past few years. Most popular of the miniature cameras is the 35 mm size, which makes negatives on ordinary movie film. Most of the miniature cameras take "double-frame" negatives, twice the size of moving picture negatives. However, some use single-frame negatives and a few extremely compact cameras employ 16 mm film. In addition, many miniature cameras are available with automatic exposure control in which a photo voltaic cell provides the input to control either the iris diaphragm or the exposure time.

High-quality miniature cameras combine the advantages of ease of handling, short focal length (for greater depth of field), interchangeable lenses, coupled rangefinders, inexpensive film, short exposure times along with their high-quality lenses, and a rather surprising versatility. There are few photographic tasks that cannot be performed with a miniature camera, because of the great number of attachments available. With the introduction of 35 mm color film, the miniature camera enthusiast enjoys another incentive in the form of color slides. This has proved to be one of the most popular forms of amateur photography.

On the other side of the ledger is the fact that a 35 mm negative is small and requires enlargement for the production of a satisfactory print. As a result, the negatives must be handled with extreme care (as should all negatives for that matter), since scratches, dust particles, and other defects will show up proportionately large on the finished print. Retouching of all small negatives is difficult, and graininess is the concern of miniature camera users.

Motion picture cameras deserve a unique place in the study of photography. The invention of the moving picture camera is generally credited to Thomas A. Edison, who was successful in making a device for showing pictures which looked very much like our modern version of moving pictures. He combined the flexible photographic film of Eastman with a device in which the images were viewed through an ordinary magnifying glass. However, it was Thomas Armat who, in 1895, first used the principle of an intermittent motion for the film. Modern motion picture cameras are intricate, but they are based upon the same principles as those used for still cameras in combination with the intermittent motion.

Amateur motion picture photography is popular among many camera enthusiasts, and cameras using either 8 or 16 mm film widths are available. Some of the 16 mm cameras are capable of doing many of the tricks done in the large studios. Slow motion, fade-ins and fade-outs, double exposures, and single frame exposures are not uncommon. The speed for projecting pictures in theaters is 24 frames per second but is somewhat slower in most home movies. This means that 24 separate photographs are projected in each second, and while the pictures are changing from one to the next, the screen is dark. When we view motion pictures, we see continu-

ous movement because the persistence of vision of our eyes does not allow us to see the intermittent motion.

A moving picture camera contains a mechanism similar to that in the projector, which moves the film through it intermittently. The shutter allows the light to enter only when the film is in the correct position. When the shutter closes, the film is pulled through to the next frame and the shutter opens again. This process is repeated 24 times a second. For slow-motion results the camera takes more than 24 pictures per second, and for fast motion it takes fewer. Many amateur motion picture cameras in both 8 and 16 mm sizes have provision for taking either fast or slow motion.

Special purpose cameras include the many thousands which have been designed and built for one or more particular jobs. Often they are adapted from existing commercial cameras and used in connection with other optical equipment. One of the finest examples of a special purpose camera is the 200 inch telescope. Although it uses mirrors instead of lenses for forming the image, it is in reality a very large, highly specialized camera. Some of the mirrors built for it may be interchanged, with a resulting variation in the size of the image. Ordinarily glass plates are used in connection with telescopes since the support for the light-sensitive material is very rigid.

The spectrograph, which is used for much of the research in physics and astronomy, may be classed as a special purpose camera. It is so arranged that light is broken up into its constituent colors by means of a prism or diffraction grating before reaching the sensitive material. By studying the resulting photographs, physicists and astronomers are able to determine a great many of the characteristics of the emitting source. The spectrograph is one of the most powerful instruments used in modern physical research.

In the biological sciences, the microscope used as a camera is the most important special purpose camera. It produces photomicrographs which enable many students of the subject to study what might otherwise be seen by one person only. Moving pictures taken through a microscope have provided unusual studies of the life history, growth, and habits of many small organisms.

The above three are only meager examples of the great number of special purpose cameras. More detailed information may be found

in literature covering the particular field of study in which these cameras are used.

Choosing a camera

The preceding descriptions show that no one camera is adaptable to every purpose. When we listed the advantages and disadvantages of the various cameras, we assumed that the camera might be called on to perform a task for which it was not especially well suited. Many items given as disadvantages might well be advantages. For instance, one of the disadvantages mentioned for the twin lens reflex was its small negative size. A photographer, who wishes excellent results without worrying about excessive enlarging or retouching, may find that this particular camera exactly fits his needs. However, if he intends to do copy work or photography of objects at a very close range, his preference might be a view camera.

Anyone who is considering serious photographic work should study his camera needs carefully and weigh the merits of the various types of cameras relative to the work in which he is most interested. The choice of a camera should not be difficult. A beginner should use a camera until he is thoroughly familiar with it, and he should master the technique of making good pictures before he considers acquiring another camera either by purchase or by trade. Too often, beginners swap cameras so much that they become completely confused and are not able to use any one camera well.

The quality of cameras, like all other commercially made products, varies among the same models. Therefore, after selecting a specific type and brand, the buyer should try three or four cameras of this particular type and brand before making a purchase.

References for Additional Reading

Data on most commercially available cameras are given by "Directory and Buying Guide," *Photography Magazine*, Ziff-Davis Publishing Co., New York. This issue is published yearly in the spring of each year.

LENSES

Light is frequently defined as radiation which is capable of exciting the sensation of sight. In the study of photography many types of radiation other than light are used to produce a blackening effect on a photographic film. Since, however, most photography is carried on by means of light, we will in this chapter present some of the properties, methods of control, and uses of light, with special emphasis on simple lenses.

Properties of light

The fact that light travels in straight lines can be shown by observing a ray of sunlight shining through a small opening in a window blind. However, this linear propagation of light exists only in a homogeneous medium: one in which the velocity of the light through the medium remains constant. If we view an object over the hot radiator of an automobile, we notice the apparent shimmering of the object. This is due to the fact that the air is heated unevenly, and the light travels faster in the warm air than in the surrounding cooler air, causing the light rays to be deviated from their straight path.

Another fundamental property of light is its wave motion. Light waves are similar to waves on the surface of water because they are transverse. Transverse waves are waves in which the vibrating particles (whatever they may be) vibrate at right angles to the direction of propagation of the wave. The fact that light consists of waves is not so readily seen as is the linear propagation. However,

by means of interference and diffraction the wave nature of light was demonstrated by Young and Fresnel in the early part of the nineteenth century.

The length of light waves is extremely short. A light wave for which the human eye has its greatest sensitivity has a wavelength of about 0.000055 cm. The centimeter unit of length, although used in a great many measurements, is too large a unit to be used conveniently as a standard in the measurement of wavelengths of light. There are two other units which are in common use. One is the Angstrom unit, which was named in honor of the Swedish physicist Anders J. Angstrom (1814-1874). One Angstrom unit is equal to 10^{-8} cm, or 10^{-10} meters. The other unit is the millimicron ($m\mu$), or one billionth (one thousand-millionth) of a meter. Thus the above wavelength could be expressed as 0.000055 cm, 5500 Angstrom units, or 550 $m\mu$.

Refraction

We have stated that light travels in a straight line in a homogeneous medium. Refraction of light is the bending of the rays of light when it passes from one medium into another.

The amount of bending of the rays of light when passing from one medium to another is dependent upon the relative speeds of light in the two media. The speed of light in a vacuum, where it has its maximum speed, is very nearly 3×10^{10} cm per second or about 186,000 miles per second. In all substances which are transparent to light the speed is less than this. The index of refraction of a substance is arbitrarily defined as a ratio of the speed of light in a vacuum to the speed of light in the substance. The index of refraction for various substances is shown in Table 3-1. As is shown,

TABLE 3-1

Substance	Index of refraction
air	1.0002918
water	1.333
crown glass	1.55
flint glass	1.67

the index of refraction of air is very nearly unity. Because of the very small difference between the speed of light in a vacuum and the speed of light in air, we are justified, in our photographic work, in assuming the index of refraction of air to be unity. This means

that we can now define the index of refraction of a substance as the ratio of the speed of light in air to the speed of light in the substance.

Frequently the index of refraction is represented by the Greek letter μ, not to be confused with the micron for which the same Greek letter is used, and we shall use it hereafter to mean the index of refraction unless otherwise stated.

Now let us consider a beam of light directed toward the surface of some medium, such as glass, as shown in Fig. 3-1. The beam of light

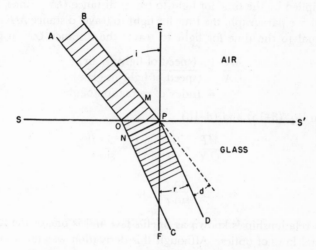

Fig. 3-1. Refraction of a light beam at an air-glass interface.

$ABOP$ traveling toward the glass is the incident beam and the beam $OPCD$ traveling in the glass is the refracted beam. The line EF is drawn perpendicular to the surface SS' of the glass and is called the normal.

The angle BPE is the angle of incidence and designated by the letter i, while the angle DPF is known as the angle of refraction and designated by the letter r. We will now find the relationship between the angle of incidence i and the angle of refraction r in terms of the index of refraction of the glass.

If line OM is drawn perpendicular to the direction of the incident beam and PN is drawn perpendicular to the direction of the refracted beam, we see that while the right side of the beam is

traveling the distance MP in air, the left side of the beam is traveling the distance ON in the glass. From trigonometry,

$$MP = OP \sin \angle POM = OP \sin i \qquad (3\text{--}1a)$$

and

$$ON = OP \sin \angle OPN = OP \sin i \qquad (3\text{--}1b)$$

Also MP = the speed of light in air multiplied by the time required for light to travel distance MP, and ON = the speed of light in glass multiplied by the time for light to travel distance ON. Since, from the above paragraph, the time for light to travel distance MP in air is equal to the time for light to travel the distance ON in glass,

$$\frac{MP}{ON} = \frac{\text{(speed of light in air)}}{\text{(speed of light in glass)}}$$
$$= \text{Index of refraction of glass.} \qquad (3\text{--}1c)$$

From Eq. (3–1a) and (3–1b)

$$\frac{MP}{ON} = \frac{OP \sin i}{OP \sin r} = \frac{\sin i}{\sin r}$$

and

$$\frac{\sin i}{\sin r} = \mu. \qquad (3\text{--}1)$$

This relationship is known as Snell's law and is one of the fundamental laws of optics. Although this derivation was made on the basis of a beam of light (with some cross-sectional area), as the beam gets smaller and smaller, the above relation still holds, and a ray of light follows the same law.

The amount of bending of a light ray is the deviation, and the angle of deviation is represented as angle d in Fig. 3-1. Notice that angle d is equal to $i - r$.

If the light beam traveled from the glass into the air, the incidence angle would then be inside the glass and the refraction angle would be in the air. When this is true, the relationship is

$$\frac{\sin i}{\sin r} = \frac{1}{\mu}.$$

This equation shows that the beam follows the same path regardless of whether it goes from the air to the glass or from the glass to the air.

Notice that Eq. (3–1) was derived on the basis that air was one of the two media. When light goes from one medium to another and neither of the two media is air we have the relationship from Eq. (3–1c)

$$\frac{\sin i}{\sin r} = \frac{\text{speed in first medium}}{\text{speed in second medium}} = n,$$

where n is the relative index of refraction between the two media. Notice also that

$$n = \frac{\mu_2}{\mu_1}$$

where μ_1 is the index of refraction of the first medium and μ_2 that of the second.

Light path through a prism

In Fig. 3-2 let the triangle ABC represent the cross section of a triangular prism. Consider a ray of light OP to be incident on the

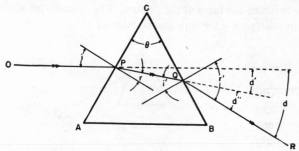

Fig. 3-2. Path of a ray of light through a triangular prism.

face of the prism. From Eq. (3–1) we know that

$$\sin r = \frac{\sin i}{\mu}. \tag{3-2a}$$

As the ray passes through the prism to point Q, the angle of incidence is now inside the prism. At Q the ray emerges from the prism in such a way that

$$\sin r' = \mu \sin i'. \tag{3-2b}$$

These relationships are true only when the prism is surrounded by air (or a vacuum). If the prism is in some other medium, μ must be replaced with n, the relative index of refraction.

The angles r and i' are related and dependent on the angle θ, which is the angle between the faces of the prism. From plane geometry we find that

$$\theta = r + i', \quad \text{or} \quad i' = \theta - r.$$

Substituting this value of i' in Eq. (3–2b)

$$\sin r' = \mu \sin (\theta - r). \tag{3-2}$$

The angle between the lines OP and QR is represented by angle d, and is known as the total angle of deviation through a prism. This is the sum of angles d' and d'' as shown in the figure.

If two similar prisms are arranged as shown in Fig. 3-3, with their bases parallel but one prism inverted, two parallel rays of light, OC through the top prism and PB through the bottom prism, are deviated or bent in opposite directions. That is, the ray OC bends downward and the ray PB bends upward. At some point Q these two rays cross. The distance q in the diagram, depends on the angle θ between the faces of the prisms. The greater the angle θ, the less is the distance q for any given value of μ.

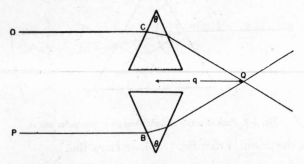

Fig. 3-3. Rays of light passing through two similar prisms.

Now let us arrange four prisms, two of which are triangular and two quadrilateral, as shown in Fig. 3-4. In this case there can be four mutually parallel light rays, one passing through each prism. If the angles between the faces of the various prisms are of certain values, all of the light rays pass through a common point Q in the same way that the two rays crossed when two prisms were used.

The process of adding more and more prisms, each with a slightly different angle between faces, could continue until there would be

an infinite number of prisms and an infinite number of light rays. At this point, then, the cross section of the prisms would no longer

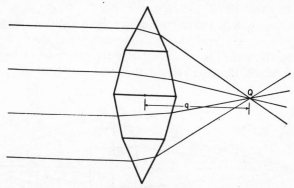

Fig. 3-4. Four rays of light converging at a point after passing through four prisms.

show any straight lines, but would be a continuous curve. A cross section of this type is shown in Fig. 3-5, and may be recognized as the cross section of an ordinary reading glass. In the simplest case these curves for the cross section of a lens are arcs of circles, and the surfaces are a small part of the surface of a sphere. The lens whose

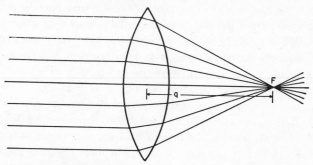

Fig. 3-5. Parallel rays converging at a point after passing through a lens.

cross section is shown in Fig. 3-5 is known as a double convex lens because both surfaces curve outward.

The double convex lens

Certain important relationships exist in a double convex lens. These relationships concern the various distances involved between

an object, the lens, and the image. In order to understand these re-
lationships, we must first define some of the terms used in connection
with a convex lens.

If we allow parallel rays, such as rays from a very distant object,
to fall on a convex lens, the rays will converge at some point Q as
shown in Fig. 3-5. The distance q from the center of the lens to the
point at which the rays cross is the focal length of the lens. In

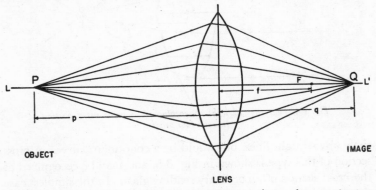

Fig. 3-6. Diverging rays passing through a double convex lens and converging to a point.

Fig. 3-6 the source of the rays is nearer to the lens, and the incident
rays are no longer parallel, but reach the lens as a set of diverging
rays. When these rays pass through the lens, they are deviated
approximately the same amount as before, but their point of inter-
section is not at the same distance as in Fig. 3-5. They cross at a
greater distance from the lens as shown in Fig. 3-6. The focal
length is represented here as distance f and the point F is the focal
point. The source is shown as point P and the corresponding posi-
tion Q is also a point. The line LL' is known as the optical axis of
the lens, and it is perpendicular to the line bisecting the lens.
Since the rays which are emitted from P actually cross Q, there is an
image of P formed at Q. This image is called a real image because
it can be focused on a screen. An image of the kind we see in a
plane mirror is a virtual image, since it cannot be focused on a
screen.

We notice from Fig. 3-5 that the parallel rays from the object
which eventually pass through the focal point are also parallel to
the optical axis of the lens. It is a general rule of optics that any

incident ray which is parallel to the optical axis of the lens emerges
so that it passes through the focal point. This fact may be used in
conjunction with another to locate images graphically. The other
rule says that any ray passing through the center of the lens, goes
through the lens undeviated. A simple proof of this rule follows
from Snell's law applied to a glass plate with parallel sides.

Let us now consider the image formed from a source that is not a
point. Such a source is shown as an arrow in Fig. 3-7. Only two of

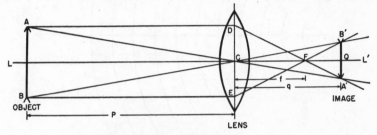

Fig. 3-7. Graphical method of locating an image.

the rays emitted from the tip of the arrow A are needed to locate the
position of the image of the tip A'. These are the two rays which
follow the rules as stated above. The ray ADA' emerges from the tip
parallel with the optical axis of the lens. This ray must necessarily
pass through the focal point F as shown. Another ray ACA' passes
through the center of the lens and is not deviated. The point at
which the two rays ADA' and ACA' cross is the location of the image
of the tip of the arrow. Similarly, the point at which the two rays
BEB' and BCB' cross is the location of the image of the tail of the
arrow. We can use this same procedure for the arrow in detail and
find the complete image of the arrow. However, this much effort is
usually not necessary, especially when the object lies almost all in
one plane.

The above method of locating an image is useful in many
problems and is accurate enough for most work in photography.
However, we can derive a mathematical formula for the same re-
lationships. In order to derive these relationships, we will find it
more convenient to consider the wave fronts of the light rays. From
any point source there are emitted waves of light consisting of
spherical wave fronts. The cross section of these wave fronts forms a
series of concentric circles such as the waves formed on a water

surface when a stone is dropped into the water. Figure 3-8 repre-
sents a part of the wave fronts emitted from a point source.

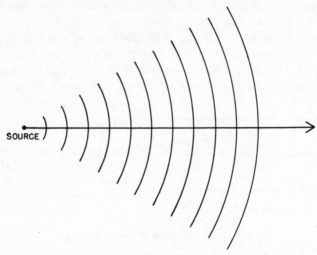

Fi g. 3-8. Spherical wave fronts emanating from a point source.

Before deriving the lens formula we must establish some relation-
ships between the length of a chord and the radius of the circle as-
sociated with it. Consider the chord AB in Fig. 3-9a. The distance
s between the chord and the arc of the circle is called the sagitta.

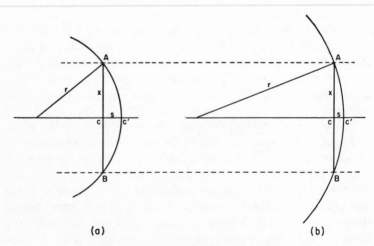

(a) (b)

Fig. 3-9. The sagitta and chord of a circular segment.

As the radius of the circle becomes larger, the distance s becomes smaller, for the same chord length, as in Fig. 3-9b. From Fig. 3-9a let the chord length $AB = 2x$. Then

$$x^2 = r^2 - (r - s)^2$$
$$= 2rs - s^2.$$

As long as we are dealing with only a small arc length, s^2 is so small compared to $2rs$ that we may neglect the s^2 term. Therefore

$$s = \frac{x^2}{2r}.$$

In general, as long as the arc is only a small part of the circle, the above relationship exists for chords of equal length, and the radius of the circle is inversely proportional to the length of the sagitta. Thus,

$$r \propto \frac{1}{s} \quad \text{or} \quad r = \frac{k}{s}$$

where k is the proportionality constant.

Let us now return to our problem of finding the mathematical relationships between the image and object of a double convex lens and refer to Fig. 3-10. From the point source P there are wave

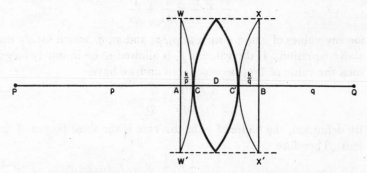

Fig. 3-10. Change of curvature of a wave front passing through a lens.

fronts emitted as in Fig. 3-8. The particular wave front that is of interest is the one which is tangent to the lens and represented as WCW'. This wave front will pass through the lens, part of it passing through the center and part of it passing through the extreme edges. The wave front will emerge as wave front $XC'X'$, since the center of it passes through the thickest part of the glass and is retarded more

than the edges. The wave front $XC'X'$ is a converging wave front with its center of curvature at some point Q where the resulting image will be formed. The light travels the distance D in glass in the same length of time that it travels the distance WX in air.

If the chords WAW' and XBX' are drawn for the wave fronts, the short distances AC and $C'B$ are the sagittas. We also have the relationship $WX = ct$, where c is the velocity of light in air and t is the time taken to travel the distance WX. From Fig. 3-10

$$WX = \frac{K}{p} + \frac{K}{q} + D = \mu D = ct$$

where K/p and K/q are the sagittas AC and $C'B$ respectively, and μD is the "optical length" of the thickest part of the lens. Since the product μD is a constant for any one lens, then $K/p + K/q + D$ must be a constant also. In the above relationship the values of p and q are not specified so that other values of p and q must satisfy the same equation. For example,

$$\frac{K}{p_1} + \frac{K}{q_1} + D = \frac{K}{p_2} + \frac{K}{q_2} + D = \mu D.$$

By simplifying we obtain

$$\frac{1}{p_1} + \frac{1}{q_1} = \frac{1}{p_2} + \frac{1}{q_2}$$

for any values of p and q such as p_1, p_2 and q_1, q_2 which satisfy the above equation. If the value of p_1 is allowed to be infinitely large, then the value of $1/p_1$ becomes zero and we have

$$\frac{1}{q_1} = \frac{1}{p_2} + \frac{1}{q_2}.$$

By definition, the value of q_1 in this case is the focal length of the lens. Therefore

$$\frac{1}{f} = \frac{1}{p} + \frac{1}{q} \tag{3-4}$$

where f is the focal length of the lens, p is the distance from the object to the lens, and q is the distance from the lens to the image.

From the discussion above we can determine two convenient methods for measuring the focal length of a lens. The first method is by measuring the distance from the lens to the image when the object is at a very great distance. The second is by measuring the

object and image distances for any setting of the lens and computing the focal length from Eq. (3–4).

If p and q are interchanged in Eq. (3–4), the result is the same formula. This fact shows that if the image is replaced by the object, the resulting image is formed at the position formerly occupied by the object. However, there is a difference in the size of the resulting image, and this difference in size will be discussed later under magnification.

Most photographic lenses have the focal length stamped on the mounting barrel so that it is usually unnecessary to measure this value. However, the lens formula, Eq. (3–4), is useful in photography for other purposes. Often it is more convenient to solve for f, which results in the following:

$$f = \frac{pq}{p + q}. \tag{3–4a}$$

The corresponding values for p and q are sometimes useful.

$$p = \frac{fq}{q - f} \quad \text{and} \quad q = \frac{fp}{p - f}.$$

As the image distance q becomes smaller, the object distance p becomes larger. This fact shows that as the object comes closer to the camera, the lens must be placed farther from the film in order for the object to be in focus. The closest that the object can come depends on the bellows extension of the particular camera. For this reason cameras are often equipped with double extension bellows, and can be focused on any object from infinity to a distance defined by

$$p = \frac{f(2f)}{2f - f} = 2f.$$

In this case the image distance is equal to the object distance and also equal to twice the focal length of the lens.

When the value of the object distance p is smaller than the focal length, q has a negative sign. The image is then formed on the opposite side of the lens, that is, the same side as the object, and it is a virtual image, or one which cannot be focused on a screen. Since this image cannot be formed on a photographic film it is not used in photography. However, a virtual image of this type has a variety of

other applications, among which is its use when formed by a convex lens acting as an ordinary magnifying glass.

Magnification

The magnification of a camera is defined as the size of the image divided by the size of the object. Consider the object, lens, and

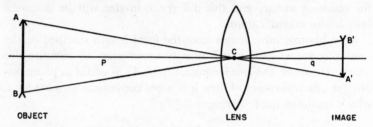

Fig. 3-11. Magnification by a convex lens.

image as illustrated in Fig. 3-11. The triangle ABC is similar to triangle $A'B'C$. Therefore

$$\frac{A'B'}{AB} = \frac{q}{p} = m \tag{3-5}$$

where m is the magnification, and p and q are the object and image distances respectively, as before.

In an ordinary camera the object is normally larger than the image with the result that m is smaller than unity. A camera equipped with a double-extension bellows can be adjusted so that the object distance is twice the focal length of the lens. Under this condition the object distance is equal to the image distance and the magnification is unity. The result is frequently referred to as "one to one" copying.

In other types of photography, such as photomicrography, the image is larger than the object. The image distance is larger than the object distance and the magnification greater than unity. According to Eq. (3-5) there is no limit to the magnification of an object. However, a theoretical limit is imposed by the finite wave length of light, and a practical limit is imposed by lens aberrations. These limitations will be discussed in Chapter Eleven.

Concave lenses

Convex lenses are called converging lenses because they converge light rays from an object to form an image. Concave lenses cause

light rays to further diverge. Figure 3-12 shows how two prisms
placed with the apex of each together diverge two parallel light

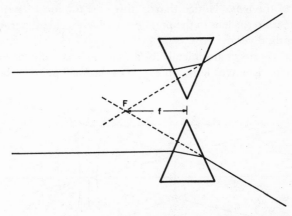

Fig. 3-12. Divergence of two parallel light rays passing through two
suitably arranged prisms.

rays. Upon emerging from the prisms, the two light rays appear to
be coming from a point *F*, which is formed by projecting the two
emerging rays back along straight lines. The use of an infinite
number of prisms, as for the convex lens, allows a whole beam of

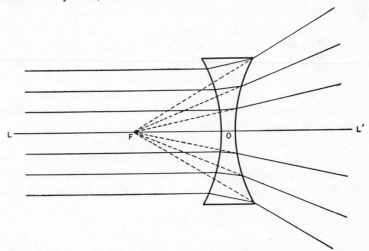

Fig. 3-13. Divergence of parallel light rays by a concave lens.

parallel light rays to diverge from a point. This situation is illus-
trated in Fig. 3-13. Here, as before, the distance OF is the focal
length of the lens. Notice that in this case the focal length is the
distance from the lens to the point *from* which incident parallel rays
apparently diverge.

Locating images graphically for a concave lens is similar to such a
problem for a convex lens. In Fig. 3-14 the focal point of the lens is

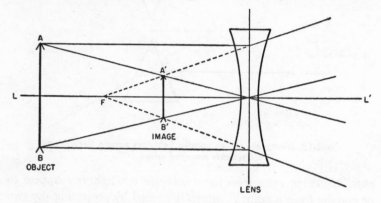

Fig. 3-14. *Graphical location of the image formed by a concave lens.*

represented by the point F. The two principles used to locate
images are: (1) any incident ray parallel to the optical axis of the
lens emerges from the lens as if it had come in a straight line from
the focal point; (2) any ray passing through the center of the lens
emerges undeviated. By using only the rays defined by the above
two statements, we can determine the size and position of the image
graphically as shown in the figure. Notice that the image is not
inverted as it was for a convex lens. Also, it is a virtual image since
it cannot be focused on a screen.

The mathematical relationship between the object distance,
image distance, and the focal length of a diverging lens can be
derived in the same way as for a converging lens. This derivation
will not be given here, but the same formula applies. This is,

$$\frac{1}{f} = \frac{1}{p} + \frac{1}{q}.$$

However, we must now stress the importance of algebraic signs.
According to practise, the following convention is ordinarily used:

The optical arrangement is drawn so that the light from the object is incident upon the lens from the left, and the object distance is considered positive. The image distance is positive when the image is formed to the right of the lens. The focal length of a diverging lens is considered negative and the focal length of a converging lens is considered positive. Thus, for a single diverging lens, q and f are both negative.

Diverging lenses are not used by themselves in photography since they do not form real images. However, they are used in conjunction with converging lenses in a variety of ways. Among these are their uses to correct some of the shortcomings of a single convex lens and to form telephoto lenses. These applications will be discussed in Chapter Eleven.

All of the above formulas treating the relationships between focal length, object distance, and image distance have been derived with the aid of the approximation that the sagitta is inversely proportional to the radius of curvature, for a given chord length. This statement is valid only when the arc of the circle is but a small part of the complete circle. In other words, for "thin" lenses, where the difference in thickness between the center of the lens and the edges is small compared with the diameter of the lens, the formulas are applicable. In reality the formulas are approximations, but are satisfactory for most problems in photography. However, for some types of work these formulas must be modified. Although some of the modifications will be given in later chapters, the complete theory is beyond the scope of this book. For further study, refer to any text covering the subject of geometrical optics.

Lens coating and cleanliness

Light is not only transmitted by a piece of glass, but some of it is also reflected from the surface. The reflected light is lost as far as use in the camera is concerned and therefore reduces the image brightness. Glass of which lenses are made reflects about 4% of the light incident upon its surface. This light loss occurs not only at the first surface, but also at the second surface of a simple lens, and at all of the surfaces if the lens consists of more than one component. With two reflecting surfaces, the amount of light lost is not serious since about 92% is transmitted through the lens. However, photo-

graphic lenses made of many components may have as many as ten reflecting surfaces, and the amount of light lost is significant. Lens coating reduces the amount of reflected light at a lens surface and increases the amount transmitted. A coating to produce minimum reflection must have an index of refraction such that its value squared equals the index of refraction of the glass. The thickness of the coating must be one-quarter wavelength, it must adhere to the glass, and it must be hard enough to withstand normal use. Only a few substances have been found which approach these ideal conditions. Among these, calcium fluoride is widely used but it still allows as much as 1% to 2% of the light to be reflected. By increasing the amount of light which forms the image, a lens coating decreases the over-all fog of the film and produces a more pleasing negative.

A lens which is not kept clean impairs the image quality. Dust and fingerprints on a lens surface scatter the light and produce an all-over fogging of the film. This scattering is particularly noticeable when the subjects are backlighted, and the resulting negative fog can be more serious than can be offset by any decrease of fog as a result of lens coating. Dust from lenses should be brushed off gently with a camel-hair brush and then the lens cleaned with the aid of a soft linen handkerchief or lens tissue.

References for Additional Reading

SIMPLE LENSES AND LENS THEORY

Ballard, S. S., E. P. Slack, and E. Hausman, *Physics Principles*, Chap. 29, D. Van Nostrand Co., Inc., Princeton, N. J., 1954.

Perkins, H. A., *College Physics*, 3rd ed., Chap. 32, Prentice-Hall, Inc., Englewood Cliffs, N. J., 1948.

PHOTOGRAPHIC LENSES

Greenleaf, A. R., *Photographic Optics*, Chaps. 1 and 2, The Macmillan Co., New York, 1950.

Kingslake, R., *Lenses in Photography*, Chap. 2, Doubleday & Co., Inc., Garden City, New York, 1952.

Problems

1. The velocity of light in a vacuum is about 3×10^{10} centimeters per second. If the index of refraction of glass is 1.5, what is the velocity of

light in the glass? What is the velocity of light in water (index of refraction = 1.33)?

2. Compute the wavelength of green light in glass and in water. Assume the wavelength in vacuum to be 5500 Angstroms and the indexes of refraction as in Problem 1.

3. What is the frequency of the vibration of light whose wavelength in a vacuum is 5500 Angstroms?

4. What is the frequency of vibration of light traveling through glass if the index of refraction of the glass is 1.5 and the wavelength of the light in the glass is 4000 Angstroms?

5. Prove that the *relative* index of refraction between two media is equal to the ratio of their indexes of refraction.

6. A 60° prism, as shown in Fig. 3-2, with index of refraction 1.5, has a light beam incident on it. The angle of incidence, i, is 30°. Compute the angle of refraction at the first face, the angles of incidence and refraction at the second face, and the total angle of deviation.

7. The focal length of a lens is 4 inches. If the object is 12 inches from the lens, where is the image?

8. Locate accurately the image in Problem 7 by graphical methods.

9. The Gaussian form of the lens equation is given by Eq. (3–4) which is

$$\frac{1}{f} = \frac{1}{p} + \frac{1}{q}.$$

An alternate form is one suggested by Newton, namely

$$xy = f^2$$

where x is the distance from the object to the focal point in object space and y is the distance from the image to the focal point in image space. Derive the Newtonian form of the lens equation from the Gaussian form.

10. A lens of 6 inches focal length is used with an object placed 4 inches from it. Where is the image formed?

11. A lens of 5 inches focal length is to be used to form an image three times as large as the object. What must be the distance between the object and image?

12. A lens of 5 inches focal length is to be used to form an image one-third as large as the object. What must be the distance between the object and image?

13. A concave lens has a focal length of − 5 inches. If an object is placed 10 inches from this lens, where is the image?

14. A concave lens of − 10 inches focal length is used with the object 4 inches from it. Where is the image formed?

IMAGE BRIGHTNESS

The two factors which determine the brightness of the image in a camera are the brightness of the object and the optical system of the camera. In the strict sense, brightness is a subjective term which is applied to the appearance as seen by the eye. For quantitative measurements, the term *luminous intensity* is used for the total light emitted by a source, *luminance* for the light emitted (or reflected) per unit area, and *illuminance* for the light per unit area incident on a surface. For convenience we will begin our discussion of object luminous intensity in terms of a point source.

Photometry of a point source

When a point source emits light uniformly in all directions, the light energy spreads out radially. An imaginary sphere, Fig. 4-1, one foot in radius with the source at its center receives all the light energy on its inner surface. Similarly, an imaginary sphere two feet in radius with the source at its center receives all the energy on its inner surface. The area of a sphere is $4\pi R^2$ and the light per unit area, or illuminance, of a sphere with a point source at its center is

$$I = \frac{S}{4\pi R^2} \tag{4-1}$$

where S is the total light emitted by the source and R is the radius of the sphere. Equation (4-1) is a statement of the inverse-square law of illumination.

The term S is known as the luminous intensity of the source and is frequently given in candlepower[1]. The quantity of light propagated through space is called flux, and the unit of flux is the lumen. The lumen is defined by

$$4\pi \text{ lumens } = \text{ one candlepower.}$$

Thus, in our previous discussion of the concentric spheres surrounding the point source, the luminous flux density at the surface of the

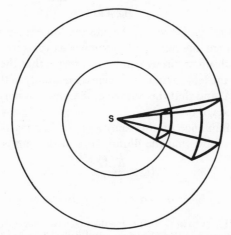

Fig. 4-1. Inverse-square law of illumination.

inner sphere is one lumen per square foot when S is one candlepower. This flux density is equivalent to the unit of illuminance known as the foot-candle. In the discussion to follow we shall use lumens for intensity units and lumens per square foot as luminous flux density or illuminance units.

Photometry of a broad source

We seldom have point sources to photograph. Astronomical photography of stars represents the best example of point sources, but most pictures are of objects of finite area.

[1] A candlepower is the luminous power emitted by a standard candle. The standard candle is defined as $\frac{1}{60}$ of the luminous intensity of one square centimeter of black-body radiation at a temperature of solidifying platinum. This standard candle is somewhat smaller than the original standard candle which was based on the rate of burning of a candle of particular composition.

Consider a source with an area A_s as illustrated in Fig. 4-2. The total number of lumens emitted or reflected from this surface is its

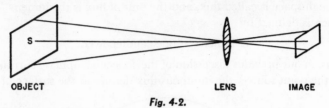

OBJECT **LENS** **IMAGE**

Fig. 4-2.

luminous intensity. However, the emitted lumens per unit area is a more convenient measure and is known as the luminance of the source. For this first discussion, let us assume that the source is far enough from the lens so that the image is essentially in the focal plane of the camera, and that the surface of the source is perpendicular to the optical axis of the lens.

Let the luminance of the source be E_s lumens per unit area. Then we can show that the illuminance at the lens is

$$I_1 = \frac{E_s A_s}{\pi p^2} \qquad (4\text{-}2)$$

where p is the object distance, and A_s is the area of the source.[2]

[2] For proof of Eq. (4-2) we see that $E_s A_s$ is the total flux in lumens from the source S. Most surfaces are rough compared with the wavelength of light, and for rough surfaces we assume Lambert's law to be true. This law states that light is emitted or reflected equally well in all directions from a rough surface. As a result of Lambert's law, the flux density I is not uniform in all directions because as the angle θ increases (see Fig. 4-3) the projected area of the source decreases. The flux density is therefore proportional to cos θ.

Let us consider an elementary ring of the hemisphere HH' defined by some value of θ as shown. The flux density is some value I everywhere on this ring. The area of the ring is $2\pi R \sin \theta\, R\, d\theta$, where R is the radius of the hemisphere. Since all the flux emitted by S is intercepted by the hemisphere we have

$$E_s A_s = \int_0^{\pi/2} I 2\pi R \sin \theta\, R\, d\theta.$$

Let the intensity at the center of the hemisphere (the position occupied by the camera lens in Fig. 4-2) be I_1. Then

$$I = I_1 \cos \theta$$

and

$$E_s A_s = 2\pi I_1 \int_0^{\pi/2} R^2 \sin \theta \cos \theta\, d\theta$$
$$= \pi I_1 R^2.$$

Then we have the illumination at the center of the hemisphere is

$$I_1 = \frac{E_s A_s}{\pi R^2}$$

which is the same as Eq. (4-2).

Equation (4–2) holds only when the linear dimensions of the source and the lens diameter are both small compared with p. The flux through the lens is the product of the flux density I_1 multiplied by the area of the lens, which is

$$F = \frac{I_1 \pi D^2}{4} \text{ lumens,}$$

where F is the flux through the lens and D is the lens diameter. All the flux F goes to form the image so the flux density, or illuminance, of the image is

$$I_i = \frac{F}{A_i} = \frac{I_1 \pi D^2}{A_i 4}$$

$$= \frac{E_s A_s \pi D^2}{\pi p^2 A_i 4}$$

$$= \frac{E_s A_s D^2}{4 A_i p^2} \tag{4–3a}$$

where A_i is the area of the image. The area of an object or image is proportional to the square of its linear dimensions. Since magnification is defined in terms of linear dimensions, the square of the magnification is

$$m^2 = \frac{A_i}{A_s} = \frac{f^2}{p^2}.$$

By substituting this value of the area ratio into the previous relation for the image brightness (actually image illuminance) we have

$$I_i = \frac{E_s D_s^2}{4f^2} \tag{4–3}$$

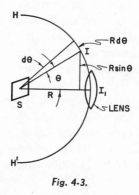

Fig. 4-3.

where I_i is in lumens per unit area, E_s is in lumens per unit area, D is the lens diameter, and f is the focal length in the same units as D. Equation (4–3) says that for a given object luminance, the image illuminance is proportional to D^2/f^2. Notice that this equation does not contain the object distance p and therefore the image illuminance is independent of the distance of the object from the camera. This is, however, under the assumption

that the object is far enough away from the camera that the image is formed essentially in the plane at a distance f from the lens.

The results of Eq. (4–3) form the basis for the custom of giving the "speed" of a lens in terms of its focal ratio. The focal ratio, or f number, of a lens is the focal length divided by the lens diameter. The image illuminance is therefore inversely proportional to the square of the f number.

A good lens is usually equipped with a light stop or an iris diaphragm which controls the amount of light transmitted to the film. Stops are generally calibrated in terms of the f number. For instance, a typical lens may have a focal length of 5 inches and a diameter of one inch. Such a lens has an f number of five. A lens of focal length 2 inches and a diameter 0.4 inches also has an f number of five. In each case the image has the same illuminance, but in the latter case the image is smaller. When a lens is equipped with an iris diaphragm, the corresponding f numbers are stamped on the lens mounting for the various positions of the diaphragm. The stamped f numbers have an indicated progression of approximately $1 : \sqrt{2}$, so that for each increase in f number the image illuminance is cut in half. There are two common progressions in use. One of them is $f/2.2$, 3.2, 4.5, 6.3, 9, 12.6, 18, etc. The other is $f/2$, 2.8, 4, 5.6, 8, 11, 16, 22, 32, etc.

The exposure of a photographic material is the product of the image illuminance and the length of time that it is exposed to the light. We have already seen in Chapter Two how the time of exposure may be varied by the shutter. The focal ratio gives an additional method of controlling exposure, and the f number and exposure time are interdependent. For example, let us assume that a film is correctly exposed when the f number is 5 and the shutter speed is $\frac{1}{200}$ second. If the lens is stopped down by means of the iris diaphragm to $f/10$ then the corresponding shutter speed must be four times as great, or $\frac{1}{50}$ second, in order to compensate for the decreased illuminance of the image.

The Uniform System (U. S.) is another system for evaluating the brightness of the image and is found on older lenses. In this system the indicated stop openings are inversely proportional to the illuminance of the image. The U. S. numbers have a ratio of $1 : 2$ and are of a value such that U. S. 16 is equivalent to $f/16$. The following table gives the relative values.

f/number	8	11	16	22	32	44
U. S. number	4	8	16	32	64	128

The calibration system of a lens is important since what may appear to be an $f/4$ lens is really marked in the Uniform System and is only an $f/8$.

The f number and the U. S. systems are both derived under the assumption that the lens transmits 100% of the light. Any actual lens not only reflects part of the incident light but also absorbs part of it. A simple lens of $f/4$ gives a brighter image than a corresponding $f/4$ lens made up of several components. The transmittance, or T, system determines the image illuminance in a more realistic way. The T numbers are similar to the f numbers except that they take into account the light lost by reflection and absorption. By definition, the T numbers give the focal ratio of an opening that would transmit the same amount of light as is actually transmitted by the lens. In every case the T number is slightly larger than the corresponding f number, but the T number gives a better measure of the image illuminance.

Image brightness of close objects

Equation (4–3) was derived under the assumption that the object is far enough away from the camera so that the image is at a distance from the lens equal to the focal length. When the object is close to the camera, this assumption is no longer valid, and we must go back to Eq. (4–3a), which is

$$I_i = \frac{E_s A_s D^2}{4 A_i p^2}. \tag{4–3a}$$

The square of the magnification is

$$m^2 = \frac{A_i}{A_s} = \frac{q^2}{p^2}$$

where q is the image distance. By substituting this value of A_s/A_i into Eq. (4–3a) we get

$$I_i = \frac{E_s D^2}{4 q^2}. \tag{4–4}$$

This equation is valid for any object distance and is equivalent to Eq. (4–3) when the object is far enough away that q is substantially

equal to the focal length. The application of Eq. (4–4) will be illustrated in Chapter Six.

References for Additional Reading

PHOTOMETRY AND IMAGE BRIGHTNESS

Kingslake, R., *Lenses in Photography*, Chap. 4, Doubleday & Co., Inc., Garden City, N. Y., 1951.

Sears, F. W., *Principles of Physics*, 3rd ed., vol. III, Chap. 13, Addison-Wesley Press, Inc., Cambridge, Mass., 1948.

Problems

1. A point source of 10 candlepower intensity is placed 10 feet from a small flat object with the surface perpendicular to the line from the source. What is the illuminance on the surface?

2. A small flat object is placed 100 feet from a 10 candlepower source. The surface of the object makes an angle of 60° with the line from the source. Compute the illuminance on the object.

3. A diffuse source with a flat surface emits 10 lumens per square foot; a lens is placed 3 feet away from the surface along a line perpendicular to the surface. Compute the luminous flux density at the lens for each square foot of source area.

4. A lens is placed 3 feet away from a flat diffuse source emitting 100 lumens per square foot. The line between the lens and the surface forms an angle of 45° with the surface. Compute the illuminance at the lens due to one square foot of the source. Now compute the illuminance at the lens due to one square foot of projected area of the source as seen from the lens. Compare the latter value with the illuminance from one square foot of the source when the surface is perpendicular to the line to the lens.

5. A sheet of white paper one foot square is held perpendicular to the sun's rays and is illuminated with 30,000 lumens per square foot. Compute the illuminance of the image of this paper when the image is formed by an $f/4$ lens at a large distance from the paper.

6. A sheet of white paper is held perpendicular to the rays of a 100-lumen point source at a distance of 20 feet. An image of the paper is formed by a lens of $f/8$ aperture at a large distance from the paper. Compute the image illuminance.

CHAPTER FIVE

FILMS

A photographic film consists primarily of a base coated with a light-sensitive emulsion. The base is almost always made of a cellulose product or glass. When cotton is treated with nitric acid it forms nitrocellulose which is a highly satisfactory base for photographic emulsions. However, nitrocellulose is so highly flammable that most photographic film is made of cellulose acetate. The acetate film base is made by treating cotton with acetic acid. Although this film will burn, its slow burning rate does not present so great a fire hazard as the near-explosive violence of the nitrate film. Cellulose acetate film is frequently referred to as *slow burning* or *safety* film.

Photographic film is manufactured on large rollers in sheets 36 to 40 inches wide and often nearly a half mile long. These large sheets are coated with the light-sensitive emulsion and then cut into the required sizes. Practically all the film comes out as roll film, sheet film, movie film, and filmpack.

Roll film is the type which is used in box cameras, folding cameras, and others that have a roll film adapter. It comes wound on spools and protected from the daylight with black paper. The leading edge of the film is fastened to the protecting paper, and the film and paper stay together as the photographer advances them through the camera. A window in the back of the camera serves the double purpose of enabling the photographer to stop the film at the proper time and to count the exposures. The necessary markings are included on the protecting paper. The convenience as well as the economy of roll film has led to its general popularity.

43

Professional photographers use sheet film more than any other type. Sheet film is relatively inexpensive, can be processed one sheet at a time and is less cumbersome than the glass plates which it has largely replaced. However, it must be loaded into a holder in a darkroom. Sheet film is inserted in the holder so that the emulsion side of the film will be toward the camera lens. To facilitate loading manufacturers mark the film with one or more notches in the upper right-hand corner. These notches serve a dual purpose. First, they allow the photographer in the darkroom to orient the film properly; second, the notches are coded for the purpose of marking the emulsion type of the film. The notching code for the particular film type is shown on each package of sheet film. Also, various reference books give the notching codes used by the film manufacturers.

The largest consumers of movie film are, of course, the motion picture industries. However, many special types of 35 mm movie film are produced for miniature cameras. Movie film is perforated with sprocket holes in accordance with the system devised by Thomas A. Edison, and both movie cameras and miniature cameras advance the film by means of the perforations. Movie film is available in both 35 mm and 16 mm widths. Most 8 mm movie cameras require 16 mm film and expose it one-half at a time. The picture size of 35 mm movie cameras is about 1 by 0.75 inches with the longer dimension across the width of the film. Miniature cameras using 35 mm film take "double frame" exposures of about 1 by 1.25 inches in size with the longer dimension along the length of the film.

Filmpack is used primarily instead of cut film where darkroom facilities are not convenient or where the time interval between successive pictures must be as short as possible. The film base for filmpack is thinner and more flexible than that used for sheet film, because the construction of the pack requires that the film be pulled from the front around a semicircular piece to the back. Each film in a pack is fastened to a piece of black paper which has on it a tab projecting out of the pack. After exposure, the tab for the exposed film is pulled, and the film moved from its position in front of the separation plate to the back. The next film is then in place for exposure. The emulsion base is so thin on filmpack that the film itself does not always lie in one plane. Packs of 4 by 5 inches and larger suffer appreciably from this difficulty. As a result, the

camera must be stopped down in order to give a larger depth of focus. Sheet film magazines, which cut down the time between successive pictures, do not have this difficulty, but they must be loaded in the darkroom. A filmpack does have a comparable advantage with sheet film in that the photographer is able to remove any number of exposed films in a darkroom without appreciably affecting the rest of the unexposed films in the pack.

Glass photographic plates are used whenever extremely accurate focusing and measurements on the finished negative are required. Therefore, most photographic telescopes and spectrographs use glass plates. Manufacturers supply photographic plates in a wide variety of emulsions and sizes, and practically any desired emulsion or size for a specific purpose can be obtained upon special order. One of the difficulties in using plates occurs when they are being loaded into holders. The emulsion side and the back are hard to tell apart. If the photographer realizes that the plates are packaged back to back and can keep track of them as they are removed from the box there is no trouble. However, if he becomes confused, the method for testing is to touch one corner of the plate with the tip of the tongue. The tongue sticks slightly to the emulsion side of the plate but not to the back.

Halation and irradiation

The emulsion of a film or plate does not absorb all the light which falls on it. Some of the light is scattered by the emulsion, producing the effect known as irradiation. Since the emulsion is not completely opaque, part of the light passes through the emulsion and is

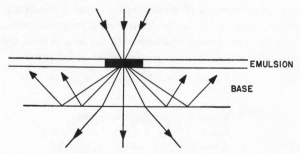

EMULSION

BASE

Fig. 5-1. Light scattered by an emulsion giving the effects of halation and irradiation.

reflected from the back surface of the film to cause halation. Halation and irradiation produce a foggy patch around the image and are especially noticeable around the image of a small bright source. (See Fig. 5-1.) The halation on films is decreased by means of an antihalation coating on the back side. This coating actually serves two purposes. The emulsion contains gelatin and the film normally tends to curl toward the gelatin side. The antihalation coating on the back is also gelatin and the net result of the two coatings is negligible curling of the film. In the antihalation coating is a colored material which absorbs the colors to which the film is sensitive and hence reduces the reflection that causes halation. Glass plates are not usually backed with an antihalation coating during manufacture. Secondary images caused from reflection are sometimes serious, particularly in astronomical work where the objects are points of light. In order to reduce this reflection, the plates must be coated on the back side. The material for this purpose must have about the same index of refraction as the glass, it must absorb the light, and it must stick to the glass. A mixture of lamp black and a thick sugar solution is satisfactory for this purpose.

Some films have a relatively insensitive emulsion coated underneath the regular sensitive one. The insensitive emulsion absorbs much of the scattered light and most of the reflected light. Since this emulsion requires considerable light to affect it, the halation produced by both the reflected and scattered light is greatly reduced.

Spectral sensitivity

The spectrum consists of a continuous series of electromagnetic waves whose wavelengths range from several miles to less than one one-hundredth Angstrom. Starting with the long waves, the list of electromagnetic waves is arbitrarily divided as follows:

> Electric waves
> Radio waves
> Micro waves
> Infrared waves (heat radiation)
> Light
> Ultraviolet radiation
> X-rays
> Gamma rays.

Figure 5-2 shows the frequency and wavelength range of each of these divisions. The action of radiation for photographic work is

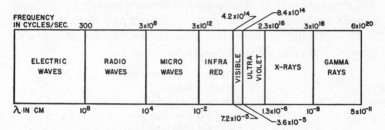

Fig. 5-2. Wavelength and frequency regions of the electromagnetic spectrum. Wavelengths are specified for vacuum conditions.

limited to the shorter wavelength end of the spectrum, and has its beginning in the infrared radiation at about 13,000 Angstroms.

The portion of the spectrum to which the human eye is sensitive is actually a narrow band extending from about 3800 to 7200 Angstroms. In this narrow band, we recognize several colors depending on the wavelength of the light. Starting again with the longer wavelengths, the eye sees the following colors:

<div style="text-align:center">

Red
Orange
Yellow
Green
Blue
Violet.

</div>

The first photographic emulsions were sensitive only to the blue and violet portions of the visible spectrum. In 1873, H.W. Vogel discovered that the addition of dyes increases the spectral sensitivity of photographic emulsions. The dyes used by Vogel and others immediately following were successful in giving the emulsion a sensitivity in the yellow, but practically none in the intervening green. Later, dyes were discovered that give an almost uniform sensitivity from the violet through the yellow. The type of emulsion having this sensitivity is known as orthochromatic or isochromatic.

In 1906, Homolka, of the Hoechst Dye Works, discovered a satisfactory dye for sensitizing the red portion of the spectrum. This discovery allowed an almost complete coverage of the visible spectrum by photographic emulsions and resulted in the introduction of

panchromatic plates by Wratten and Wainwright in the same year. Since that time, many dyes have been added to the list of sensitizers, and the sensitivity of photographic emulsions has been continually pushed farther and farther into the infrared part of the spectrum.

Photographic emulsions in common use are divided into six general divisions. These divisions are:

1. Ordinary blue sensitive
2. Orthochromatic
3. Panchromatic type A
4. Panchromatic type B
5. Panchromatic type C
6. Infrared.

Figure 5-3 shows the sensitivity of these emulsions. Wavelength is plotted along the abscissa (horizontal) and relative sensitivity along

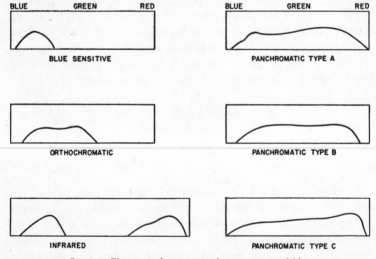

Fig. 5-3. The spectral sensitivity of various types of film.

the ordinate. These curves were drawn from wedge spectrograms for the various films. Wedge spectrograms are made by covering the slit of a spectrograph with an optical wedge and using the particular emulsion for the photograph. Manufacturers publish wedge spectrograms for the emulsions which they produce. The exact form of the spectrograms depends as much on the illuminating source used as on the spectral sensitivity of the film. The light from

the sun has a higher percent of its energy in the shorter wavelengths than does the ordinary incandescent source, and for this reason the wedge spectrograms are often given for both daylight and tungsten sources. In every case the relative sensitivity is higher in the red for a tungsten source than for daylight.

Figure 5-4 shows the spectral sensitivity of the eye. Type B panchromatic film has the emulsion which most nearly matches the sensitivity of the eye.

The ordinary blue-sensitive film is seldom used in any kind of pictorial work, but we generally use this type of emulsion when we make transparent prints such as lantern slides. Process film for

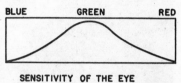

SENSITIVITY OF THE EYE

Fig. 5-4. Relative spectral sensitivity of the eye.

copying black and white drawings is available with ordinary blue-sensitive coating. While printing paper is not considered to be film, the emulsion for this purpose is also of the blue-sensitive type.

Orthochromatic film for general pictorial work has been almost completely replaced by panchromatic. Panchromatic film is the most widely used of any type of negative material, and the types B and C are the most popular.

Emulsions which are sensitized in the infrared are also sensitive in the blue region. However, the blue sensitivity can be apparently decreased or eliminated completely by the use of a red filter in connection with the film. If this filter is not used, the resulting negative appears very much as if it were a blue-sensitive film. The long wavelengths of infrared radiation are both interesting and useful photographically. Light which passes through the earth's atmosphere is scattered by the molecules of air and the impurities which are present. The amount of scattering is inversely proportional to the fourth power of the wavelength of the light. As a result, the violet and blue portions of the spectrum are scattered much more than the red and infrared. The sky, when photographed by infrared light, appears almost black on the finished print. In contrast, the leaves of trees reflect a high percentage of the infrared and appear almost white on the print. Objects which are photographed at a distance through the atmospheric haze are more distinct if photographed with infrared light. Besides its pictorial

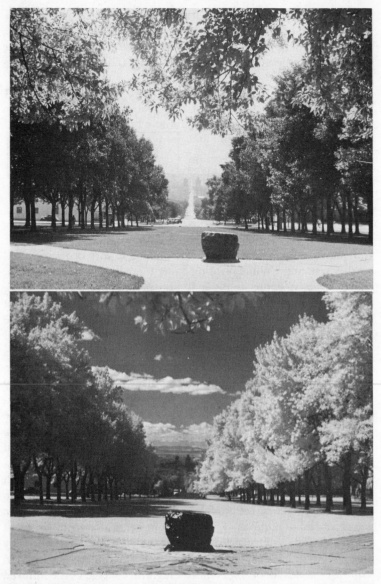

Fig. 5-5. Above, landscape in ordinary light with panchromatic film. Below, landscape with infrared-sensitive film.

value, infrared film is used in many types of specialized work. For example, writing or printing on charred paper is invisible by ordinary photographic means, but becomes legible when photographed with infrared radiation.

Contrast

Although the subject of contrast will be more fully covered under Photographic Sensitometry (Chapter Eight), we will discuss it briefly here. The contrast of a negative material determines the manner in which it reproduces the differences in luminance of objects. If one object has ten times the luminance of another, what is the difference in appearance of the images in the resulting negative? The brighter object produces a blacker image on the negative. If it is ten times as black, the contrast of the negative produces luminous fidelity. However, if the image is less than ten times as black, the contrast of the negative is low, while if it is more than ten times as black, the contrast is high. Films are purposely made with different degrees of contrast. Process film, which is manufactured for the purpose of copying black and white drawings or printed material, needs a very high degree of contrast, because the resulting print should be either black or white with no intermediate tones. Negative material which is made for pictorial work must include the tones between black and white, and do so with a high degree of accuracy in order that the finished picture will resemble the original as nearly as possible. However, for certain artistic effects we sometimes like the tonal range to be increased or, more commonly, decreased.

The most pleasing contrast depends largely upon the artistic taste of the individual. The resulting contrast for any film is dependent on two factors. First, it is inherent in the emulsion of the film, and second, it depends on the developer used and the length of time of development. Although no film is capable of reproducing the great range of light values that exist in nature, intensity ranges of 1:150 or even 1:200 are reproducible photographically. This range is greater than the usual range found in any one picture and compares favorably with the intensity range of the human eye at any given time. A photograph can, then, give a fair reproduction in black and white of the tones that we see.

Film speeds

One of the factors which affect the blackening of a photographic emulsion is its inherent sensitivity to light. This sensitivity is known as the speed of the film. Many systems have been devised to indicate the relative speeds of films, but the three most common ones in the United States are the Weston, General Electric, and the American Standards Association (ASA). The Weston and General Electric systems were originally determined for use with their exposure meters, but these systems have since been more generally accepted. Somewhat earlier film speeds were given in terms of American and European Scheiner numbers, DIN degrees, and the inertia numbers of Hurter and Driffield. Table 5-1 lists the relative exposures required and the corresponding film speed numbers of the various systems.

TABLE 5-1

Relationship Between Exposure Requirements and the Various Film Speed Systems

Exposure required for film density of one. (*lumen-seconds per sq cm*)	H & D number	DIN°	American Scheiner	European Scheiner	Weston	General Electric	ASA
2.5×10^{-4}	35	1/10	8	14	0.8	1	0.9
2.0	45	2/10	9	15	1.0	1.5	1.3
1.5	56	3/10	10	16	1.3	2	1.6
1.3	72	4/10	11	17	1.5	2.5	1.8
1.0	91	5/10	12	18	2.0	3	2.5
8.0×10^{-5}	117	6/10	13	19	2.5	4	3.3
6.7	150	7/10	14	20	3	4.5	3.7
5.0	190	8/10	15	21	4	6	5.0
4.0	240	9/10	16	22	5	7.5	6.3
3.3	308	10/10	17	23	6	9	7.5
2.5	390	11/10	18	24	8	12	10
2.0	500	12/10	19	25	10	15	12
1.7	636	13/10	20	26	12	18	15
1.3	800	14/10	21	27	16	24	20
1.0	1050	15/10	22	28	20	30	25
8.3×10^{-6}	1300	16/10	23	29	24	36	32
6.2	1700	17/10	24	30	32	48	40
5.0	2100	18/10	25	31	40	60	50
4.0	2700	19/10	26	32	50	75	64
3.1	3500	20/10	27	33	64	100	80
2.5	4400	21/10	28	34	80	120	100
2.0	5600	22/10	29	35	100	150	125
1.6	7200	23/10	30	36	125	200	160
1.3	9100	24/10	31	37	160	250	200
1.0×10^{-6}	11600	25/10	32	38	200	300	250

For a more complete discussion of exposure and film speeds see Chapters Six and Eight.

We notice that some of the series of numbers are arithmetical progressions while others are geometrical progressions. For example, the American Scheiner number 26 corresponds to the Weston number 50. However, for Weston 100 the American Scheiner number is 29. Both the Scheiner and the DIN numbers are arranged so that an increase of 3 (degrees) indicates a doubling of the sensitivity. Others are arranged so that the number is proportional to the sensitivity. The film speed numbers given in Table 5-1 are actually based on entirely different principles for determining the relative speed, and the equivalence of values of the different systems is far from exact. The numbers listed give only an approximation of the reaction obtained in practice and serve as a guide for determining exposure.

Due to the different color sensitivities of the various films, two exposure speeds for each type of film are necessary depending on whether daylight or tungsten light sources are used. Since the tungsten sources have a smaller part of their energy in the short wavelengths, the exposure index (film speed number) is usually smaller for tungsten sources. The amount of decrease of the film speed number depends on the color sensitivity of the film, so that no one standard correction can be used for all films. For a typical panchromatic type B film the Weston rating may be 50 for daylight and 32 for tungsten. However, for an orthochromatic film with a daylight Weston rating of 50 the tungsten value is about half of this or 25.

Film speeds are determined under a given set of conditions of temperature and moisture content. As a sensitive material increases its moisture content, its sensitivity decreases. This decrease in sensitivity is usually not serious except under rare conditions. However, the moisture content of a roll of movie film is often greater on the outside of the roll than on the inside, and the variation of the resulting pictures is noticeable. The variation of sensitivity with temperature is so slight that it is ordinarily neglected. An exception occurs in astronomical work where resulting negatives must be measured with a high degree of accuracy or compared with previous photographic work.

Latitude

The term latitude is rather loosely used for what should be called exposure tolerance. The exposure tolerance of a photographic

emulsion is described as the maximum amount of overexposure or underexposure compatible with production of a satisfactory picture. This tolerance depends on the latitude of the film and on the luminance range of the objects in the picture. For any particular film the latitude depends on several factors among which is the thickness of the emulsion. We mentioned that one method of reducing halation was by coating the film first with a slow emulsion. This double coating also serves the purpose of increasing the latitude of the film, and most commercial film is made with two coatings. The subject of the determination of the latitude of emulsions will be further discussed under Photographic Sensitometry (Chapter Eight).

Grain

A photographic emulsion contains silver salts which are not divided into individual molecules but are clumped together as very tiny grains. The size of these grains is important whenever enlargements are made from negatives. There are two places in which the grain size of a negative material is controlled. First, the manufacturer controls it when the film is made. Unfortunately, the larger grains of silver salt seem to be the most sensitive to light and therefore the faster emulsions will, in general, exhibit more graininess. However, even films with high speeds are capable of considerable enlargement without objectionable grain. The size of the resulting silver grains is also determined in the developing process which is carried on by the photographer or processor. The best results are to be found with the use of a developer recommended by the manufacturer of the film, as these developers are balanced chemically to conform to the film. Temperature is of prime importance to small grain size since high temperature softens the emulsion and the grains tend to coagulate and increase in size. Also, the processing solutions should all be at the same temperature throughout the processing work.

The noticeable graininess increases with the blackening of the negative up to a certain critical value, and then decreases. In a landscape picture the grain is usually most noticeable in the sky. In fact, maximum graininess appears on a print where there is a large expanse of gray. Large gray areas are the places to check for

the appearance of grain because the apparent grain is minimized in
areas where there is maximum detail of the picture.

References for Additional Reading

SPECTRAL SENSITIVITY AND SPEED OF FILMS

"Films," *Kodak Reference Handbook*, 4th ed., Eastman Kodak Co., Rochester,
N. Y., 1947.

Lester, H. M., *Photo-Lab-Index*, 10th ed., Morgan and Lester, New
York, 1949.

PREPARATION OF EMULSIONS AND FILMS

Mees, C. E. K., *The Theory of the Photographic Process*, Part I, The Macmil-
lan Co., New York, 1951.

EXPOSURE

Photographic exposure is defined as the product of the image brightness and the exposure time. The image brightness is directly proportional to the object luminance and inversely proportional to the focal ratio. The exposure time is controlled by the camera shutter.

The determination of the correct exposure can be one of the most troublesome aspects of photography. Exposure meters are a valuable aid to the solution of this problem, but they do not completely solve it. Correct exposure depends on the interrelation of the light intensity, film speed, stop opening, and shutter speed. Each of these four parameters must be properly evaluated to produce a satisfactory negative.

Exposure meters

The prime purpose of an exposure meter is to evaluate the luminance of the object. An exposure meter also provides the information necessary to relate the object luminance with the film speed, stop opening, and shutter speed. There are two types of meters in general use. One of them depends on light values determined visually, and the other depends on the light sensitivity of a photoelectric cell.

Most objects are visible because of the light they reflect. Therefore an exposure meter which gives the value of this light is the most accurate. Two early types of meters measured light incident on the object instead of light reflected from the object. Hurter and

Driffield constructed the first exposure meter in the early days of photography. This instrument was actually an air thermometer, and it measured the incident radiation by the expansion of air in a bulb. The Hurter and Driffield meter measured the total incident radiation, which is not always a reliable estimate of the actinic (short wavelength) light. The actinometer, which was developed later, removed this difficulty. This device utilized a piece of photographic paper which darkened perceptibly when exposed to light. The photographer calculated the correct exposure by measuring the length of time that was required to darken the paper by a predetermined amount. The actinometer had two advantages over the Hurter and Driffield instrument in that it was less fragile and was affected only by the actinic light.

The visual extinction meter is one type of exposure meter in use which measures the reflected light. This instrument depends on the transmission of an optical wedge, which is a semitransparent sheet that varies the amount of transmitted light from point to point in a continuous manner. The light transmission through the optical wedge is altered until the object just disappears as seen through the wedge. Then, by means of a suitable scale, the correct combination of stop opening and shutter speed is determined for any film speed. Some extinction meters have transparent numbers which vary in opacity in such a way that the last number seen is used as the indicator on the scale for correct exposure. The chief objection to this type of meter is that it is used visually. Our eyes are made to compensate for changes in the light intensity, and, although the reading of the meter gives good relative light values, the absolute light value is subject to error. On the other hand, the visual extinction meters are designed to correct this difficulty partially. Some of them are arranged so that the meter fits closely over the eye, and the eye is less affected by the over-all lighting conditions. Others have a compensating scale which corrects according to the circumstances under which the reading is made. For example, a reading taken with dark surroundings is usually too high because the iris of the eye admits a large amount of light. A correction is applied to the reading to give the film more exposure than indicated from the reading.

The photometer is another type of visual exposure meter. This instrument measures light values by comparing the intensity of an

unknown source (the object to be photographed) to a source of known intensity. An exposure meter of this type generally operates by varying the intensity of the filament of the standard source. The chief difficulty with this instrument arises from differences in color between the standard source and the unknown source. The eye can accurately judge relative light intensities only when the two sources are the same color.

The opening of the iris of the eye changes involuntarily depending on the intensity of the light, so that a measure of the diameter of this opening is an indication of the intensity of the light present. An exposure meter based on this principle was introduced in Germany, but did not receive general acceptance. One of its objectionable features proved to be the calibration. The eyes of different individuals are not the same size and the scale of measurement had to be adjusted to allow for this variation.

The introduction in the early 1930's of a photoelectric cell which generated its own voltage was a great stride forward in solving the problem of exposure in photography. One type of photovoltaic cell consists of copper oxide coated on a copper base. When exposed to light, electrons pass from the copper oxide to the copper and an electric current is produced when the circuit is completed. Photovoltaic cells, originally introduced by Weston under the name Photronic cells, convert light energy which strikes them directly into electric energy. Previously the cells used in photoelectric meters were of the type which required that batteries and control devices be used in connection with them. Actually, the light intensity on the cell varied the electric resistance of the cell, and from that variation the light intensity was calibrated by measuring the current through the cell. However, with the introduction of the Photronic cell for exposure meters, the only auxiliary equipment needed was a very sensitive ammeter. Over a large range of light values, the current output by the cell is proportional to the intensity of the light falling on it. Since this type of cell is an impartial judge of the light intensity (within certain limits) it does not have the errors connected with the human eye.

Photoelectric exposure meters are basically nearly all alike. However, the appearance and operation of different makes vary and it is a wise procedure to follow carefully the directions given for any particular meter. In general, most meters have the angle of

view restricted by means of lenses or light shields, and they are de-signed so that the coverage is about the same as the angle of view of the average camera lens. This angle is roughly 60°.

Some exposure meters give the light value directly in foot-candles (lumens per square foot). Others are graduated with arbitrary scales which, when transferred to the calculator scale for exposure, give the correct shutter speed and stop opening for any film speed. The color sensitivity of the Photronic cell is very nearly the same as the eye except that the range of the cell is somewhat greater. A comparison of the relative spectral sensitivities of the eye and Photronic cell is shown in Fig. 6-1.

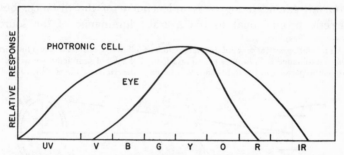

Fig. 6-1. Comparison of the relative spectral sensitivities of the eye and a Photronic cell.

An exposure meter which is used at the same position as the camera reads the average light value throughout its angle of view. This light value is satisfactory providing that the subject and the surroundings are of about the same luminance. However, if the subject is either more intense or less intense than the average value for the complete angle of view, the meter does not give the correct exposure for the subject. Let us take, for example, the problem of photographing a dark-colored meteorite on a white background. If the exposure meter is used at the distance of the camera, the angle of view includes a part of the white background, and, if the indicated exposure is used, the negative will be too transparent to show good detail in the meteorite. In other words, the average luminance of the entire field of view of the exposure meter should be nearly the same as the luminance of the subject. In order to correct this error, we should bring the exposure meter close enough to the meteorite so that the angle of view includes only the meteorite. At this position

the exposure meter reads the same as if the meter were at the camera distance and the entire field of view filled by the meteorite. This result may not seem correct at first thought, so let us examine the basis for its validity. The intensity of a point source varies inversely as the square of the distance, but the area of the field of view of an exposure meter varies directly as the square of the distance. We may consider the source to consist of many point sources, the illumination from which varies inversely, but the number of which varies directly as the square of the distance in such a way that one effect exactly cancels the other. The general conclusion may be stated as follows: For a given angular field of view, the illumination from an extended source is independent of the distance, but is directly proportional to the average luminance of the source.[1]

[1] The mathematical proof of this statement is as follows: Consider a broad flat surface whose luminance is E_s lumens per square foot. For sake of simplicity, we will let the surface be parallel to the light-sensitive surface of the exposure meter. (See Fig. 6-2.)

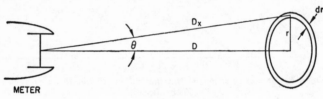

METER

Fig. 6-2.

The illumination produced by an elementary ring of the surface of area $2\pi r \, dr$ is

$$dI = \frac{E_s \cos^2 \theta \, 2\pi r \, dr}{D_x{}^2},$$

where D_x is the distance from the elementary ring to the meter, r is the radius of the ring, dr the width of the ring, and θ is the angle subtended by r at the meter. The $\cos \theta$ arises twice and therefore appears as $\cos^2 \theta$. The first $\cos \theta$ is due to Lambert's law. The second occurs because the direction of the light makes an angle θ with the normal to the surface of the meter. (Compare the above relation with Eq. 4-2.) From Fig. 6-2, we see that $D = D_x \cos \theta$, so we have

$$dI = \frac{Es \cos^4 \theta \, 2r \, dr}{D^2}.$$

However, $r = D \tan \theta$, and $dr = D \sec^2 \theta \, d\theta$.

Therefore, $dI = \frac{E_s 2\pi D^2 \cos^2 \theta \tan \theta \, d\theta}{D^2}.$

Let ϕ be half the angle of view of the meter, and the illumination of the meter surface is

$$I = 2\pi E_s \int_0^\phi \sin \theta \cos \theta \, d\theta$$

$$= \pi E_s \sin^2 \phi \text{ lumens per square foot.}$$

Since D does not appear in the value for the illumination, the illumination is independent of the distance.

Temperature and humidity are two enemies of light-sensitive cells. As for photographic film, the temperature effect is not significant at ordinary temperatures. The humidity effect on light-sensitive cells has been reduced by sealing the cell in the meter so that no moisture can penetrate. This necessary protection and the fact that the sensitive ammeter is itself a very delicate instrument require that the meter be handled with the care given a fine camera. When a meter is handled roughly or dropped accidently it should be returned to the manufacturer for checking and recalibration.

Estimating exposure

There are two schools of thought concerning the determination of the correct exposure for photographic material. One group of photographers believes completely in the use of exposure meters and considers a meter just as important to photography as a camera lens. This group justifies its arguments from the standpoint that guessing the exposure is a ridiculous procedure when light-intensity measurements can be made easily and with great accuracy by using an exposure meter. Photographers who do not use exposure meters feel that a meter is surplus equipment in practically all cases, and that continued use of a meter is like learning to walk with a crutch so that it can never be thrown away. Both of these points of view are perhaps exaggerations, but each contains some truth. There are a few situations in photographic work in which the light value is extremely difficult to estimate. On the other hand, there are equally as many situations in which an exposure meter is of no value. Perhaps the strongest argument against constant dependence on an exposure meter concerns the analogy with the crutch. Exposure meters of the photoelectric type frequently do get out of adjustment, and a photographer who is completely dependent on a meter does not realize the malfunction until too late. The ability to estimate exposures correctly can be developed by anyone wishing to take the trouble to learn, and the occasion is rare in which this ability cannot be used successfully.

One of the best methods of estimating the necessary exposure is to work from a standard exposure which the photographer has found from past experience to produce a satisfactory negative. For example, on a bright clear day a film with an ASA speed of 64 requires an exposure of $\frac{1}{100}$ sec at $f/11$. By working from this one

exposure, we can determine the correct exposure for almost any daylight condition. If the film speed is doubled, the exposure time is $\frac{1}{200}$ sec, or the stop opening of the camera should be set at $f/16$ for the $\frac{1}{100}$ sec shutter speed. The same method applies for any film speed and the necessary corrections to the shutter speed or stop opening can be made. However, if the lighting conditions are different, this must also be taken into account.

On a day which has a slight haze over the sky (high cirrus clouds) the amount of light is almost cut in half. When there is a bright sky with no shadows apparent (usually high stratus type clouds) the light is cut by about one-fourth, and with a completely overcast sky and relatively dark clouds, the light value is about one-eighth of the value of the bright sunny sky. This last type of sky condition requires an exposure of $\frac{1}{50}$ sec at $f/5.6$ provided we use a film with a rating of ASA 64. A photographer can make tables worked out on this basis or he can purchase similar ones at a nominal cost in any photographic store. One such chart is shown in Table 6-1.

TABLE 6-1
Exposure Guide for Average Conditions

Film speed	Clear day, bright sunlight			Slight haze			Bright, no shadows visible			Dark overcast		
	125	64	32	125	64	32	125	64	32	125	64	32
$f/\#$	Shutter speed (reciprocal)											
16	100	50	25	50	25	10	25	10	4	10	4	2
11	200	100	50	100	50	25	50	25	10	25	10	4
8	400	200	100	200	100	50	100	50	25	50	25	10
5.6	800	400	200	400	200	100	200	100	50	100	50	25
4.5	***	800	400	800	400	200	400	200	100	200	100	50

We can use this chart for films both slower and faster than those indicated by applying a little simple arithmetic. Many popular films have speeds of 250 or higher and require the shortening of exposure by the corresponding ratio. Also, some films are of speed below those indicated on the chart even though the tendency of manufacturers is to drive film speeds upwards. Special process films as well as some color films fall into this latter category and require increased exposure. Fortunately, when the exact exposure time or f/# is not available the film latitude usually suffices for a near approximation to the arithmetic answer obtained when determining exposure from the chart.

The problem of determining the correct exposure under artificial light is, perhaps, less difficult than for daylight. A photographer can make a standard exposure chart on the basis of the number and distance of photoflood bulbs, and he can determine exposures in a manner similar to that used with the daylight chart. The distance from the bulbs to the subject must be taken into account by assuming the inverse square law to be effective, but the distance of the camera from the subject does not affect the exposure. Exposure guides are available for artificial light also, and they are satisfactory in view of the latitude of films.

The reflecting character of the subject to be photographed can change the exposure estimate, but the effect is seldom greater than one stop one way or the other. For example, on a bright day when the ground is covered with snow, better results are obtained by closing the camera about one stop. Corrections of one-half to one full stop less light are necessary for most seascapes or pictures in which there is a high percentage of light reflected by water.

The angle at which the light strikes the subject must frequently be taken into account. If the light source is behind the subject (backlighted), a reduction of as much as two stops is necessary to bring out the required detail. A common example of backlighting occurs when the subject is between the camera and the sun. With a little practice and experience photographers can estimate the necessary exposure with surprising accuracy. There is no substitute for experience in photography.

In many cases the correct exposure is determined by trial-and-error methods and then one standard procedure is always followed. This standardization is common practice for many kinds of scientific work, particularly for work in which the negatives are used for accurate measurements. The negatives are often further calibrated with a sensitometer (see Chapter Eight) for evidence of possible unequal development.

Exposure for close-up pictures

As described in Chapter Four, the image brightness is inversely proportional to the square of the f number of the lens as long as the object distance is large compared with the image distance. Exposure meters are calibrated on the basis of this assumption. For photographs of objects at close range, we must increase either the

exposure time or diameter of the iris diaphragm (decrease the f number). Equations (4-3) and (4-4) furnish the required information for determining the amount of the necessary correction. Eq. (4–3) is

$$I_i = \frac{E_B D^2}{4f^2} = \frac{E_B}{4(f/\#)^2}$$

where the image brightness, I_i, was derived on the assumption of large object distance. Equation (4–4) is

$$I_i' = \frac{E_B D^2}{4q^2}$$

where the image brightness, I_i', was derived with no assumption concerning the object distance. If we assume that we know the correct exposure based on I_i, we can find the correction to apply by taking the ratio

$$\frac{I_i}{I_i'} = \frac{q^2}{f^2} \qquad\qquad (6\text{--}1)$$

where f is the focal length and q is the image distance. For example, let us assume that the indicated exposure is $\frac{1}{50}$ second at $f/8$. The correct exposure is either $\frac{1}{50} \times q^2/f^2$ at $f/8$, or $\frac{1}{50}$ second at the f number of $8 \times f/q$. (The unfortunate situation exists that the letter f is universally used for both focal length and focal ratio. Where confusion might otherwise exist, the focal ratio will be given either as f number or $f/\#$). For an object distance of three and one-half times the focal length of the lens this correction amounts to less than one-half stop and can generally be ignored. However, when we are working with object distances smaller than this value, we should apply the correction. When the object and image distances are equal, the correction q^2/f^2, is four, which is two f numbers smaller than the indicated f number.

References for Additional Reading

EXPOSURE METERS AND EXPOSURE GUIDES

"Films," *Kodak Reference Handbook*, 4th ed., Eastman Kodak Co., Rochester, N. Y., 1947. This reference gives many practical hints on the use of exposure meters as well as exposure guides.

The best source of material concerning exposure meters comes from the operating instructions available from the manufacturers.

Problems

1. The correct exposure combination for a film is found to be $\frac{1}{50}$ sec at $f/11$. What is the correct exposure time at $f22$?

2. If the correct exposure combination for a film is 10 sec at $f/64$, what is the stop opening required for $\frac{1}{10}$ sec exposure?

3. An exposure meter indicates a required exposure combination of 2 sec at $f/11$. What is the correct combination if the object is to be photographed with a magnification of unity? Give two answers, one based on 2 sec and the other based on $f/11$.

4. Compute the correction necessary to give correct exposure when an object is being copied at an object distance of 6 inches with a 4 inch focal length lens.

5. The sun illuminates a piece of white cardboard with 30,000 lumens per square foot. A camera, some distance away, photographs the cardboard with a lens of $f/11$ at $\frac{1}{50}$ sec. Compute the exposure (product of image illuminance and exposure time).

6. A certain film requires an exposure of one lumen-second per square foot for noticeable blackening. A white surface is held perpendicular to the rays of a 100-candlepower lamp and 5 feet away from it. What exposure time is requred for an $f/8$ lens to produce noticeable blackening on the film when photographing the white surface?

FILTERS

Light filters, to which this chapter has reference, modify the light which passes through them. In the early days of photography when only blue-sensitive emulsions were available, filters had little use. For example, blue-sensitive film rarely shows clouds because the difference in intensity between the blue sky and the clouds is negligible when viewed in blue light. The introduction of dye sensitization improved the spectral sensitivity of photographic emulsions and increased the possibilities of reproducing the tone values of all colors.

Types of Filters

For black and white photography, we use filters with either of two purposes in mind. Since the introduction of orthochromatic and panchromatic emulsions, the sensitivity of film more nearly approaches that of the eye, but still does not agree completely with it. In order to cut down the blue end of the spectrum and increase relatively the green and red, we use a filter of a light-yellow color. A filter for this purpose is known as an orthochromatic filter. Filters are also used to increase the contrast between colors. Two colors may be easily distinguishable to the eye because of their color difference, but when reproduced in black and white they frequently appear to have the same tone value. For example, the eye readily distinguishes between the flower and leaves, shown in Fig. 7-1a, because of color differences, but they appear in black and white with nearly the same tone value. Figure 7-1b shows the

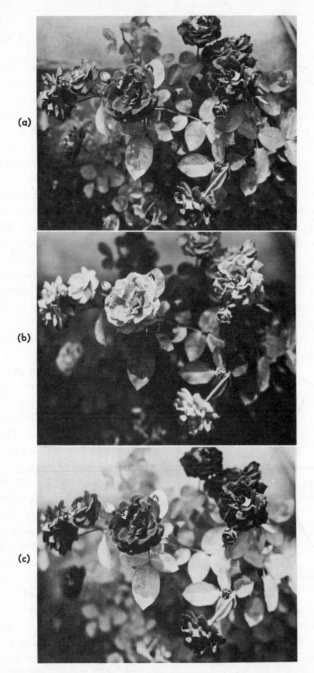

Fig. 7-1. Red flower photographed through (a) no filter, (b) red filter, and (c) green filter. All three photographs were made with panchromatic film.

same scene taken with a red filter, while Fig. 7-1c was taken with a green filter. Notice how the green leaves are a light tone as seen through a green filter, while the flower is a light tone when seen through the red filter. This illustration is one example of a more general principle applicable to filters. Whenever we wish a particular subject to be of light tone (on the print) we use a filter which is the same color as the subject. The converse of this principle holds also: to render a subject dark in tone we use a filter of different color from the subject. When we wish a particular subject to be almost black on the print, the proper choice of filter is the color which is the complement of the color of the subject. The selection of the complementary color requires that we know the spectral distribution of the light emitted or reflected by the subject. Since this knowledge is seldom available, we can resort to the color chart shown in Fig. 7-2. The complementary colors are shown opposite each other, and this chart is satisfactory for most photographic uses.

The relative tone values of colors reproduced in black and white are actually the result of four parameters. The first of these is

determined by the color of the light which illuminates the object. A blue object appears almost black if it is illuminated by a red light. Thus a photograph taken under these conditions would show the object black even though the film is blue sensitive. However, we generally use either daylight or tungsten light sources, and the effect of the color of the source is taken into account in the spectral sensitivity curves of the various emulsions.

Fig. 7-2. Color chart showing approximate complementary colors opposite each other.

The color of the object determines the second parameter. Our eyes determine color with reasonable accuracy, but they are not infallible. When the illumination of objects is by means of daylight or a tungsten source, our eyes are able to give satisfactory estimates of color.

The third and fourth parameters are determined by the filter
and the spectral sensitivity of the emulsion, respectively. Proper
choice of a filter depends on the sensitivity of the film and the result
which is desired. A red filter used in connection with an ortho-
chromatic film yields a clear negative with no image, since the film
is not sensitive to red light transmitted by the filter. Filters are
available with almost any transmission desired, and the transmission
spectrum of the filter is published by the manufacturer. The most
popular color filters used by photographers are yellow, green, red,
orange, and blue. The diagrams in Fig. 7-3 represent typical

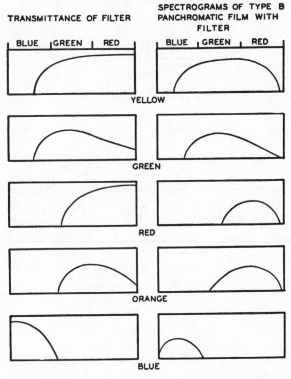

Fig. 7-3. Spectral transmittances of various typical filters and
their effects on the spectral sensitivity of panchromatic type B film.

spectral transmittances of these filters and the resulting spectro-
grams of panchromatic type B film in combination with the filters.

The yellow filter is perhaps the most widely used of all. It gives, in combination with orthochromatic or panchromatic type films, a result that most nearly resembles the values seen by the eye. Light red filters are used for the special effect of giving a darker sky than is normally seen by the eye. Other filters are used whenever contrast between colors is desirable.

As a typical illustration of the importance of the four parameters for tone reproduction, let us analyze the effects of various filters on

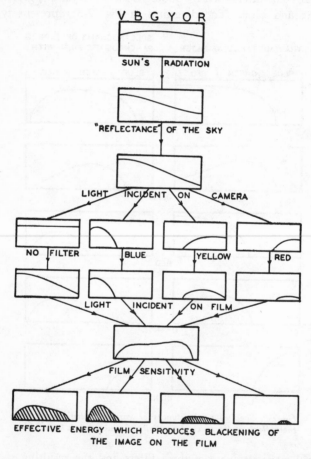

Fig. 7-4. Effect of various filters on the sky light as photographed by panchromatic film.

the colors in a typical landscape. We will consider the following subjects: the sky, a cloud, a red shirt, and a yellow flower. Figure 7-4 shows the effects of three filters on the light from the sky. Figures 7-5, 7-6, and 7-7 show corresponding effects on the other three subjects. Because of the similarity of these diagrams, we will discuss only Fig. 7-6.

In box 1 the intensity of the sun's radiation is plotted against color (wavelength). This radiation is reflected by the red shirt but

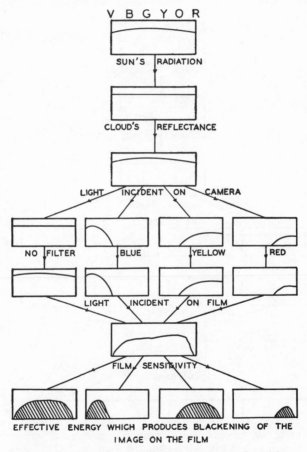

Fig. 7-5. Effect of various filters on the sunlight reflected by a cloud as photographed by panchromatic film. (The effect is negligible in this case.)

not all colors are reflected equally well. Box 2 shows the reflectance of the shirt plotted against color. Reflectance is defined as the ratio of the reflected radiation to the incident radiation, and is therefore a number always smaller than one. The light incident on the camera is that which is reflected by the red shirt and is shown in box 3. This curve is the result of multiplying together, wavelength by wavelength, the curves in boxes 1 and 2. The boxes in row 4 show the relative transmittances of the three filters, and no filter. Transmittance is defined as the ratio of the transmitted light to the

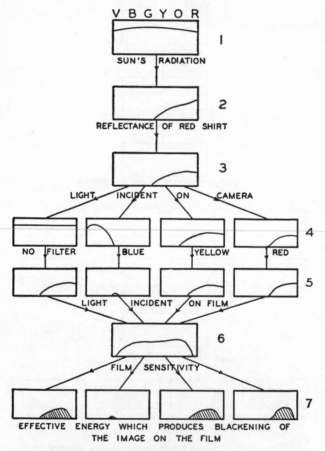

Fig. 7-6. Effect of various filters on sunlight reflected from a red shirt and photographed with panchromatic film.

incident light and is again a number less than unity. The filters modify the light incident on the camera and give the spectral distribution shown in row 5. This light is incident on the film and causes blackening in accordance with the spectral sensitivity of the film as shown in row 7.

The photographic prints of the landscape photographed with the filters are shown in Fig. 7-8. Compare these prints in detail with the charts for the various subjects and filter conditions.

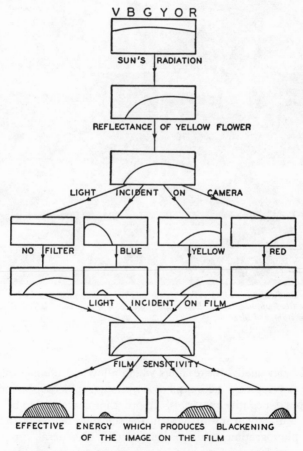

Fig. 7-7. Effect of various filters on sunlight reflected from a yellow flower and photographed with panchromatic film.

Fig. 7-8. Landscape including yellow flower and a red shirt photographed with panchromatic film; upper left, no filter; upper right, blue filter; lower left, yellow filter; and lower right, red filter.

Safelights

Darkroom safelights are filters which allow the photographer to see the development taking place on photographic paper and certain types of negative materials. In order for a safelight to be really safe, it must not transmit light in the sensitive region of the particular photographic emulsion being used. In general, a red safelight is satisfactory for use with paper, blue-sensitive films, and orthochromatic films. However, just any red light is not a safelight,

because a light that appears red in color to the eye may transmit a considerable amount of blue and yellow light also. When any unusual fogging occurs on film or paper it can often be traced to a safelight that does not filter out all the actinic rays. An easy method of checking the transmission of a safelight is to look at it through a diffraction grating. If there is sufficient blue or yellow light transmitted to endanger the emulsion, it can usually be seen in this manner and the safelight discarded. The sensitivity of photographic papers (with the exception of some special types such as Varigam) is in the blue region of the spectrum, while the maximum sensitivity of the eye is in the yellow-green portion. For this reason a yellow safelight is desirable for use during printing or development of blue-sensitive emulsions.

Monochromatic filters

For many years scientists have realized that an optical filter which would isolate a very narrow band of wavelengths would have great advantages. This narrow band filter would allow photography of objects in (nearly) monochromatic light. An indirect solution to this problem was employed in the spectroheliograph devised by G.E. Hale. This instrument is used for photographing the sun in the wavelength of the light which is characteristic of a chemical element. Astonomers regularly photograph the sun with the light emitted by hydrogen, calcium, or sodium. The resulting spectroheliograms contribute substantially to our knowledge of the sun.

The quartz monochromator provides an ideal substitute for a narrow band filter. This device was developed principally by Wood, Lyot, and Evans, but even a brief outline of the theory of the monochromator is beyond the scope of this book. The monochromator passes a very narrow band of light only a few Angstroms wide, and can be used in the optical system of instruments in much the same way as an ordinary filter. We can understand the principle of the operation of the monochromator by inserting a piece of cellophane tape (or other double refracting crystal) between two polarizing sheets. The colors produced are a result of the thickness of the cellophane tape and also the relative orientation of the polarizers. By sandwiching many double refracting crystals of selected thicknesses between polarizing sheets, we can isolate a very narrow band of wavelengths.

Intermediate between the ordinary color filters and the mono-chromator is a type of interference filter which transmits a band only a few Angstroms wide. Again, the complete theory of these filters is beyond the scope of this book. The general principle of operation of the filters stems from two partially reflecting, plane-parallel mirrors which reflect light back and forth between them several times. The mirrors consist of a transparent material which is coated with silver on both sides. The particular wavelength band transmitted by the filter depends on the thickness and index of re-fraction of the transparent material. Thus, these filters operate on the same principle as the Fabry-Perot interferometer, but their transmission band is fixed. Narrow band interference filters of this type are available for almost any region of the visible spectrum.

Polarizing filters

Since the invention of sheet polarizing material, its use as a light filter has found wide application to photography. A knowledge of the characteristics of polarized light is necessary in order to under-stand more clearly the uses of a polarizing filter.

In Chapter Three we discussed the transverse nature of light waves and mentioned that the vibrations are at right angles to the direction of propagation. These vibrations can be compared with the vibrations of a rope. If we fasten a rope at one end and hold the other end taught, we can produce transverse waves in the rope by shaking it. The waves are propagated along the rope and each particle of the rope vibrates at right angles to the direction of propagation. Let us assume that the rope is horizontal and the shaking motion is up and down along a vertical line. The resulting waves on the rope are plane polarized because all of the vibrating particles are vibrating in the same plane. If the end of the rope is moved in a circle, the resulting wave motion is circularly polarized. In our discussion of polarized light we are concerned only with plane polarization, so that further references to polarization mean plane polarization.

Let us imagine now that our rope is run through a picket fence. As long as we continue to move the rope up and down, the waves move along the rope as before. However, if, instead of moving the rope up and down, we try to make it vibrate from side to side, the waves will move along the rope as far as the picket fence, but will

stop there since the rope cannot vibrate sideways because of the pickets. The picket fence does to the vibrations of the rope what the polarizing filter does to light.

Although light is a transverse vibration, the vibrations do not all. lie in the same plane. Instead, ordinary light vibrates in all directions which are perpendicular to the direction of propagation, as shown in Fig. 7-9. Certain substances resolve the heterogeneous

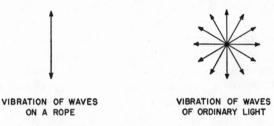

VIBRATION OF WAVES
ON A ROPE

VIBRATION OF WAVES
OF ORDINARY LIGHT

Fig. 7-9.

vibrations of ordinary light into two component vibrations at right angles to each other. Each component is plane polarized. Substances which have this property are said to be double refracting. When a double-refracting material is cut in a particular manner and inserted between the eye and a source of light, the eye sees two images of the source. Each of these two images is plane polarized and their planes of vibration are at right angles to each other. Examples of double-refracting materials are calcite, quartz, and mica.

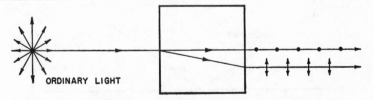

ORDINARY LIGHT

Fig. 7-10. Transmission of light through a double-refracting substance.

Some double-refracting materials absorb one of the polarized rays more than the other, and when the material is thick enough, this ray is almost completely absorbed. Tourmaline is one of the best examples of this kind of material. Let us imagine that light is transmitted through two pieces of tourmaline. By rotating one of

the tourmaline crystals we can find a critical position where the transmitted light is almost completely eliminated. Returning to our mechanical analogy, we may consider the light, after it has passed through the first piece of tourmaline, to be like the wave on the rope that is constrained to move between the pickets of the fence. If, after the fence, a second picket fence is placed so that the rope must vibrate between its pickets also, we have the same situation that exists when light passes through two pieces of tourmaline. Now imagine the second picket fence to be rotated so its pickets are horizontal instead of vertical; then none of the original vibration of the rope can be transmitted through both fences.

Substances which behave optically like tourmaline are called dichroic. Polarizing screens are made of tiny crystals of a dichroic substance such as quinine iodosulfate. These crystals are all brought into alignment by ingenious chemical and mechanical methods so that their polarizing planes are all parallel. Produced in this manner, a polarizing sheet has the same effect as if it were one dichroic crystal, but it has the obvious advantage that it can be produced in whatever size sheets are required. Usually a sheet is cemented between glass plates for use as a camera filter.

A polarizing filter transmits light vibrating in only one plane, and if it were 100% efficient, the transmitted light would be just half the intensity of the incident light. However, it actually transmits only about 42%, and therefore the camera exposure must be adjusted accordingly.

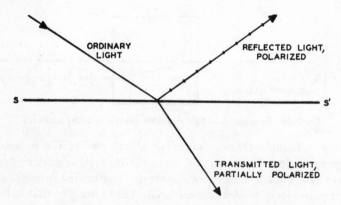

ORDINARY
LIGHT

REFLECTED LIGHT,
POLARIZED

S S'

TRANSMITTED LIGHT,
PARTIALLY POLARIZED

Fig. 7-11. Light transmitted through and reflected from a nonmetallic surface.

Besides the use of dichroic crystal, there are two other ways in which light is polarized that are of interest to the photographer. When light is reflected by a nonmetallic surface, such as glass, water, or paint, the reflected light is partially polarized. The degree of polarization depends on the angle of incidence of the light and the index of refraction of the reflecting material. Maximum polarization occurs when the refracted ray and the reflected ray form an angle of 90°. The plane of polarization of the reflected ray is parallel to the reflecting surface. This relationship is shown in Fig. 7-11 where the reflecting surface is SS'. The dots on the reflected ray show that the plane of polarization is perpendicular to the paper. Since the reflected ray makes an angle of 90° with the refracted ray, we can derive the formula from Snell's law that

$$\mu = \tan i \qquad (7\text{–}1)$$

where μ is the index of refraction of the reflecting material and i is the angle of incidence. Equation (7–1) is known as Brewster's law.

Although the reflection from a single surface does not usually give complete polarization, there is a sufficient amount of polarization to

Fig. 7-12. Elimination of light reflected from a glass show window by means of a polarizing filter: left, no filter; right, polarizing filter.

be useful for photographic purposes. Consider the problem of photographing an object through a window glass. If the illumination must travel through the glass from the same side as the camera, we can eliminate the reflected glare with a polarizing filter. The position of the camera and light source should be oriented so the light is incident at the polarizing angle in accordance with Brewster's law. This angle is about 57° for glass. The polarizing filter should be adjusted so that its plane of polarization is at right angles to the plane of polarization of the reflected light. We can orient the filter visually by rotating it until the reflected light is at a minimum. Although all the light passing through the filter is now polarized, the reflected light, which is polarized in the plane at right angles, is almost completely eliminated.

We can apply the same principle for reducing glare due to reflection from the surface of water. In this case the polarizing angle is 53°. Even if the incident light is not at the angle for maximum polarization, a polarizing filter produces a noticeable effect and it is useful for reducing glare. Most of the reflecting surfaces which one encounters in photography reflect light which is partially polarized.

Small particles which scatter light also polarize it. The best example of this kind of polarized light comes from the clear sky. The amount of polarization depends on the angle between the direction the picture is taken and the direction of the sun. We find that maximum polarization occurs when the camera is pointed 90° from the sun. When the sun is directly overhead, the part of the sky that exhibits maximum polarization is anywhere on the horizon. If the sun is just rising or setting, the maximum polarization occurs on a circle running from north to overhead to south. During the morning, the maximum polarization occurs in the west and in the afternoon it is in the east. We can use a polarizing filter to darken the sky for greater contrast with the clouds, since the light reflected from the clouds is not polarized. By pointing the camera 90° from the sun, we obtain the maximum contrast between the clouds and the sky background. The best method for determining the amount of sky darkening is by orienting the filter visually. An auxiliary filter is attached to some types of polarizing filters, and the correct orientation can be determined by sighting through the auxiliary one. The connection between the two filters maintains their planes of polarization parallel with each other. This arrangement

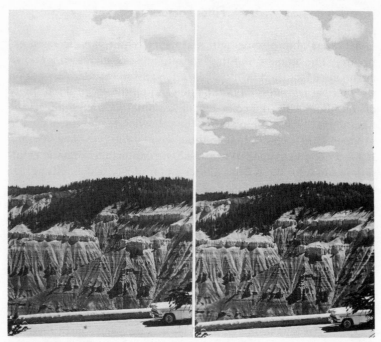

Fig. 7-13. Polarizing filter used for darkening the sky: left, no filter; right, polarizing filter.

minimizes the opportunity for a change of orientation between the time of visual use and the time the picture is taken.

Atmospheric haze is caused by small particles which scatter light. A polarizing filter reduces the effects of atmospheric haze when subjects are sidelighted. This reduction is particularly valuable in scenic pictures of mountains or other distant objects where the haze obscures detail.

The great advantage of a polarizing filter is its insignificant effect on colors, and this advantage allows us to use these filters with color film. Also, a polarizing filter renders clouds visible on film that is only blue sensitive. On any film, the amount of sky darkening can be controlled by changing the orientation of the filter. Rotation of the filter varies the amount of scattered polarized light which it transmits.

Filter Factor

All filters absorb some light and hence require an increased exposure. The amount that the exposure must be increased is known as the filter factor. The filter factor for any given filter depends on the spectral transmission of the filter and on the spectral sensitivity of the film. Also, the color of the illuminating source affects the filter factor. Take, for example, the yellow correction filter used to produce tone values similar to those seen by the eye. The Wratten K2 is a good example. When used with an orthochromatic emulsion in sunlight, the K2 has a filter factor of 2.5, which tells us that the exposure should be increased two and one-half times, or about one and one-quarter stops. This filter factor tells us that the film is more sensitive to blue light than to yellow light. However, for a panchromatic emulsion the filter factor is 2. The greater spectral sensitivity of the panchromatic material decreases the filter factor since both the yellow and red regions are sensitive to light.

When used with a tungsten source, the filter factor of a K2 filter and orthochromatic film is 2. There is relatively more yellow light from a tungsten source than from sunlight, and the filter factor is smaller. For panchromatic material and tungsten source the filter factor is only 1.5. Manufacturers of filters list the filter factors for various types of emulsions used with both tungsten and sunlight sources. A red filter, of course, has no listing for orthochromatic film since this type of emulsion is not sensitive to red light. Filter factors are really based on average conditions, and should be used with caution. When a subject is predominantly of one color, the filter factor can be considerably in error. To take an extreme example, we might think of a picture in which the subject is predominantly blue. The normal filter factor for a red filter is about 4. However, when used with the blue subject, the filter factor of a red filter would be many times this value, and we might find that we would be unable to produce a satisfactory picture at all with this combination.

The filter factor usually used for a polarizing filter is 2.5. This number indicates that the filter transmits 40% of the light and is a good approximation for practical use. The filter factor in this case is always the same since a polarizing filter transmits all colors about

equally well and does not change the spectral distribution of the incident light appreciably. Sometimes we use a polarizing filter in connection with a color filter. The filter factor of the color filter must be multiplied by the filter factor of the polarizing filter to determine the correct value for the combination.

Position of Filters

Ordinarily we think of filters as being placed over the camera lens. When used in this position, a filter must be of an optical quality comparable with the camera lens. The two types of filters in general use are made of gelatin and glass. The gelatin filter for use over a lens is cemented between glass plates and constitutes a highly satisfactory filter for most photographic work. The gelatin by itself is satisfactory from an optical standpoint but it is easily damaged. Glass filters for use with a camera are very satisfactory, but are more expensive, harder to reproduce, and are not manufactured in so wide a variety of spectral transmission bands as are the gelatin ones. Glass filters are more durable than the gelatin filters even when the latter are cemented between glass. The selection of a gelatin filter should be made with great care, and it should be obtained from a reliable manufacturer, since there is danger not only of the use of poor quality glass but also of faulty cementing.

Filters can be placed in one of three places: near the lens, over the light source, or directly in front of the film. Filters placed over the light source are usually large, but they do not have to be of any particular optical quality other than that which will give the correct spectral transmission. Often a large filter used over the light source is less expensive than a smaller filter used near the lens. If the filter is used near the film it must be completely free from dust and scratches. The optical quality of a filter for this purpose is not critical, but it must be reasonably good.

A polarizing filter can be used over the light source to reduce direct reflection. One of the most common applications of this arrangement is for copy work in which the material to be copied has a slick surface. Polarizing filters are available in large sheets for this purpose.

References for Additional Reading

SPECTRAL TRANSMITTANCE AND FILTER FACTORS

Kodak Wratten Filters, 18th ed., Eastman Kodak Co., Rochester, N. Y., 1951.

"Filters," *Kodak Reference Handbook*, Eastman Kodak Co., Rochester, N. Y., 1947.

Lester, H. M., *Photo-Lab-Index*, 10th ed., Morgan and Lester, New York, 1949.

POLARIZING FILTERS

Land, E. H., "Some Aspects of the Development of Sheet Polarizers," *J. Opt. Soc. Am.*, vol. 41, 1951, pp. 957-963.

NARROW BAND FILTERS

Information concerning these filters is available from:

 (a) Baird Associates, University Road, Cambridge 38, Mass.

 (b) Bausch and Lomb Optical Co., 332 Martin St., Rochester 2, N. Y.

 (c) Farrand Optical Co., Inc., Bronx Blvd. and E. 238th St., New York 70, N. Y.

MONOCHROMATIC FILTERS

Evans, J. W., "The Birefringent Filter," *J. Opt. Soc. Am.*, vol. 39, 1949, pp. 229-242.

Problems

1. A photographic reproduction in black and white is to be made of a chart which has blue lines on a red background. Considering the finished print, what color filter would be necessary to produce black lines on a white background? (Assume panchromatic film.)

2. In Problem 1, what filter would produce white lines on a black ground? What kind of print would be obtained from orthochromatic film and no filter?

3. A red filter used with panchromatic film has a filter factor of 6. If the exposure meter indicates $\frac{1}{100}$ sec at $f/11$, what must be the f number when the filter is used and the exposure time is $\frac{1}{100}$ sec?

4. A yellow filter with a filter factor of 1.5 is used with a polarizing filter with a factor of 2.5. What is the filter factor for the combination?

5. A diamond has an index of refraction of 2. What is the angle of incidence necessary to produce maximum polarization of the reflected ray?

6. Certain types of glass have an index of refraction of 1.6. Compute the angle between the plane of the glass and the direction of the camera for maximum polarization.

SENSITOMETRY

The study of sensitometry includes the relationships between the intensity of the light falling on the film and the resulting blackening produced after development. However, a discussion of the chemical process of development will be delayed until the following chapter.

Density

The blackening of a photographic emulsion is measured in terms of density. In this instance we are speaking of the optical density and not of the physical density, which is measured in mass per unit volume. Light which strikes a developed photographic negative is partially absorbed by the metallic silver in the emulsion. Let the intensity of the incident light be I_o and the amount transmitted be

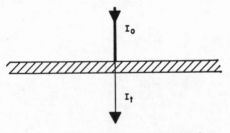

Fig. 8-1. Incident (I_o) and transmitted (I_t) radiation.

I_t. The opacity of the emulsion is defined by the ratio I_o/I_t. Since this ratio is always greater than unity, the opacity always has a value greater than one. We notice that the opacity is the reciprocal of the total transmittance.

The density of a photographic material is the common logarithm (to the base 10) of the opacity and is defined by

$$D = \log 0 = \log \frac{I_o}{I_t}.$$

Let us check a few values of incident and transmitted light for a better understanding of the term density. If the incident light were not absorbed at all (very nearly true for clear glass), the transmitted light would be equal to the incident light and the ratio $I/_oI_t$ would be unity. Since the logarithm of 1 is zero, the density would be zero. If 90% of the incident light were absorbed, the ratio of the incident light to the transmitted light would be 10:1, in which case the density would be one. In the extreme case where there is no light transmitted and the body is opaque, the ratio I_o/I_t is infinity and the logarithm is also infinity, which shows that the density is infinitely large. In photographic work, densities larger than 3 are rarely encountered, and densities of 4 are exceptional. For a density of 3, there must be 99.9% of the light absorbed by the film.

Characteristic curves

The first successful work toward finding a relationship between light intensity and the resulting density of a photographic emulsion was done by Hurter and Driffield in the latter part of the nineteenth century. When different parts of a photographic emulsion are exposed to a light source of given intensity for varied lengths of time, the resulting image densities can be plotted on a graph against the logarithm of the exposure ($\log It$). Figure 8-2 shows a graph of this kind. The curve in Fig. 8-2 is known as the H and D curve (after Hurter and Driffield). Sometimes it is called the characteristic curve because it gives the characteristics of a particular emulsion. The form of the H and D curve depends primarily on the emulsion type and secondarily on the development.

From the appearance of the characteristic curve, we notice that perceptible blackening occurs only after a certain required exposure. The exposure required to produce perceptible blackening is known as the threshold exposure and is represented by the distance OA in Fig. 8-2. The toe of the curve is shown between A and C, while from C to D the curve is essentially a straight line. This latter region is considered the most valuable because density in-

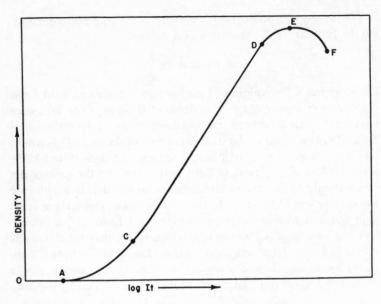

Fig. 8-2. H and D curve of a typical emulsion.

creases uniformly with the logarithm of the exposure. From D to E the density continues to increase with the exposure, but at a smaller rate. This portion is known as the knee of the curve. From E to F there is a decrease of density as the exposure increases. If a negative material is exposed in the part of the curve from E to F, the resulting images are reversed from negative to form positive images. The resulting positive images are known as solarized images. Solarization occurs as a result of overexposure, and its application is usually limited to special effects.

Correct exposure

The criterion for a correct exposure is that all the densities of all parts of the negative shall lie between the C and D points of the characteristic curve. The length of this straight-line part determines the latitude of the film. Assume, for example, that the difference between C and D on the log It scale is 2. This means that an intensity range of 1 to 100 could be correctly represented. If, however, the intensity range of the subjects to be photographed is only 1 to 60, we have an exposure tolerance of $\frac{100}{60}$. When the intensity

range is equal to the latitude of the film, the exposure tolerance is 1, and there is only one exposure which is correct.

Contrast

When the opacity of the negative is proportional to the brightness of the object, we have the conditions for a negative giving luminous fidelity. This statement does not necessarily mean that the negative gives the most pleasing picture. Since the relationship

$$D = K - \log It$$

must be satisfied to achieve this perfect negative, the slope of the characteristic curve must be 1. That is,

$$D_1 - D_2 = \log It_1 - \log It_2$$

for any values of density and exposure. An increase of $\log It$ must cause a numerically equal increase in the density. If the density increases faster than $\log It$, the negative has greater contrast, and if the density increases more slowly than the logarithm of the exposure, the negative is "flat" or of low contrast. Figure 8-3 shows the characteristic curves of three negatives which have three different contrasts. The slope of the characteristic curve is denoted by the Greek letter γ (gamma), and it follows that a negative with a high gamma has high contrast.

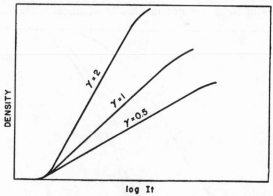

Fig. 8-3. H and D curves for negatives having three different contrasts.

The contrast of a negative depends not only on the inherent properties of the emulsion, but also upon the development. In

general, the longer the development the greater the contrast. Figure 8-4 shows the general relation between time of development and contrast. The curve approaches a maximum value which is

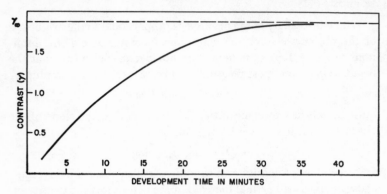

Fig. 8-4. Typical variation of gamma with development time.

known as γ_∞ (gamma infinity). Although equations have been found which express the relationships shown in the figure, we usually follow the curves published by the manufacturers. From these curves we can regulate the time of development to give any desired value of contrast below γ_∞.

The characteristic curves of the same emulsion exposed to different colors of light are not ordinarily identical. The curves are

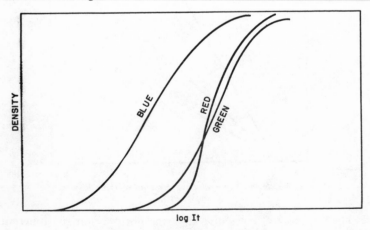

Fig. 8-5. Variation of contrast with color.

displaced along the log It axis in accordance with the relative sensitivities of the different colors, and the slope also varies because the contrast generally increases as we go from the blue toward the red end of the spectrum. The variation of contrast with color is a particularly serious problem in color photography.

Speed indexes

In Chapter Four we found that an emulsion has an inherent sensitivity to light which determines its speed. Also, the various relationships among speed rating systems were given. These relationships are not exact, and cannot be made exact, except for any one type of emulsion. The reason that there is no exact relationship is because the speeds in the different systems are based on different parts of the characteristic curves.

The H and D numbers are based on the inertia of the film. In Fig. 8-6a, let us continue the straight-line portion of the characteristic curve downward until it crosses the log It axis at some point C. The distance OC represents the inertia of the film. The H and D

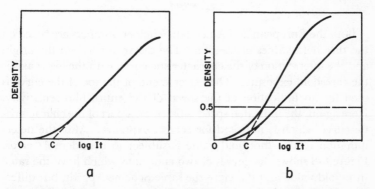

Fig. 8-6. (a) Method of determining the H and D inertia speed of a film. (b) Two films with the same inertia but different speeds for a density of 0.5.

numbers are based on the corresponding distances OC of the various films. This method is based on the assumption that a negative material with a low inertia will have a high speed, but this assumption is not always valid. Figure 8-6b shows how two films with the same inertia can have very different speeds when a density of 0.5 is used.

The DIN degree system, which originated in Germany, is based on the exposure required to give a density of 0.1. The difficulty of this system is its failure to give enough weight to the linear part of the curve. Figure 8-7 shows how two films can have the same DIN number, but have two entirely different speeds in the linear part.

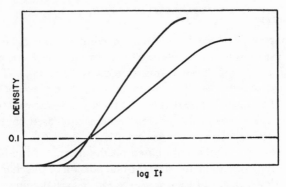

Fig. 8-7. Characteristic curves of two films having the same DIN speed but with different speeds in the linear part of the curves.

Both the European and American Scheiner numbers are based on the threshold values of the film. The distance between the origin and the intersection of the characteristic curve with the log It axis is the threshold exposure. The extreme end of the toe of the curve is used for an indication of the speed of the entire film sensitivity. Here again, the indicated speed is based on a part of the characteristic curve which is not used for correct exposure. Also, the determination of this threshold value is subject to considerable error. Figure 8-8 shows the curves of two emulsions which have the same threshold value and therefore the same Scheiner speeds, but different speeds in the linear part. The American and European Scheiner numbers are the same except for the starting point of the series of numbers representing the speeds. (See Table 5-1.)

The systems of numbers originating in this country are similar to the H and D numbers since they take into account the linear portion of the characteristic curves. The Weston index is determined by the exposure necessary for the density to equal the gamma (slope of the curve), using the developer recommended by the manufacturer of the film. The General Electric number is determined in

a similar manner to the Weston number, and the more recent ASA index is a compromise between the Weston and the GE systems.

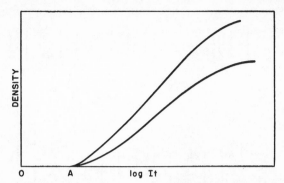

Fig. 8-8. Characteristic curves of two emulsions having the same Scheiner speeds but different speeds in the linear portion.

Sensitometers

A sensitometer is an instrument which exposes films by means of known light values, or known ratios of light values. Sensitometers consist of three general types of instruments.

The step-wedge sensitometer uses an optical wedge to vary the light intensity. The density does not increase smoothly, but increases in a series of finite steps. To be useful, the step wedge must have been previously calibrated. The characteristic curve of a film can be plotted by measuring the densities of the image of the step wedge. Say, for instance, that the step wedge has a uniform progression of densities such as 0.1, 0.2, 0.3, 0.4, etc., and the negative material is given the same time of exposure for the whole step wedge. The logarithm of the exposure on the film is inversely proportional to the densities of the step wedge. By measuring the densities on the negative material, corresponding to the image of the wedge, we determine the information necessary to plot the characteristic curve.

In any sensitometer the most convenient variation of the light intensity is a geometrical progression because the characteristic curves are plotted according to the logarithm of the light values. The tube sensitometer accomplishes this result in a unique manner. It is based on the fact that the light which strikes the film is directly

proportional to the solid angle subtended at the film by an opening. The light source must be uniformly bright. A cross section of a tube sensitometer which gives a light ratio of 1:256 is shown in Fig. 8-9.

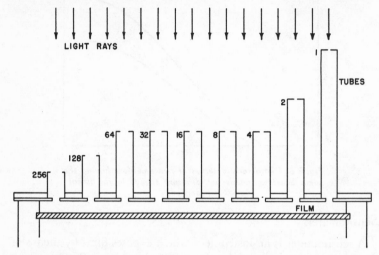

Fig. 8-9. Cross section of a tube sensitometer giving light intensity ratios in a geometrical progression. The numbers represent the relative light intensities on the film.

Not only the sizes of the openings but also the lengths of the tubes change the solid angle. The tube sensitometer derives its name from the fact that the light is confined within hollow cylinders or tubes between the openings and the negative material. The insides of the tubes must be painted a flat black so that they do not reflect any light. Frequently, threads or stops are also inside the tubes to reduce reflection.

Another type of sensitometer depends on the sizes of openings cut in a revolving disk which is inserted between the light source and the negative material. An example of such a disk or sector wheel is shown in Fig. 8-10. Actually, instead of varying the light intensity, this device varies the time of exposure. Although the two are not quite interchangeable, intermittent exposures shorter than a certain critical value have the same effect as if the light intensity were varied. When more convenient, an opaque rectangular curtain with slits in it can be used in much the same way as a focal-plane shutter. A series of slits of varying widths are cut in this opaque curtain, and the effect is the same as that of the rotating disk.

Densitometers

A densitometer is a device which measures the density of a light-absorbing material, or more specifically, of a photographic negative. Densitometers are actually specialized types of photometers graduated to read density directly.

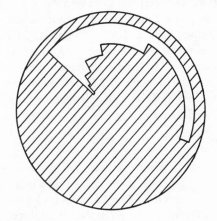

Fig. 8-10. A sector wheel for a sensitometer.

In one type of densitometer a light beam is split into two paths. One of the split beams passes through an optical wedge of calibrated density and the other through the material to be measured. By matching visually the intensities of the two light beams, we find the density of the unknown material from the density of the calibrated wedge. The matching of the two images is accomplished by ingenious optical arrangements in order that both beams of light can be compared in the same field of view. One difficulty of this instrument is that not all emulsions appear the same color by transmitted light, and matching densities under these conditions is difficult.

A Marten's densitometer is similar to the one just described. Here the beam is split and one is passed through the negative material. The other is made to vary in intensity by means of polarizing devices. Two Nicol prisms serve as the polarizing devices since they give efficient polarization in the visible region of the spectrum. The intensity of the beam through the two Nicol prisms is varied by rotating one of the prisms. This instrument is calibrated to read directly in density for any angle of the Nicol prism.

A densitometer based on the Weston photronic cell is also popular. This instrument requires only one light path and is much simpler optically. The light shines through a small opening directly onto the photovoltaic cell, and a rheostat is adjusted to give a zero reading on the ammeter connected to the cell. The negative material is inserted between the light and the cell. The light absorbed by the negative changes the output of the cell and the ammeter is calibrated to read directly in density. Since there is no human element in this type of densitometer, differences in color for the various emulsions play little part in the determination of the density. However, the photoelectric densitometer is not so sensitive in the higher densities as those which depend on comparison of two light beams.

Reciprocity failure

We have previously assumed that the blackening effect on a photographic film depends only on the product of the image illuminance and the length of time of exposure for a given development. For example, when the f number is doubled, the exposure time is quadrupled for the same exposure. Thus the blackening effect is determined by the product It, where I is the intensity of the light and t is the length of time the light falls on the film. The relationship is expressed by

$$E = It$$

where E is the blackening produced. This equation expresses the reciprocity law of photographic emulsions. Although this law is reasonably accurate over the range of light intensities and exposure times met in most pictorial work, it does not hold true where there is a large variance of these values. Schwarzschild suggested that the relationship could be more nearly represented by the formula

$$E = It^p$$

where p is a constant for any one emulsion.

Let us take an example illustrating the failure of the reciprocity law. Suppose that we expose films in a sensitometer having nine · different light intensities with the following ratios: 1, 2, 4, 8, 16, 32, 64, 128, 256. We now expose 15 films in the sensitometer with the following exposures: $\frac{1}{64}$, $\frac{1}{32}$, $\frac{1}{16}$, $\frac{1}{8}$, $\frac{1}{4}$, $\frac{1}{2}$, 1, 2, 4, 8, 16, 32, 64, 128,

256 minutes. By graphing log I against the density for each film we obtain a series of characteristic curves which look similar to the curves shown in Fig. 8-11. The films must all be of the same emul-

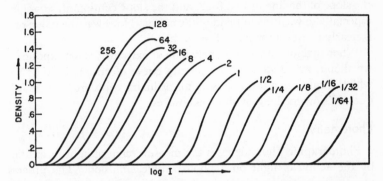

Fig. 8-11. *Characteristic curves resulting from exposures (in minutes) as indicated.*

sion and receive identical development. By selecting a density of 0.8 which is represented on most of the curves, we can make a graph by plotting log I as the abscissa, and log It as the ordinate. By doing so, we obtain a curve as shown in Fig. 8-12. If the reciprocity

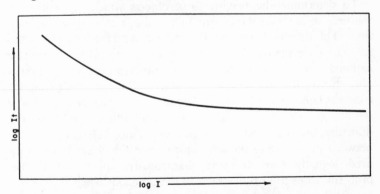

Fig. 8-12. *Reciprocity curve. Deviation from a straight line parallel to the log I axis represents the reciprocity failure.*

law were completely valid, the line in the graph of Fig. 8-12 would be a straight line parallel with the log I axis. If the Schwarzschild relationship held, the line would still be straight, but would be parallel to the log I axis only when $p = 1$.

In general, then, neither relationship is correct. The reciprocity law holds only in the region from about one second to one minute exposure. The value of the Schwarzschild exponent, p, determines the slope of the line in Fig. 8-12, and the slope continually changes, especially toward the left end of the curve. However, the value of p is nearly constant for a small interval.

When making either extremely long or extremely short exposures, we should investigate the reciprocity curve of an emulsion. One which is rated as a fast emulsion for ordinary exposure times is frequently slow for long or short exposures.

Photometry

Photographic photometry is the measurement of light intensities by the action of light on a photographic emulsion. The process usually amounts to comparing two photographic images on the same photographic negative, one of the images having been formed from a light source of known intensity. Occasionally, the comparison must be made between images on different negatives. In this case the negatives must be identical in composition and have undergone identical development processes.

To determine the brightness of objects which are not point sources, we measure the density of the image on the photographic film. This density determines the value of $\log It$ from the characteristic curve for the emulsion. Usually the photographic material is exposed in a calibrated sensitometer either before, after, or preferably during the exposure of the object. This system requires a constant light source for the sensitometer. Voltage regulators and the pre-aging of bulbs for the light source both help alleviate this difficulty, but it still remains a problem. Also, differences in color between the source of the sensitometer and the object to be measured actually give different characteristic curves. A further problem arises from differences in development when the sources cannot be compared on the same negative. However, if the sensitometer is correctly calibrated and its light source held constant, the differences in processing appear on the resulting characteristic curves and proper correction can be made.

Any photographic material which has been processed shows a measurable density whether or not it has been exposed to light. The

density for areas which have not been exposed is known as fog. The density due to fog is not constant even on one negative. In general, the fog density is smallest where the density due to the light exposure is greatest. For proper photometric values, only the density caused by exposure is wanted, and the total density as measured by a densitometer should be corrected. Although many complex formulas have been derived for this correction, none of them is completely satisfactory. Unless the densities to be measured are very small, we usually ignore the fog density and use the total density.

When the images are of point sources, the density has little meaning. For this condition, the diameter of the image is plotted against the logarithm of the exposure. The diameter of the image is a linear function of the logarithm of the exposure within certain limits. In astronomical work many of the objects are points of light, and the brightness of the stars can be determined by means of this relationship. In practice, stars of unknown brightness are compared with stars whose brightness has been carefully determined. The Harvard and Mt. Wilson observatories have determined the brightness of several stars near the north celestial pole with great accuracy. These are known as the North Polar Sequence, and the location near the pole was chosen since this region is visible throughout the year in the northern hemisphere. The sizes of the images of two stars which are far apart on a photographic plate are difficult to compare. A calibrated step scale, or "fly-spanker," of star images aids in the comparison of image diameters under these conditions.

The density of images of a photographic plate may be measured in great detail with an instrument called a microdensitometer. This instrument has an exceedingly small hole for the light source and records the densities graphically as the negative is moved in relation to the hole. An instrument of this type is invaluable for work in spectroscopy where the relative intensities and contours of the spectral lines are important for determining the properties of the emissive source.

The problems of photographic photometry are highly specialized and no two processes are quite the same. More extensive material is available from photographic literature and literature on the subjects for which photometry is used.

References for Additional Reading

S E N S I T O M E T R Y

James, T. H., and G. C. Higgins, *Fundamentals of Photographic Theory*, Morgan and Morgan, New York, 1960, Chaps. 4, 9, 10, and 11.

Mees, C. E. K., *The Theory of the Photographic Process*, The Macmillan Co., New York, 1951, Part IV.

Problems

1. A photographic negative has a density of 1.5. How much of the incident light does it transmit?

2. Two photographic negatives have densities of 1.3 and 0.7, respectively. How much of the incident light is absorbed by each negative?

3. In Problem 2, the one negative is laid on top of the other. What fraction of the incident light is transmitted by the combination? What is the density of the combination?

4. A tube sensitometer has one tube of length one inch and aperture diameter of $\frac{1}{4}$ inch. Another tube is of length 2 inches and aperture diameter $\frac{1}{16}$ inch. What is the exposure ratio produced by the two tubes?

5. If one tube of a tube sensitometer has a length one inch and aperture diameter $\frac{1}{8}$ inch, what must be the length of a tube with aperture $\frac{1}{32}$ inch to give the same exposure?

6. The following data were obtained from a series of exposures and density measurements on a film:

Exposure (lumen-sec per sq ft)	Density
0.1	0.04
0.2	0.20
0.4	0.50
0.8	0.90
1.6	1.30
3.2	1.70
6.4	1.94
12.8	2.02
25.6	1.90

Plot the characteristic curve of the film.

7. From the data in Problem 6, determine the value of the following quantities: (a) contrast (gamma), (b) threshold exposure, (c) inertia, (d) latitude.

DEVELOPMENT AND PHOTOGRAPHIC CHEMISTRY

The photographic process is divided into two parts. The first concerns the image formation and has been briefly discussed in previous chapters. The formation of the image is an optical problem, and its study comes under the heading of geometrical optics. The second part of the process consists of perpetuating the image, and its study comes under chemistry. We shall discuss the second part in this chapter.

Emulsions

Modern photographic emulsions consist of one or more of the silver halides deposited in gelatin. The silver halides used are silver chloride, silver bromide, and silver iodide. They are not deposited within the gelatin as individual molecules, but are held in suspension as tiny crystals or grains. The suspension of the grains is often compared to the suspension of fruit in a fruit jelly.

A typical bromide emulsion such as that used for enlarging paper and many films is prepared by adding a solution of silver nitrate to a solution of potassium bromide and gelatin. The resulting silver bromide is heated for a certain length of time during what is termed the ripening process. The ripening process increases the sensitivity of the emulsion, and during this time ammonia is frequently added. The exact reason for the increase of speed during the ripening

process is still not fully understood, but during this interval the grain size increases and the speed of the emulsion is increased from 100 to 1000 times. However, the grain size is not solely responsible for the increased emulsion speed. The sensitizing in the ripening process is partly due to the formation of small particles of silver sulfide on the surface of the silver bromide crystals. The sulfide for this compound comes from allyl isothiocyanate (mustard oil) which is introduced into the gelatin for this specific purpose. The discovery of this use of mustard oil represents one of the most interesting parts of the history of photography. The effect of mustard oil was traced back to the fact that the gelatin used for a certain batch of plates had come from a particular group of cows who had eaten mustard.

After the ripening process the gelatin is allowed to cool, then it is shredded and the soluble potassium nitrate is washed out of it. It is then usually heated again for more thorough "digestion" at which time more gelatin is added. After the digestion the emulsion is cooled and ready for coating on the base. The individual processes vary widely among manufacturers, but all include essentially the steps mentioned.

Latent image

Prolonged exposure of a photographic emulsion to light changes the color of the emulsion, and the image resulting is known as a printed-out image. However, an emulsion that has been exposed for a short period in a camera has no visible reaction to the light. Upon proper development the image formed by the short exposure is rendered visible. Evidently light does something to the emulsion which causes that particular part to change more easily from the silver halide to metallic silver. This "something" that is formed by the action of the light is termed the latent image. The silver halide crystal in the pure state does not show this difference to development when light strikes, and it is only with the presence of an impurity that it occurs. Modern photographic emulsions use mustard oil in the gelatin to supply the ̇impurity, and we believe that minute specks of silver sulfide, which are formed by the reaction of the silver halide with the mustard oil, make a differential development possible.

The theory of the formation of the latent image, although by no means complete, is best explained by the sulfide speck hypothesis. Even in the crystal state, the grains of silver halide are presumed to be ionized. The following ionization occurs:

$$AgBr \rightarrow Ag^+ + Br^-$$

in which the silver carries a positive charge and the bromine carries a negative charge. The charges on the silver and the bromide ions are equal but opposite and each equal to the charge of an electron. The process of reduction which is done by the developing agent, reduces the charge on the silver ion by neutralizing the positive charge with an electron, and thus creates metallic silver. The sulfide speck in the silver bromide crystal upsets the electrical balance of the crystal and forms a nucleus around which the metallic silver apparently grows.

The action is probably best explained by an energy-level diagram. If we assume that the lowest energy level is occupied by the silver bromide crystal which does not have a sulfide speck, it is represented by line *A* in Fig. 9-1. The presence of the sulfide speck

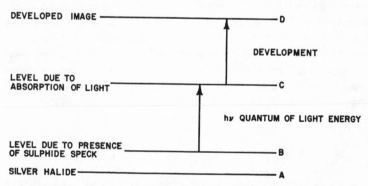

Fig. 9-1. Energy-level diagram illustrating the relative energies involved in the photographic process.

upsets the electrical balance of the crystal in such a way that it occupies a level slightly higher as represented by line *B*. When the crystal absorbs light, the energy level is brought still higher as in line *C*. The energy of the light is represented by $h\nu$, where h is Planck's constant and ν is the frequency of the light. During development, the energy level rises still higher by the addition of an

electron from the developing agent, and the metallic silver is formed. There is good evidence to indicate that the latent image not only represents a higher energy level of the crystal, but also consists of metallic silver. Presumably, the light supplies enough energy to form some metallic silver. The small silver sulfide speck collects the silver and the combination acts as a nucleus for the silver formed by the action of the developer.

Many theories of latent-image formation have been devised during the past years, and the theory presented above is a combination of several. Although not yet complete from a mathematical standpoint, the advances in quantum mechanics, the application of the electron microscope, and highly refined laboratory techniques all point to a complete solution.

Processes other than exposure to light may produce a latent image. When the emulsion is treated by certain vapors or immersed in hydrogen peroxide the effect is similar to exposure to light, and the silver halide becomes developable. As a matter of fact, the action of hydrogen peroxide is very similar to that of light, because it produces a typical characteristic curve even to the reversal effect. Excessive temperatures or pressures also render the image developable. The pressure effect is utilized in autographic cameras where a stylus imprints the writing by pressure applied to the negative material. Excessive temperature often produces an overall fogging of the film and should be avoided for best negative results. An indelible pencil also renders the silver halide developable and is frequently used in the darkroom for identification purposes.

Development

Two developing processes are usually recognized. The first of these is the usual reduction of the ionized silver in the silver halide grains by a reducing agent. The other process, known as physical development, depends on the silver derived from a soluble silver salt contained in the developer itself.

The primary purpose of ordinary developers is to reduce the silver halide to metallic silver. Chemically speaking, a reducing agent is a substance which reduces the positive charge of an ion by supplying electrons. Reduction is the opposite of oxidation. Al-

though many substances are reducing agents, the strength of the reducing agent used in developers must be of just the right amount to reduce the silver halide crystals which have been exposed to light but leave the others unreduced. A simple photographic development process is shown by the following chemical formula:

$$AgBr + H_2O + R \rightarrow Ag + HBr + ROH$$

where the letters represent the chemical elements and R is the reducing agent. Most of the actual reactions during development are not this simple, and, indeed, some are not completely understood. However, the above relation is sufficient to determine the general scheme of the reaction.

Reducing agents are commonly listed in order of their reduction potential or strength which cause the reduction. The reducing agents which satisfy the requirements for developers are limited in number and only a few of those practicable are in general use. These reducing agents are related to benzene, C_6H_6, shown in Fig. 9-2. Figure 9-3 shows the structural formulas of the most common reducing agents used in photographic developers. The list gives them in order of their reducing strength and compares their actual reduction potential with hydroquinone.

Fig. 9-2. Chemical structure of benzene.

Before discussing the properties of some of these developing agents, we will first discuss the constituents of the complete developer. Reducing agents by themselves are not satisfactory for developing a photographic emulsion, and their action must be altered so that they produce satisfactory results. A chemical developer ordinarily consists of the following constituents:

1. The reducing agent
2. An accelerator
3. A preservative
4. A restrainer
5. A solvent (usually water)

Most reducing agents react so slowly that their activity is increased by the addition of an alkali to the developer. Potassium hydroxide and sodium hydroxide (KOH and NaOH) are both strong accelerators, but they soften the gelatin so much that extreme care is necessary in their use. The carbonates of sodium and potassium

Chemical name	Formula	Relative reduction potential (hydroquinone - 1)	Synonyms and trade names
Diaminophenol Hydrochloride	OH / NH$_2$,HCl / NH$_2$,HCl	35	Amidol
Monomethyl para-aminophenol sulfate	OH / NH·CH$_3$,$\frac{1}{2}$H$_2$SO$_4$	20	Metol, Elon Photol, Pictol, Rhodol, Veritol
Trihydroxybenzene	OH / OH / OH	16	Pyrogallol, Pyro, Pyrogallic acid
Chlorohydroquinone	OH / Cl / OH	7	Adurol
Para-aminophenol hydrochloride	OH / NH$_2$,HCl	6	Rodinal Kodelon (oxalate)
Parahydroxyphenyl Glycin	OH / NH·CH$_2$COOH	1.6	Glycin, Athenon, Monazol
Hydroquinone	OH / OH	1.0	--------
Paraphenylenediamine (base)	NH$_2$ / NH$_2$	0.3	--------

Fig. 9-3. Chemical structures (as different from benzene) and the relative reduction potentials of the common developing agents.

106

(Na_2CO_3 and K_2CO_3) form satisfactory accelerators. Their one disadvantage is that they liberate gaseous carbon dioxide in an acid fixing bath, and under conditions of relatively high temperature (80° to 90°F) the carbon dioxide can form blisters on the gelatin of the emulsion. Although not so active as other accelerators, both borax and sodium metaborate ($Na_2B_4O_7$ and $NaBO_2$) increase the activity of the developing agent. These substances are especially good where there is danger of blisters being formed, since they do not release a free gas in the presence of a weak acid.

Developing agents are reducers, and they exhibit a strong affinity for oxygen. Air coming in contact with the developer or dissolved in the water readily gives up its oxygen to the developing agent, and the resulting oxidation ruins the strength of the reducing agent. To counteract this effect the solution contains a preservative. The most common preservative used is sodium sulfite (Na_2SO_3) which is an unstable compound and readily takes on another atom of oxygen from the air to form sodium sulfate (Na_2SO_4). Although the sodium sulfite has a great affinity for oxygen, it does not act as a developing agent and is therefore ideal for use as a preservative. It also serves a second purpose. Sodium sulfite prevents the accumulation of oxidation products formed by the developing process. These products frequently stain the emulsion. Pyro developers are especially bad about staining and need a high concentration of sulfite to control them.

One of the oxidation products of a developing process is a halide ion with a negative charge. As soon as the development process begins, these ions create an acid condition which would stop further development if the action of the alkali present did not counteract it. However, the alkali must be restrained because it fogs the photographic emulsion. The addition of more bromide ions provides the required restrainer. We have, then, an apparent paradox. We put too much alkali in the developer and restrain the action by adding additional bromide. The explanation is that we create a balance between the alkali and the bromide, both of which are in comparatively large quantities. The bromide ions formed by the developing process give a relatively small increase in the total number and do not slow down the developing process noticeably. The restrainer is usually supplied by potassium bromide dissolved in the developer. Its action shifts the characteristic curve of the emulsion to the right on the log (It) axis, as shown in Fig. 9-4.

Of the many hundreds of developers which have been compounded, most of them contain the above constituents in various

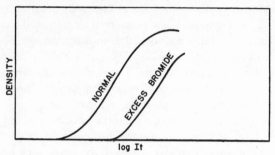

Fig. 9-4. The effect of excess bromide on the characteristic curve of a photographic emulsion.

proportions. A typical universal developer consists of the following:

Developing agent	Metol	3.0 grams
Preservative	Sodium sulfite (desiccated)	45.0 grams
Developing agent	Hydroquinone	12.0 grams
Accelerator	Sodium carbonate (desiccated)	76.5 grams
Restrainer	Potassium bromide	1.9 grams
Solvent	Water to make	1.0 liter

(Du Pont 53-D all-purpose developer)

Both the sodium sulfite and the sodium carbonate are listed as desiccated. Anhydrous, or desiccated, indicates that there is no water of crystallization present. Many substances such as these take on water from the air and are known as hydrophilic. This water combines with the crystal to form a semichemical combination and increases the weight of the crystal without increasing the amount of the desired chemical. For instance, sodium carbonate often takes on one molecule of water for each molecule of the carbonate. It is known as monohydrated, and has the chemical formula $Na_2CO_3 \cdot H_2O$. The molecular weight of sodium carbonate is 106 and that of water is 18. Therefore if monohydrated sodium carbonate is used instead of the desiccated, the amount in the developer formula should be increased by $\frac{18}{106}$, or about 17%. When sodium carbonate is obtained as crystal sodium carbonate, it has ten molecules of water for each molecule of carbonate. Here the desiccated amount must be increased by $\frac{180}{106}$, or about 170%.

The corrections of the sodium sulfite or any other hydrophilic substances are derived in the same manner.

Figure 9-3 gives developing agents listed in order of their activity. Amidol is such a vigorous developing agent that it acts even under slightly acid conditions. It deteriorates rapidly in solution, and a developer containing it is generally prepared just before use. Amidol makes a highly satisfactory developer where vigorous reduction is necessary and is used for some types of printing, lantern slides, and transparencies. A developer of this type needs no alkali other than the sulfite, which is only slightly alkaline compared with the carbonates.

Metol is a relatively vigorous developing agent and will also develop without an alkali. It develops rapidly but it gives a low contrast. For this reason it is usually used in combination with hydroquinone. Metol has the longest useful life of any of the developers listed. It is notably efficient in building up shadow detail in a negative because its action is only slightly affected by bromide and other restrainers.

Pyrogallol was formerly the most popular of all developing agents. Its tendency to stain the image due to oxidation products is both an advantage and a disadvantage. The amount of staining produced depends on the concentration of the preservative, and a developer of almost any desired contrast can be prepared with it. However, this very fact reduces the uniformity of results from the use of a pyro developer. As a developing agent it is most often used alone, but is occasionally used with metol or glycin.

Adurol is a developer of medium activity. It has little tendency to fog or stain and is affected only slightly by the action of potassium bromide and other restrainers. Its present use is mainly for the production of "warm" tones on photographic papers. However, it has largely been replaced by a combination of metol and hydroquinone.

Rodinal is a developer with exceptional keeping qualities and can therefore be made in concentrated form with little danger of excessive oxidation. The base from which it is derived, paraminophenol, is only slightly soluble in water and thus the hydrochloride or sulfate is used. Also, the oxalate is marketed under the name of Kodelon. The image produced by rodinal is free from stains and rodinal is used with an accelerator, usually one of the carbonates.

Glycin is a slow-acting developer which produces a gray-black image on the negative. It does not oxidize directly with the air and therefore does not stain the image. Its characteristics make it a valuable fine grain developer and it is often used in conjunction with other developing agents such as metol and paraphenylenediamine for this purpose.

Hydroquinone in conjunction with metol is the most popular combination of developing agents. The action of hydroquinone is relatively slow and results in high density and contrast rather than detail. This effect is counterbalanced by the metol in most developers. The activity of hydroquinone is very sensitive to restrainers and to temperature. Hydroquinone is almost inactive when used at a temperature less than $10\,^{\circ}C$ ($50\,^{\circ}F$). It oxidizes readily both in the crystalline form and in solution, so that it requires either an airtight container or the presence of a large amount of sulfite in the developer.

Paraphenylenediamine is a very slow-acting developing agent which is particularly valuable for its fine grain results. Part of the fine grain produced in the negative with this agent is due to its solvent action on the silver halide. The resulting image is cream-colored by reflected light so that certain negatives appear as positives when viewed by reflected light. The base of this developing agent, $C_6H_4(NH_2)_2$, as shown in Fig. 9-3, is slightly alkaline in solution and can be used without an accelerator. However, the hydrochloride, $C_6H_4(NH_2)_2 \cdot 2HCL$, requires the use of an alkali with it. Both the base and the hydrochloride are toxic to the skin and must be used with caution, preferably with rubber gloves. The salts, however, are not toxic when used in solution.

The solvent used for developers is generally water. Ordinary tap water is usually satisfactory for photographic purposes, but distilled water is used when the results depend on controlled development. Alcohol is sometimes used in combination with water for development which must be carried on at higher temperatures, and the use of alcohol as a solvent is common in tropical climates.

Physical development

Physical development depends on the action of a silver salt in the developer to build up a metallic silver deposit around the latent image. The final image is the same in both physical and chemical

reduction development processes, that is, metallic silver. The salt often used for physical development is silver nitrate. The development by this process frequently takes several hours but because of this has the advantage of being easily controlled. Also, physical development can take place after fixation but the process takes place more slowly and may require as long as several days.

Fine grain development

Although the grain size is fixed during manufacture, the resulting size of the silver grains can be varied to a limited extent during development. The control of granularity in development is possible in two ways. One method of limiting grain size is to incorporate in the developer a substance which dissolves the silver image slightly. This process usually results in reducing the effective emulsion speed and must be taken into account in the original exposure. Silver is slightly soluble in sodium sulfite so that an added supply of this preservative produces finer-grain results. The use of a vigorous developing agent tends to make the emulsion grains actually "dance around" during the developing process and come into contact with one another forming clumps. Clumping increases the grain size of the image to a noticeable extent and is to be avoided in fine grain developers. A developing agent with a low reducing potential is necessary for fine-grain work. Glycin and paraphenylenediamine in combination are commonly found in developers which produce low granularity.

Excessive temperatures during development soften the gelatin and permit clumping of grains to take place more readily. Also, all solutions during the development, rinse, and fixation processes should be at the same temperature in order that no expansion and contraction of the gelatin take place which will induce clumping of the grains.

Agitation

As development proceeds the developing agent oxidizes and becomes weaker. The oxidation product is heavier than the developer so that it tends to settle to the bottom. If the development is to be uniform, the solution must be agitated during development. Agitation is necessary in both tray and tank developing, where in the former case the film is horizontal and in the latter it is vertical.

However, since the oxidation product settles, agitation is not so critical for tank development as for tray development. The best type of agitation is one in which there is no regular motion. Uniform periodic agitation frequently causes standing waves which form a developing pattern on the emulsion.

Temperature effect on development

Figure 8-4 shows how the gamma (contrast) depends upon the length of time of development. Actually there are two variables upon which the gamma depends, the other being temperature. For a negative material to be developed to a given value of gamma, both the temperature of the reaction and the length of time the reaction takes place must be taken into account. From the study of chemistry we find that a reaction of this kind doubles in speed for an increase of about 18°F. This rule of thumb can be applied to the developers in common use except where the temperature is so high that the period of absorption of the developer by the gelatin becomes important. Manufacturers of photographic products publish curves which give the time-temperature relationships necessary for development to a particular gamma. Figure 9-5 shows a curve of this type for gamma of 0.9.

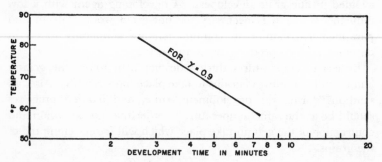

Fig. 9-5. Typical time-temperature curve for development to a given value of gamma.

Fixation

Fixation is the process which removes the silver halide from the emulsion and leaves the unexposed parts clear. The silver halide is insoluble in water and it must be changed into a soluble salt in order for the water to wash it from the emulsion.

Sodium thiosulfate ($Na_2S_2O_3$) is the only fixing agent in common use, and acts as a satisfactory fixer even when used by itself. However, silver is slightly soluble in sodium thiosulfate, and if the film remains too long in the solution, the image fades. The action of sodium thiosulfate was discovered by the English astronomer John Herschel who thought it was sodium hyposulfite. In modern chemical terminology the name sodium hyposulfite for this compound is erroneous, but through usage it has become known as *hypo*. When dissolved in water it absorbs a large amount of heat and the solution grows cooler as the hypo dissolves. The exact chemical reaction which occurs between the sodium thiosulfate and silver halide is not known. The sodium and silver undoubtedly form a complex soluble thiosulfate and a sodium halide.

During the processes of development and fixation the gelatin of the emulsion becomes soft and is easily damaged. To reduce this hazard, a hardening agent is commonly incorporated in the fixing bath. Alum and chrome alum have the required characteristics for hardening the emulsion and they are both used. Alum is potassium aluminum sulfate, $AlK(SO_4)$, and chrome alum is potassium chromium sulfate, $CrK(SO_4)$. The chrome alum is generally superior with respect to hardening and solubility, but is more expensive. Alum and sodium thiosulfate react to form sulfur, which is not soluble, but sodium sulfite combines with the sulfur to form more thiosulfate. Thus sodium sulfite is another constituent of the fixing solution.

A combination of the above three ingredients is likely to form a precipitate unless an acid is added. The action of an acid on the sodium thiosulfate also forms sulfur. As a result, a weak acid such as acetic or citric acid is used. Acetic acid is the most successful of the acids for this purpose and the most universally used. An acid in the fixing bath also serves the purpose of stopping the action of the developer and reducing possible stains on the emulsion. For this reason an acid rinse between the developer and the fixer is convenient and prolongs the useful life of the fixing bath.

Combinations of the above four ingredients are commonly found in fixing solutions. The exact proportions depend on the purpose for which the fixer is used, and many different formulas are recommended by the various manufacturers of photographic products. The time for fixation depends on the temperature and the con-

centration of the sodium thiosulfate. If the solution is too strong the fixer can form a product which is insoluble, and if it is too weak the time necessary for fixing is increased to a point where fixation does not occur. The optimum range between these two extremes lies between a 30% and 40% solution of thiosulfate.

The time of fixation is generally determined by a rule of thumb. This rule allows the fixing action to proceed twice as long as it takes for the creamy silver halide to disappear in an unexposed section of the emulsion. Since the fixation is a logarithmic process, this rule is justified. For the fixation of emulsions on paper, there is good indication that fixing occurs within one minute with a fresh fixing bath. However, a minimum limit of ten minutes is usually given since the fixation rate depends on the degree of exhaustion of the fixing bath.

Washing

Washing removes the soluble products of the developing and fixing processes from the emulsion. The removal rate depends on the concentration and is thus logarithmic. If one minute of washing leaves 10% of the chemicals in the gelatin, then at the end of two minutes there will be 1% and at the end of three there will be 0.1%, etc. The products can never be removed entirely. However, an emulsion is considered properly washed when the remaining sodium thiosulfate has a concentration of 0.5 milligrams per square inch of film. This limit includes the deposit left on both sides of the film base. If the film is to be kept for a long period of time, the concentration should be reduced to 0.1 mg/sq in. Ordinarily film is satisfactorily washed in freely moving fresh water in twenty minutes. Photographic paper, however, requires more time since the chemicals are absorbed by the paper. Recent experiments indicate that hypo is actually adsorbed by the paper base and can never be removed beyond a certain point. A period of not less than one hour is recommended for paper washing.

A few chemical tests have been devised for indicating the presence of hypo after a period of washing. Most of them depend on a change of color or the precipitation of an insoluble product after the reaction with sodium thiosulfate. Although hypo tests are successful, certain substances present in the washing water give a result similar to that of hypo. All tests should be conducted first

with the water alone to determine whether or not the substances are present.

Drying

Before printing negatives, we generally dry them. A wet emulsion contains about ten times its weight of water and the usual procedure is to allow the water to evaporate. We can speed up the evaporation by forcing air around the emulsion or heating the air. However, an emulsion that has not undergone a hardening process should not be warmed.

In most areas where the drinking water is processed before use, it contains chemicals which are likely to leave spots on the emulsion or on the back side of the film. In either case they will show up in the finished print. To eliminate the possibility of these spots we can remove the surplus water before drying. This can be done with a squeegee, a piece of cotton, or a sponge. Any of these methods is satisfactory but care must be taken to have the material perfectly clean and free from lint. Cleanliness includes freedom from dirt, grit, and chemicals. For example, a sponge which is used to remove surplus water must not previously have been used for cleaning the hypo from the bench top. This combination would render the washing process valueless.

If forced air is used, either warm or cool, there should be a dust filter around the films to prevent small particles of dust from sticking to the emulsion. Furthermore, the rate of drying should not be changed, since this can cause streaks in the emulsion.

Rapid drying is sometimes accomplished chemically by one of two methods. Replacing the water in the emulsion with a more volatile fluid aids the drying process. If a negative is immersed a few minutes in denatured alcohol, it can be dried rapidly in forced air. The second method requires the use of certain salts which have a dehydrating effect on the emulsion. Potassium carbonate satisfies this condition, and when made in a saturated solution it replaces the water of an emulsion immersed in it. However, after printing, the negatives should be rewashed and dried in the usual way.

Chemical reversal

Film which is overexposed so much that solarization occurs produces a positive transparency. Ordinarily, the downward trend of

the characteristic curve is so unreliable that transparencies made by this method are unsatisfactory. Furthermore, the equivalent slow film speed for solarization requires exposures of the order of an hour or so. Reversal during processing is a practical method for making positive transparencies and requires only an extra step or two more than ordinary negative processing.

In order to reverse photographic emulsions, we require that the normal silver image be removed and the remaining silver halide be converted into metallic silver. The first step follows the normal developing procedure, and development is allowed to continue until it is essentially complete. The second step consists of a water rinse. At this point, the film can still be fixed into the usual negative, or it can be reversed into a positive. For reversal, we immerse the film in a solution which converts the silver into some other silver compound. Potassium bichromate (or dichromate) changes the metallic silver into a white compound, and the effect is known as bleaching. Sulfuric acid, in the same solution, dissolves all of this silver compound out of the gelatin but leaves the original silver halide. Thus there remains an undeveloped, unexposed, positive image consisting of the silver halide. Other materials can be used as a bleach, potassium permanganate for example, but all of them leave a stain on the film because of their own color. A sodium bisulfite rinse subsequent to the bleach removes this stain.

Since only the silver halide image remains after the bleach, the film can be exposed to white light and redeveloped to form a positive. The exposure is not critical but should be sufficient to give good dark shadows. Actually, the white light can be turned on shortly after immersing the film in the bleach. If the second development is not carried to completion, a fixing bath should be used to dissolve the residual silver halide. The usual washing and drying complete the process.

Any photographic emulsion can be reversed in the manner just described. However, the result is not always so satisfactory as the usual negative-positive process. Special films and papers are available for reversal and these generally give pleasing results. Home movie film represents the most common film which is produced specifically for reversal, and it can be reversed by anyone willing to spend the time and effort necessary.

Ordinary negative materials give satisfactory reversal transparencies, but their effective speed is diminished. The reason for

this loss of speed lies in the construction of the emulsion. Many commercial emulsions consist of a combination of fast and slow emulsions in conjunction with each other to give greater exposure tolerance. Upon reversal, the slower emulsion, which has not been exposed by the original image, turns dark and forms a transparency which is too dense. For satisfactory reversal results, ordinary film must be exposed three or four times as much as for negatives. No exact criterion exists for the necessary amount of overexposure, and a trial-and-error method must be applied.

Monobath solutions

A proper combination of developer and sodium thiosulfate mixed together forms a solution which both develops and fixes in one operation. A solution for this purpose is known as a monobath solution.

Since both developing and fixing chemicals are present in a monobath solution, both processes proceed simultaneously. This effect, in general, slows down the effective speed of the emulsion and reduces contrast. Highlight areas, which have been heavily exposed, receive incomplete development because the fixing component dissolves part of the silver halide before development can be completed. Some reduction of speed results from this action. The sodium thiosulfate acts proportionately more in the heavily exposed regions and reduces the contrast compared with the contrast of normal development.

The chief advantage of monobath solutions is their saving in space rather than their saving in time. Portable darkrooms in which large films must be processed represent the greatest potential application of monobath processing techniques. Replacement of the normal develop-rinse-fix procedure by a one solution treatment saves space by requiring fewer tanks and less room for handling the film.

Rapid Processing

Rapid processing techniques fall into two classes. The first of these depends on the increased rate of a chemical reaction with increasing temperature and concentration of the solutions. The second process combines increased concentration with the properties of a monobath solution.

Normal photographic development gives excellent results for temperatures between 60°F and about 80°F. When processing emulsions under conditions of temperatures higher than 80°F, we must use certain precautions not required for normal development temperatures. The gelatin of photographic emulsions softens seriously when it is subjected to solutions whose temperature is high. One method of counteracting the softening is with the addition of a hardener to one of the solutions, as mentioned previously. Besides the potassium or chrome alum present in most fixing baths, formaldehyde and tannin also form satisfactory hardening solutions.

Rapid processing by means of concentrated solutions usually follows the common develop-rinse-fix procedure. Temperatures well over 100°F are used and solutions concentrated to the point of saturation give fast results. In many cases the solutions are sprayed on the emulsion. Hardening is required, and frequently special emulsions which do not soften easily are used for high-temperature processes.

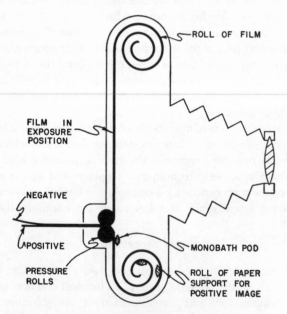

Fig. 9-6. Diagram illustrating the operation of a Polaroid Land camera.

The complete processing time, except for a thorough wash, can be made as short as a few seconds. Films which are to be retained for long periods of time must later be washed and dried in the usual manner.

Polaroid Land process

The second method of rapid processing is best exemplified by the Polaroid Land camera. Not only does this process develop the negative with a highly concentrated monobath, but it also forms a positive print from materials initially present in the negative. Figure 9-6 shows the construction of a Polaroid Land camera. Both the film and a paper support for the positive print are inserted in the camera, and the film is exposed in the usual fashion. After exposure, the film and paper are brought together and pulled between two rollers. However, just before the film-paper combination enters the rollers, the pressure of the rollers breaks a pod which contains the monobath solution. This solution is squeezed in between the film and paper so that it can develop the film and "print" the paper.

The Polaroid Land process depends on the action of the monobath contained in the pod. The monobath solution contains hydroquinone and sodium hydroxide as the developer, sodium thiosulfate as the fixer, and sodium sulfite to aid fixation. These four chemicals are dissolved in a plastic solvent of high molecular weight. The complete solution forms a viscous fluid which covers uniformly the interspace between the film and paper, and the action of the monobath follows essentially that of other monobath solutions. Development takes place slightly sooner than fixation, and the thiosulfate attacks the undeveloped silver halide to form a complex silver thiosulfate molecule. However, the solvent of the Polaroid Land process contains such heavy molecules that the complex silver thiosulfate has little opportunity to diffuse. Thus there remains only the task of converting the silver thiosulfate into metallic silver and depositing it on the paper backing. In order to accomplish this conversion, microscopic crystals of a metallic sulfide are put on the positive paper support during its manufacture. These crystals perform the necessary task of precipitating silver on themselves to produce the positive print. The complete reaction requires only about one minute, and the negative can be separated from the print at the end of this time.

The unique feature of the Polaroid Land camera is the mono-bath process just described. Other cameras can be adapted with special backs to use this process, and some are available. Principal advantages of this process are its short time between exposure and resulting print as well as its simplicity of operation. The chief disadvantages result from the impossibility of making either extra prints from the same negative or enlargements from the original negative. Both of these difficulties have been overcome in certain cases by the introduction of a reusable negative.

Reduction of Density

A negative which has been subjected to overexposure frequently shows a density range which is not practical for printing. The same is true of a negative which has been overdeveloped. In both of these cases the negative may require reduction of density, but the treatment is not the same.

The reduction of a photographic negative is that process which decreases the density of the developed image. It is not to be confused with the developing process in which the silver ion is reduced to metallic silver. The process of density reduction generally takes place after the photographic material has been thoroughly fixed and washed. Actually, reduction is a chemical oxidation process in which the silver is oxidized to form a soluble compound. This compound is removed from the emulsion by the solvent of the reducer.

Photographic reduction is divided into three types depending on the comparison of contrast in the material before and after reduction. These three types are:

1. Subtractive reduction
2. Proportional reduction
3. Superproportional reduction

Subtractive reducers remove the same amount of silver from all parts of the emulsion regardless of the density. This reduction has the effect of subtracting a given amount of density and leaves the contrast unchanged. Figure 9-7 shows a series of three diagrams illustrating the effects of the three types of reducers. Part (a) of this diagram shows the effect of a subtractive reducer on three density values of an emulsion. The density before reduction is given by the total shaded area, and the part removed by the reducer is shown by

the crosshatched area. Figure 9-7 also shows the effect of subtractive reduction on the characteristic curve of the emulsion. Subtractive reduction is used whenever the contrast of a negative is satisfactory, but the over-all density is too high. A typical example arises from overexposure with normal development.

Proportional reduction removes an amount of silver which is proportional to the amount present. The action of this reducer is analogous to shaving off a uniform layer of the emulsion and decreasing the density in proportion to its original amount. The contrast of the photographic material subjected to proportional reduction is lessened. This type of reducer corrects overdevelopment.

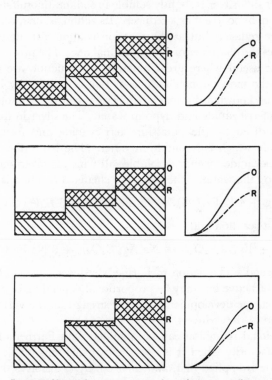

Fig. 9-7. Upper diagram, action of a subtractive reducer. Middle diagram, action of a proportional reducer. Lower diagram, action of a superproportional reducer. The letter O represents the original density and characteristic curve while R represents the values after application of the reducer.

Frequently it is also used to reduce the contrast of subjects which are too contrasty even though the density is satisfactory. The effects of a proportional reducer on the density and the characteristic curve are shown in Fig. 9-7b.

Superproportional reducers remove a greater proportionate amount of silver from the high densities than from the low densities. Since they have little effect on the low densities of a negative, they can be used safely where the preservation of shadow detail is important. A typical case is one in which the subject is contrasty and the negative has been underexposed and overdeveloped. The action of the superproportional reducer is shown in Fig. 9-7c.

The fact that silver is slightly soluble in sodium thiosulfate allows a solution of hypo to act as a reducer. Its action, at first, is that of a subtractive reducer, but as the reaction continues it more nearly approaches the character of a proportional one. The process is slow and is not useful where great amounts of reduction are needed. Probably the most popular reducer is that originated by Howard Farmer, and known as Farmer's reducer. It consists of a solution of potassium ferricyanide and hypo in water. The silver in the emulsion is oxidized by the potassium ferricyanide and forms silver ferrocyanide which is insoluble in water. The hypo dissolves the silver ferrocyanide forming a soluble salt which is taken out of the emulsion by the water. The complete chemical reaction is

$$4\,Ag + 4\,K_3Fe(CN)_6 \rightarrow Ag_4Fe(CN)_6 + 3\,K_4Fe(CN)_6$$

for the first reaction and

$$3\,Ag_4 + 16\,Na_2S_2O_3 \rightarrow 4\,Na_5Ag_3(S_2O_3)_4 + 3\,Na_4Fe(CN)_6$$

for the second. The action of Farmer's reducer is generally considered subtractive but may be proportional depending on the type of emulsion, the development, and the strength of the various materials used in the reducer.

Proportional reduction can be obtained with Farmer's reducer most satisfactorily when it is used in two solutions. That is, the ferricyanide is applied first, and then the hypo dissolves the silver ferrocyanide afterward in a separate solution. The number of subtractive and proportional reducers that can be found in the handbooks and references on photography is large. However, the number of superproportional reducers is relatively small. One of

the most successful is the reducer which depends on the action of ammonium persulfate, $(NH_4)_2S_2O_8$, in solution with a small amount of sulfuric acid.

Two important factors determine whether or not a particular reducer acts in a subtractive, proportional, or superproportional manner. One of these factors is the length of time required for the solution to penetrate the emulsion compared with the time necessary for the chemical reaction to take place. Whenever the time of penetration is long compared with the reaction, the reducer acts in a proportional fashion. When the situation is reversed, the action is mainly subtractive. These facts explain the dependence of the final contrast produced by a reducer, such as Farmer's, upon the concentration.

The other important factor is the nature of the products produced by the reaction of the reducer with the silver. If the reaction rate is increased by the product formed, the decrease in density is greatest in the denser portions of the negative and superproportional reduction results. For example, ammonium persulfate reacts with silver to form silver sulfate and ammonium sulfate in accordance with the following chemical equation:

$$(NH_4)_2S_2O_8 + 2\,Ag \rightarrow Ag_2SO_4 + (NH_4)_2SO_4.$$

The soluble silver sulfate increases the solubility of the silver and speeds up the reaction.

Intensification

Intensification is that process by which the density of the photographic material is increased. Although it is difficult to correct a negative which has been underexposed, the low densities due to underdevelopment can be corrected satisfactorily. The processes of intensification used are nearly

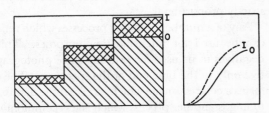

Fig. 9-8. Intensification, showing the proportional character of the process and the resulting change in the characteristic curve.

proportional and result in the densities and the characteristic curve shown in Fig. 9-8.

The processes of intensification are readily divided into three methods.

 1. Deposition of additional silver on the image.
 2. Replacement of the silver with another metal which gives an increased density.
 3. Replacement of the silver image with a dye image.

Additional silver can be deposited on the image from a silver salt in the presence of a developing agent. A typical combination for this purpose is silver nitrate and elon. They are used with sodium sulfite for a preservative and hypo to render the solution slightly acid. The intensification is permanent and easily followed to the desired degree.

One of the most popular intensifiers consists of potassium dichromate in the presence of hydrochloric acid. This solution bleaches the finished photographic emulsion. The metallic silver is oxidized to form silver chloride and the chromium remains in the form of an oxide or a chloride. After bleaching, the negative is redeveloped in a standard developer and the resulting image has a higher density than the original because of the presence of the chromium compound. If the redevelopment is not carried on to completion, the negative may be reduced instead of intensified, and thus the same process serves for either reduction or intensification. Another advantage of the chromium intensifier is that the process can be repeated to give greater intensification than that obtained with only one action.

Mercury is another metal commonly used for intensification purposes. The image formed is not permanent, but the results are strictly proportional.

Any of a number of toning processes which render the image sepia can be used for intensification purposes. This result applies to negatives to be used for printing since photographic paper is sensitive only to the blue end of the spectrum. The sepia tone actually forms a colored image which increases the density to blue light. Dye toning is another process which is less commonly used as an intensifier, but it has a disadvantage because the density for printing is often different from that which appears visually. Therefore, the

visual estimate of contrast is difficult and the choice of paper is uncertain.

References for Additional Reading

ELEMENTARY PHOTOGRAPHIC CHEMISTRY AND FORMULAS

Elementary Photographic Chemistry, Eastman Kodak Co., Rochester, N. Y., 1941.

Lester, H. M., *Photo-Lab-Index*, 10th ed., Morgan and Lester, New York, 1949.

Kodak Reference Handbook, "Processing," 4th ed., Eastman Kodak Co., Rochester, N. Y., 1947.

ADVANCED PHOTOGRAPHIC CHEMISTRY

James, T. H., and G. C. Higgins, *Fundamentals of Photographic Theory*, Morgan and Morgan, New York, 1960, Chaps. 3, 5, 6, and 7.

Mees, C. E. K., *The Theory of the Photographic Process*, The Macmillan Co., New York, 1951, Part III.

RAPID PROCESSING AND MONOBATH SOLUTIONS

Land, E. H., "A New One-step Photographic Process," *J. Opt. Soc. Am.*, vol. 37, 1947, pp. 61-77.

GENERAL DISCUSSION

Mack, J. E., and M. J. Martin, *Photographic Process*, McGraw-Hill Book Co., Inc., New York, 1939.

Neblette, C. B., *Photography*, D. Van Nostrand Company, Inc., Princeton, N. J., 1952.

Problems

1. A negative material has a contrast of 1.2. The application of a proportional reducer reduces each opacity to 75% of its original value. What is the contrast after reduction?

2. A particular intensifier cuts the amount of transmitted light in half for each part of a film. If the original gamma is 0.4, what is the value of gamma after intensification?

PRINTING

Photographic printing is the making of positives from negatives by exposing photographic emulsion through the negative. The production of contact prints, enlargements, and transparencies is correctly included in this discussion. A contact print is made with the negative in direct contact with the positive material, and the combination is exposed to a source of light as shown in Fig. 10-1.

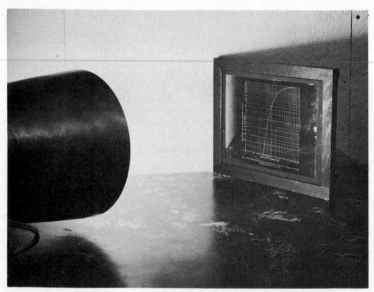

Fig. 10-1. A simple method for making contact prints.

Enlarging, or projection printing, can be considered the reverse of the process of producing a negative in a camera. A special holder contains the negative and allows light to pass through it. The light then passes through a lens which focuses the image of the negative onto the positive emulsion. Transparencies can be made either way, that is, by contact or by projection. The emulsion for transparencies is coated on a base similar to the base for negatives so that we can view the transparencies by the light transmitted through them.

Printing emulsions

Paper-based emulsions, or photographic paper, can be divided into two general classes. First is the printing out paper on which an image is formed directly by the action of light. This paper requires no development and is often used for proofs in portrait photography. Because it fades with time, printing out paper is less popular than developing out paper. Developing out paper requires developing, fixing, washing, and drying processes similar to those for a negative.

Developing out papers also use a silver salt as the light-sensitive ingredient. Silver chloride, silver bromide, or a combination of the two furnish the necessary salt. The silver chloride papers are slow in their reaction to light compared with the bromide papers. As a result, papers which are intended for contact printing are made with silver chloride, and the papers designed for projection printing are made with silver bromide. The intensity of the light from an enlarger is usually less than that used for contact printing. The chlorobromide papers are between the chloride and bromide papers in speed and can be used for either contact or projection printing.

Characteristics of printing paper

Unlike negative materials, photographic papers are unable to record the relative light intensities that are encountered in the usual picture. Papers with very rough surfaces exhibit intensities of the order of 1:16, and glossy papers a somewhat greater range, with 1:75 being the maximum. As a result of this short range, the characteristic curves of papers do not show the long straight-line portion that is noticeable for negative materials. A typical characteristic curve is shown in Fig. 10-2 for a paper emulsion. The

dotted line represents the characteristic curve of a negative material for comparison.

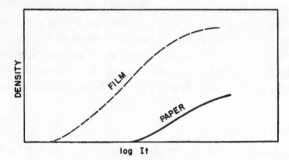

Fig. 10-2. Comparison of the characteristic curves of typical paper and negative materials.

The density of photographic papers is not the same as that of negatives. Here we are interested in the reflection density which is defined by the following relationship:

$$D = \log \frac{I_0}{I_r}$$

where I_0 is the amount of light reflected from the paper base with no image on it, and I_r is the amount of light reflected from the image surface after development. The incident light for both I_0 and I_r must be the same.

The fact that the straight-line portion of the characteristic curves for paper is so short indicates that there is resulting distortion of the tonal values as recorded on the paper. However, if we consider only the straight-line part, we see that in order to correct a negative which has a relatively low contrast we need a paper which has a relatively high contrast. To produce a print with luminous fidelity, we should choose a paper whose contrast, when combined with the contrast of the negative, gives us a gamma of unity. In other words, the product of the gamma of the negative and the gamma of the paper should equal one ($\gamma_n \times \gamma_p = 1$). This relation is called the multiplied gamma and is the criterion for producing a perfect print over the straight-line portion of the paper emulsion.

Figure 10-3 shows three characteristic curves for different papers which represent three different contrasts. The first one ($\gamma = 0.6$) is that of a long-scale paper since the exposure range on it is relatively

long. This type of paper produces a "flat" print and is used in combination with a contrasty negative to produce a normal print.

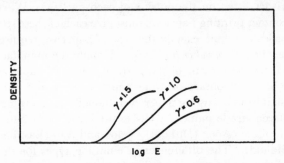

Fig. 10-3. Characteristic curves of three different grades of photographic paper. (Displacement along the log E axis does not necessarily represent a true exposure requirement.)

The second curve represents a paper having a contrast more nearly normal, and is used with negatives having a gamma of nearly unity. For thin negatives with low contrast, the paper having a contrast of 1.5 would be necessary to counterbalance the flatness of the negative.

Contact printing

The usual form of contact printer consists of a light source, a diffusing screen, clear glass plate, negative, printing paper, and an arrangement to hold the paper in close contact with the negative. Such an arrangement is shown in Fig. 10-4. Although the simple

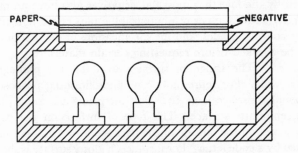

Fig. 10-4. Arrangement of a contact printer.

printing frame shown in Fig. 10-1 is satisfactory, the rate of production of prints can be considerably increased by the addition of a light-tight box which supplies the necessary light.

The various types of contact printing papers are far too numerous to be listed here, but they commonly have several identifying characteristics listed on the outside of each package. When purchasing contact printing paper we must give each of these specifications in order to obtain exactly the type of paper we require.

1. *Manufacturer's brand or trade name.* Usually the manufacturer's name and the trade name of the particular type of paper appear. Also, the words "contact printing paper" are on the outside to distinguish it from enlarging paper even though the enlarging paper has a different trade name. A few examples of trade names are: Convira (Ansco), Apex (DuPont), Velox and Azo (Eastman), Industro (Haloid). The differences in emulsion types for the same manufacturer are shown by different trade names and usually indicate a slight difference in the color of the finished print for portrait, photofinishing, or other uses.

2. *Grades or contrast.* Due to the limited latitude of paper materials, they are made in several different grades of contrast. Usually the contrast is indicated by a number with a maximum of six grades for any one paper. The numbers are 0, 1, 2, 3, 4, and 5, and the contrast increases with the number. Numbers 2 or 3 are considered normal depending on whether the photographer develops his negatives to a greater or lesser contrast. In general, the higher the contrast of a paper, the slower is its response to light. This rule results in a slightly increased exposure requirement for the higher numbers. However, this effect is usually more than counterbalanced by the fact that most flat negatives also have an over-all low density. Many types of photographic papers are not supplied in all six contrast grades, and the specifications of the manufacturer should be checked before requesting certain materials.

3. *Surface.* The range of surfaces available on photographic papers is wide. For reproduction or photofinishing purposes, the most popular surface is glossy. Portrait prints are more pleasing with a semimatte surface. The type of surface on the paper is usually stated on the outside of the package in words, and also it is indicated by a code letter. For instance, a glossy surface is shown by the letter F for Eastman products and by the letter R for Du Pont products. These code letters are listed in the handbooks of photography, or in pamphlets enclosed with the printing paper made by the various manufacturers.

4. *Color*. The color of the paper is limited to a few which might be classed as white or off-white. Names such as ivory or buff are not uncommon for classifying the off-white papers.

5. *Weight*. Three weights of paper are in common use. These are single weight (SW), medium weight (MW), and double weight (DW).

6. *Size*. In this country the size of photographic paper is given in inches. A great variety of sizes is available and the range is from postage stamp size to rolls 40 inches wide. Any particular size can be obtained upon special order from the manufacturer, but the width is limited to 40 inches.

7. *Expiration date*. The expiration date of photographic emulsions is one of the important items which appear on the outside label of the packages of both paper and negative materials. The expiration date should always be checked before the material is accepted. Photographic emulsions tend to fog as they become older, and the rate at which this takes place depends largely upon the type of storage to which they have been subjected. Changes in temperature and humidity are especially damaging in this respect. If the emulsion has been stored properly, it may often be satisfactory for two or three years after its expiration date. However, the safest procedure is to refuse photographic materials which have lapsed, as the manufacturer's guarantee is no longer valid.

8. *Number of pieces*. The number of sheets of photographic material is also shown on the front of the package. Formerly, photographic paper in small quantities was packaged by the dozen. However, most manufacturers package paper in quantities of 10, 25, 100, 500, and 5000 sheets per package.

Enlarging

Projection printing requires a faster paper than that usually used for contact work. Even if the resulting prints are the same size as the negative, there are some advantages in making prints in this fashion. The usual enlarger consists of a light-tight box with either a diffusing screen or a set of condensing lenses for distributing the light uniformly over the negative area. Then there is a negative holder followed by a lens with a focusing arrangement similar to the view camera. The lens projects an image of the negative onto the en-

larging paper and an exposure is made. The elements of a simple enlarger are shown in Fig. 10-5.

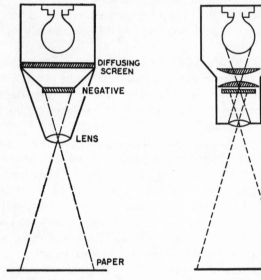

Fig. 10-5. Elements of a simple
diffusing enlarger.

Fig. 10-6. Optical system of a
condenser enlarger.

Certain advantages are inherent in both the diffusion type of light source and the condenser light source. In a condensing lens arrangement the condensing lenses focus an image of the light source on the projection lens as shown in Fig. 10-6. Considering the simplest case, in which the light source is a point, we find a directed ray of light through each point of the negative. When this ray meets the silver grains of the emulsion, it is scattered in all directions, and only a very small part of the original light goes through the emulsion toward the projection lens. Thus there are two effects on the light, both of which are produced by the silver image of the negative. One is the partial absorption of the light by the image, and the other is the scattering of the light by the silver grains. These two effects work together and produce an apparent density that is greater than that determined by using diffuse light. A negative printed with a condenser type enlarger shows more contrast than the same negative printed with a diffusing type. Also, graininess,

scratches, and other defects are more apparent when a condenser enlarger is used.

Since the condenser focuses the light source on the projection lens, the stop openings on the lens are not an accurate indication of the relative brightness of the projected image of the negative. In the extreme case, where the light source is a point, changing the stop openings of the projection lens has very little effect.

When a negative is lighted by diffuse light the same scattering occurs, but the diffuse light is already coming from essentially all directions and the scattering by the negative does not further decrease the light intensity. Only the absorption of the light by the image is effective in negative contrast. Diffuse enlargers are therefore

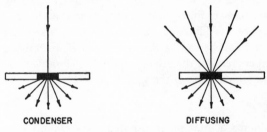

CONDENSER DIFFUSING

Fig. 10-7. Comparison of the effect of an emulsion on the light from a condenser enlarger and a diffusion enlarger.

valuable for reducing the apparent graininess on the final print and rendering scratches less noticeable. However, the light source must be of greater intensity than for a condenser enlarger, but the stop openings of the diffusion enlarger lens bear the proper relationship with each other.

Silver bromide emulsions are used for enlarging papers, and their speed is about $\frac{1}{10}$ to $\frac{1}{100}$ that of negative materials, and from 10 to 100 times as fast as contact paper. The identification of enlarging papers is similar to that of contact papers and the words "for projection printing" are frequently on the label. The contrasts available are more limited than with contact papers and in certain cases only one contrast is manufactured for a given type of emulsion and surface. This is true, for instance, with Opal G (Eastman). The older system of marking enlarging paper for contrast is used in some cases, and grades of normal, medium, and contrast indicate three grades corresponding to numbers 2, 3, and 4. Many papers are

numbered in the same manner as contact papers both as to surface and contrast. However, instead of six grades being available, only four are usually found for projection paper, namely, numbers 1, 2, 3, and 4.

Several photographic papers are available which provide a variable contrast. The action of these papers depends on the principle that photographic emulsions can have different contrast when exposed to light of different wavelengths as mentioned in Chapter 8 and illustrated in Fig. 8-5. Normally the contrast increases from the blue toward the red end of the spectrum. A set of filters varying from deep blue to yellow provides the necessary change of wavelength and gives as many as ten choices of contrast with one paper. The obvious advantage of these variable contrast papers is the reduction of the paper stock necessary for a photographer to keep on hand at any one time. However, ordinary photographic paper is sensitive only to blue light and can be used with a yellow safelight, but the variable contrast papers require the use of a special safelight which transmits only the orange-red part of the spectrum.

Transparencies

The problems of making transparencies are similar to those of making enlargements. Although transparencies can be made by contact printing, there is more loss of detail from the original negative than when they are produced by projection. Transparencies have a great advantage over prints because they have about the same opacity ratio as the original negatives. While the typical print has a tonal range of 1:16, a transparency made from the same negative may show a range of 1:100. To the observer, the added range gives brilliance to the transparency which he does not notice in the print.

Special emulsions are coated on a transparent base for the production of lantern slides and other transparencies. These emulsions are similar to those for enlarging paper, but they are from two to ten times as fast. Some types of materials for this purpose have a frosted side in the back to diffuse the transmitted light.

Washing and drying prints

Washing of prints has been discussed in the previous chapter. In order to be thoroughly washed, the prints must have excellent agita-

tion and must be separated during the process. Whenever two prints stick together during washing they do not wash completely and in a short time one or both will turn yellow.

The methods of drying prints depend on the surface of the paper. Glossy prints are dried on a ferrotype plate with the face of the print against the plate. A ferrotype plate is a piece of sheet metal coated with highly glossed black enamel, or chromium plate. The black plates usually require treatment with paraffin to keep the prints from sticking, but the chromium plates require no such treatment. Prints can be dried by simply allowing the water to evaporate, but the drying rate can be increased by applying heat to the plates. This method reduces the drying time to as little as a few minutes.

Prints which do not have glossy surfaces can be dried in a number of ways. One of the most popular is by inserting the print between blotters and allowing it to dry over night. Commercial dryers are manufactured which dry matte prints rapidly for large-scale production.

Toning

The process of toning prints changes the gradations in black and white to gradations between white and some color. The methods by which this is accomplished generally fall into two classes. Toning can be accomplished by replacing the silver image with a dye image (such a method is used in Kodachrome) or by changing the metallic silver to a compound which has a color desired by the photographer. Of these processes only the latter will be discussed here, and the dye image process reserved for Chapter Twelve.

Of the colors used for toning, probably sepia is the most popular. The most common method of sepia toning is the sulfide process. Silver sulfide produces a sepia tone which varies with the original development used, and the sulfiding process. An accurate scientific description of sulfide toning is difficult because of the many variables, and the photographer is forced to experiment until he has found a satisfactory combination.

One method of producing silver sulfide in the emulsion is to oxidize the silver to form silver bromide, which is nearly invisible on the paper. Then the bromide is removed and replaced with sulfur from a suitable sulfur compound. This method is termed an indirect sulfiding process. In the direct process, the silver is converted

directly to silver sulfide by the action of free sulfur. Free sulfur can be formed in a variety of ways in the solution.

A number of other colors can be produced either by direct substitution or by combination with the sulfide process, and several single toning solutions are available commercially. These processes depend on the differential deposition of a dye by means of a mordant. A mordant is an inorganic compound which causes the dye to precipitate on it, and the dye colors the mordant the same color as the dye. Silver ferrocyanide is a typical mordant. Prints can be toned by changing the silver to a suitable mordant and then applying a dye. For single-solution toning processes, the mordant and dyeing constituents are in the same solution.

Transparencies can be toned in the same manner as prints, with satisfactory results. However, transparencies are more brilliant when toned with the dye image process rather than the mordant dye combination.

References for Additional Reading

CHARACTERISTICS OF PRINTING PAPERS AND
PRACTICAL HINTS

"Kodak Papers," *Kodak Reference Handbook*, 4th ed., Eastman Kodak Co., Rochester, N. Y., 1947.

Lester, H. M., *Photo-Lab-Index*, 10th ed., Morgan and Lester, New York, 1949.

PHOTOGRAPHIC OPTICS

There are very few single-element photographic lenses. Even relatively inexpensive cameras contain lenses made of two components, and some photographic lenses consist of as many as seven elements. The difference between the terms *element* and *component* as applied to lenses is not always clear. However, in the following discussion the word element will be used to mean a single "thin" lens while component will refer to one or more elements cemented together. Thus a high-quality photographic objective contains one or more components, each of which contains one or more elements. Usually the individual elements can be treated as "thin" lenses following the principles outlined in Chapter Three, but the combination of several elements to form a complete lens requires a more thorough analysis.

Thin Lenses in Contact

In Chapter Three we applied the method of the change of curvature of a wave front to derive the lens equation. This equation,

$$\frac{1}{f} = \frac{1}{p} + \frac{1}{q}, \tag{11-1}$$

relates the focal length of a lens to the object distance p and the image distance q. Let us consider a lens made of two elements which are in contact. Figure 11-1 illustrates this situation. We will assume each lens to be thin enough that the combination can

still be treated by the lens equation. For this combination, Eq. (11-1) is valid, but f now represents the focal length of the com-

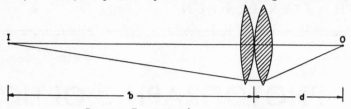

Fig. 11-1. Two positive lenses in contact.

bination. To obtain this equivalent focal length in terms of the individual focal lengths, f_1 and f_2 of the two elements, we can apply the change of curvature technique in a manner similar to that in Chapter Three. Equation (11-2) results from this application.

$$\frac{1}{f} = \frac{1}{f_1} + \frac{1}{f_2}. \qquad (11\text{-}2)$$

The focal length of the combination is smaller than the focal length of either component when positive lenses are in contact. Equation (11-2) holds as well for diverging lenses as for positive lenses as long as the focal length of a diverging lens is considered negative. It is also valid for combinations of negative and positive lenses.

Since the equivalent focal length of lenses in contact follows a reciprocal relationship, focal lengths of lenses are frequently expressed in reciprocal form. The power of a lens in diopters is the reciprocal of its focal length in meters. Thus, a lens of 2 diopters has a focal length of 50 cm. Equation (11-2) becomes

$$D = D_1 + D_2, \qquad (11\text{-}3)$$

where the $D's$ represent the powers of the lenses in diopters. This notation allows direct addition for finding equivalent powers of lens combinations in place of the more cumbersome reciprocal formula in terms of focal length. The expression of reciprocal focal length in terms of diopters is used almost exclusively by oculists and opticians for fitting spectacles. In photography, its convenience applies principally to portrait and copy lens attachments.

Lens Aberrations

Chapter Three introduced us to the relationships which exist among the object distance, the image distance, and the focal length

of a lens. We applied Snell's law to lenses in order to find these relationships. However, when deriving the lens equation, we made several assumptions for the sake of simplicity. Lens aberrations result largely from the invalidity of these assumptions and we will discuss them in the following paragraphs.

Lens aberrations cannot be correctly called "defects in lenses" since aberrations result only from a more rigorous application of Snell's law than was done previously. Although lens aberrations reduce the image quality, this reduction results from "defects in the lens design" rather than from defects in the lens itself.

In the following discussion of lens aberrations, we will treat them one at a time as if the others did not exist. This method illustrates the principles involved, but we should be aware that all aberrations exist simultaneously and the design of a good lens requires minimizing the aberrations to a high degree.

Chromatic aberration

One of the simplifying assumptions of Chapter Three concerned Snell's law directly:

$$\text{index of refraction} = \mu = \frac{\sin i}{\sin r}. \qquad (11\text{--}4)$$

This equation is a perfectly valid statement for any particular wavelength of light. However, the index of refraction is not the same for all wavelengths of light. Table 11-1 shows how the index of refraction varies with wavelength for two types of glass commonly used in lenses.

TABLE 11-1

The Variation of Index of Refraction of Light of Different Colors for Crown and Flint Glass

Color	Violet	Blue	Green	Yellow	Orange	Red
Wavelength	4100 A	4700 A	5300 A	5900 A	6100 A	6700 A
Crown glass index	1.538	1.531	1.526	1.523	1.522	1.520
Flint glass index	1.604	1.596	1.591	1.588	1.587	1.585

When a ray of white light passes through a prism, this ray breaks up into several rays of different wavelengths as shown in Fig. 11-2. As a result of the varying index of refraction, the red

ray deviates less than the violet ray, and the white light spreads into a spectrum. Thus the prism disperses the white light into its component colors, and the effect is known as dispersion.

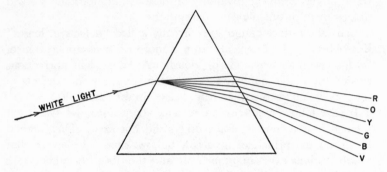

Fig. 11-2. Dispersion of white light by a prism.

A lens can be considered to be made of an infinite number of prisms, and it disperses the light in a manner similar to a prism. Figure 11-3 shows the effect of lens dispersion on a point source of

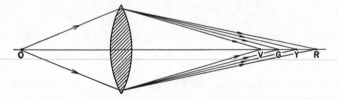

Fig. 11-3. Dispersion of white light by a convex lens.

white light located on the optical axis. The violet light, being most refrangible, is focused at a position nearest the lens, while the red image is farthest away. The images formed by other colors appear between the violet and red in the usual spectrum order. Lens dispersion can be easily demonstrated with the aid of a long-focus spectacle lens and a small flashlight bulb. At the near focus, the image appears blue surrounded by a yellowish-red halo; a little beyond this point, the image is red surrounded by blue light. Thus, even in the absence of other aberrations, the image of a point source formed by a simple lens is a point image only if the source is monochromatic.

The use of two or more elements in a lens can reduce chromatic aberration. Let us consider, for the moment, a lens made of two elements. The dispersive power of one element must be counter-balanced by the dispersion of the other in order to reduce chromatic aberration. Crown and flint glass form a satisfactory combination for this purpose. Usually the crown glass, of lower dispersion, forms the first element and it is a positive lens. The flint glass element follows and the two elements are either cemented together or placed very close together as shown in Fig. 11-4. A lens of this type

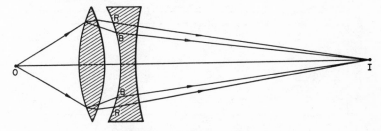

Fig. 11-4. An achromatic lens.

is called an achromatic lens, or frequently just an achromat. This lens is shown corrected for the blue and red regions of the spectrum.

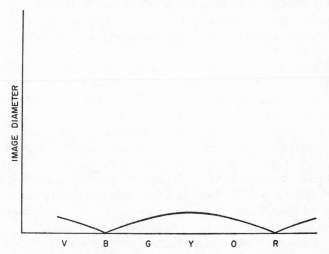

Fig. 11-5. Image diameter as a function of color in the blue-red focus of the achromatic lens shown in Fig. 11-4.

A two-element, or doublet, lens is capable of color correction for only two wavelengths. The example above gives a pattern shown in Fig. 11-5 when the diameter of the image is plotted against wavelength. This color correction curve results from studying the image diameter in a plane perpendicular to the optical axis and passing through point I in Fig. 11-4. An alternate method of representing the color correction of a lens is illustrated in Fig. 11-6. This graph shows the focal length plotted against wavelength

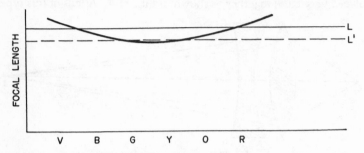

Fig. 11-6. Focal length as a function of color for the achromatic lens shown in Fig. 11-4.

for the typical achromatic doublet of Fig. 11-4. The solid horizontal line L represents the focal length at point I. We see from Fig. 11-6 that the red-blue achromatism is not unique for this doublet. Line L' represents a focal length for which the lens is corrected in the green and yellow.

Adding a third element to a lens permits color correction for three wavelengths. In general, the number of corrected wavelengths cannot be greater than the number of lens elements. However, lenses made of several elements are not always corrected for the maximum number of wavelengths possible because some of the elements correct other aberrations, and the glass available places a limitation on the chromatic corrections.

Lenses designed for use with orthochromatic film are frequently not satisfactory for use with panchromatic film. The color correction for these lenses often extends only to the yellow region of the spectrum, not into the red. Similarly, lenses designed for visual use, such as telescope or microscope lenses, usually require filters which transmit in the yellow-green portion of the spectrum before they are satisfactory photographically.

Spherical aberration

Another of the simplifying assumptions in Chapter Three concerns the derivation of the lens formula. In order to find the focal length in terms of the object and image distances, we used the approximation that the sagitta is inversely proportional to the radius of curvature when the chord length remains constant. This approximation gives sufficiently accurate results only when the cross section of the lens surface is a very small arc of a circle. We further used the assumption that $\cos \theta = 1$ for small values of the angle θ. This approximation occurred for the ray at the edge of the lens, that is, the ray which travels through air while the ray on the optical axis travels through glass.

Neither of these two approximations is ever exactly correct, and the combination gives rise to spherical aberration. Even if the source were monochromatic, lenses would suffer from spherical aberration. As a result, the image of a point source is not a point image, but extends in the image space roughly parallel to the optical axis as shown in Fig. 11-7. The rays which pass through

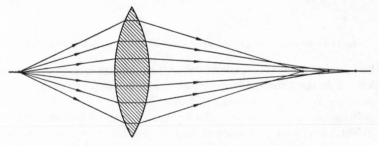

Fig. 11-7. Spherical aberration of a double convex lens.

the outer part of the lens come to a focus closer to the lens than the rays which pass through the center portion of the lens.

Lens designers correct spherical aberration by combining lens elements in such a way that the spherical aberration of one element counterbalances that of another. This method does not eliminate spherical aberration completely, but it serves well enough to be of use in most camera lenses. Spherical aberration can also be corrected, in certain cases, with the use of nonspherical surfaces. However, these surfaces are so difficult to manufacture that they are rarely used in commercially available equipment.

Astigmatism

Chromatic and spherical aberrations exist even when the object is on the optical axis of the lens. Astigmatism produces a defective image of objects which lie off the lens axis. Consider a point A (Fig. 11-8) lying below the lens axis. The point is imaged at A'

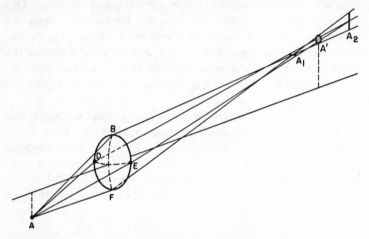

Fig. 11-8. Astigmatic images of a point source formed by a double convex lens.

but the image is not a point. Instead, the image is a small circle known as the "circle of least confusion." In front of A' at some position A_1 the image becomes a short horizontal line, while at a position A_2 the image is a short vertical line. When the point object A is moved to the side of the lens axis, the A_1 image becomes a vertical line, while the A_2 image is the horizontal line. The A_1 line image in either case is known as the primary image and A_2 is the secondary image. However, the circle of least confusion represents the position of best focus.

Astigmatism results from the failure of the rays in the ADE plane (Fig. 11-8) to converge at the same point as the rays in the ABF plane. The effect of astigmatism is usually minimized in lenses by separating the elements slightly. Also, it can be reduced by the proper location of light stops in the optical system.

The astigmatism of a lens is not the same as the astigmatism of the human eye. This defect of the eye results from the nonsphericity of the eye lens and is usually corrected by means of a cylindrical

component in spectacle lenses. However, the image formed by an astigmatic eye is similar to the off-axis image formed by a simple lens as shown in Fig. 11-8.

Curvature of field

We would expect the image of a plane object to be curved if it is formed by a simple lens. In Fig. 11-9, the tip, A, of the arrow

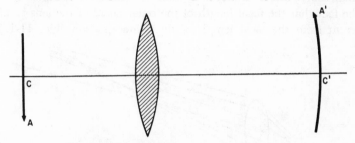

Fig. 11-9. Curvature of the image of a plane object.

is farther from the lens than is the center C. From the lens equation we know that the farther the object is from the lens, the closer the image is to the lens. Thus in the image space A' is closer than C' to the lens. In reality, curvature of field and astigmatism represent two manifestations of the same off-axis phenomenon. One of the best methods of illustrating the principles of astigmatism and curvature of field is to consider the image of a spoked wheel. An uncorrected lens forms the image of the rim of the wheel at the primary image surface P (Fig. 11-10), while the spokes are imaged

Fig. 11-10. Images of a wheel formed by a simple lens. Astigmatism and curvature of field cause the spokes and rim to be imaged at different places.

at the secondary surface S. The surface shown by F represents the best focus for the whole wheel.

Curvature of field and astigmatism are corrected in lenses by essentially the same methods. The resulting corrected lens is known as an anastigmatic lens or simply as an anastigmat.

Coma

Coma is an off-axis aberration which smears the image of a small source into a "comet-like" image. This aberration arises from the fact that the focal length of the outer zones of the lens is different from the focal length of the center portion (Fig. 11-11).

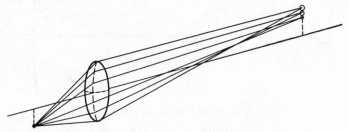

Fig. 11-11. Comatic image formed by a simple lens.

Since the magnification depends on the focal length, an off-axis object is not faithfully reproduced because of this variation in focal length of different parts of the lens. Even though the lens is corrected for spherical aberration, coma may still exist. However, the method of correcting for coma is similar to that for spherical aberration. Two elements are chosen so that the comatic aberration of one counterbalances that of the other and the lateral magnification of the combination is nearly constant for the various zones of the lens.

Distortion

In the previous aberrations, we have been concerned mainly with the degradation of the image of a small source. Distortion is the measure of the ability of a lens to produce an image geometrically similar to a plane object. The most convenient method for illustrating distortion consists of considering an object made of a plane rectangular grid. Two types of distortion are recognized and illustrated in Fig. 11-12. The variation in magnification with distance from the lens axis causes both barrel and pincushion distortion. Barrel distortion results when magnification decreases

with distance from the axis, while pincushion distortion results from increasing magnification.

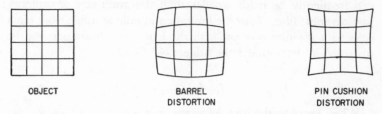

OBJECT BARREL PIN CUSHION
 DISTORTION DISTORTION

Fig. 11-12. Barrel and pincushion distortion.

Two methods are in common use for correcting distortion. The first is the proper positioning of light stops, and this method is used extensively for both simple and compound lenses. The second method consists of the use of symmetrical lens elements as shown in Fig. 11-13. The element L_1 used alone with the light stop would

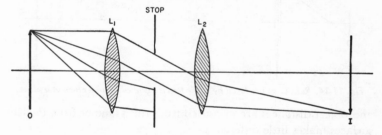

Fig. 11-13. Position of light stop to reduce distortion.

produce pincushion distortion, while L_2 and the stop would give barrel distortion. However, the symmetrical combination gives a distortionless image. A combination similar to that of Fig. 11-13 is known as a rectilinear lens.

Lens Design

The design and production of a good lens is one of the most exacting and painstaking processes known. The design requires balancing the aberrations to give a satisfactory lens made of a reasonable number of elements. Manufacture of a lens consists of producing the proper surfaces correct to within a quarter of the

wavelength of light (less than five one-millionths of an inch). In spite of the difficulties, the diameter of the image of a point source can frequently be made smaller than the grain size of ordinary photographic film. Thus the limitation in photographic work often rests with the film and not with the lens. This limitation will be discussed in detail under the subject of "Resolution."

Thick Lenses

When locating the image formed by a single thin lens, we can assume that the refraction of the rays takes place in one plane. This plane is perpendicular to the lens axis and passes through the center of the lens as illustrated in Fig. 11-14. Whether the image

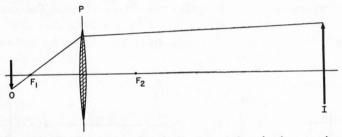

Fig. 11-14. Refraction produced by a thin lens is assumed to take place at a plane.

and object distances are measured from this plane or from the lens surfaces makes little difference.

When several elements are fitted together to form a camera lens, the thickness of the lens can be important. The lens thickness is also important for a single lens when the radii of curvature of the lens surfaces are comparable in length to the lens diameter. Both of these cases can be treated together and the analysis applies equally well to a "fat" lens and to a combination of several thin

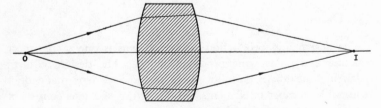

Fig. 11-15. Refraction of rays by a thick lens.

lenses. We will limit our discussion to situations applicable to photography.

Consider a thick lens as shown in Fig. 11-15. The first surface of the lens refracts the incident rays from point O. The rays travel in straight lines through the lens and are further refracted at the second surface. In place of one plane for the thin lens, we need two planes to describe the paths of rays through a thick lens. These planes are known as the principal planes of the lens, and they are determined in the following manner: Consider the thick lens in Fig. 11-16 with the focal points F_1 and F_2 on each side of it. Rays

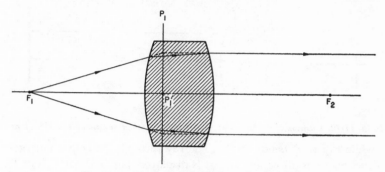

Fig. 11-16. The first principal plane of a thick lens.

which pass through F_1 emerge from the lens parallel to the optical axis. If we project the incident ray ahead into the lens, and project the emergent ray back, the two rays meet at some point P_1. The collection of all such points as P_1, formed by the rays passing through F_1, forms the first principal plane of the lens. The inter-

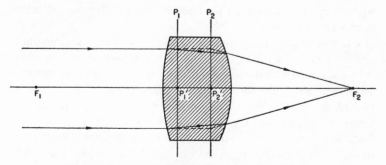

Fig. 11-17. First and second principal planes of a thick lens.

section P_1' of this plane with the optical axis of the lens is the first principal point of the lens.

The second principal plane is defined in a similar manner for rays passing through F_2, that is, for rays parallel to the optical axis in the object space. Figure 11-17 shows this plane as P_2 and the second principal point as P_2'. The focal length of the lens is equal to the distance $P_2'F_2$ which is also equal to F_1P_1'.

For purposes of locating the image graphically, we use the principal planes in accordance with their definition. Thus, in Fig. 11-18, the ray IF_1I' acts as if all the refraction took place at P_1,

Fig. 11-18. Location of the image by the graphical method as applied to a thick lens.

while ray IF_2I' bends at P_2. The ray through the center emerges unchanged in direction, but it is displaced longitudinally from P_1' to P_2'.

The lens formula holds for thick lenses as well as for thin lenses. However, the object distance p is defined as the distance from the object to the first principal plane, and the image distance q is the distance from P_2' to the image. Thus the sum of p and q is not equal to the separation between the object and image since the distance between the principal planes accounts for part of this separation. For a simple thin lens, we assume that the principal planes are coincident.

We can locate the principal planes of a lens experimentally, provided we know the focal length. The first procedure is to locate the focal points with the aid of a distant source. Then we measure a distance equal to the focal length of the lens from each focal point toward the lens. This procedure locates the principal points and therefore the principal planes as well. For some types of lenses, the first and second principal planes are reversed from the normal order shown in Fig. 11-18. Thus the distance between the focal points can be less than twice the focal length.

A question which frequently arises concerns the distance scale marked on a camera equipped with a focusing adjustment. If, for example, the scale indicates the object should be 3 feet away for good focus, to what point on the camera should this 3-foot distance be measured? From the discussion above, we find that the 3 feet refers to the distance from the object to the first principal plane of the lens. However, some cameras contain scales which indicate a distance from the object to some special mark on the camera. To these, the above discussion does not apply.

Compound lenses

Equation (11–2) holds for lens elements close enough together so that they are essentially in contact. For lenses made of elements separated by a substantial amount, we require a different technique. Consider two positive thin lenses, as shown in Fig. 11-19, with focal

Fig. 11-19. *Object and image distances for a compound lens.*

lengths f_1 and f_2, respectively, and separated a distance d from each other. The method used for computing the image position requires us to treat one lens at a time. The first lens forms an image, I_1, at a distance q_1. Then

$$q_1 = \frac{p_1 f_1}{p_1 - f_1}. \qquad (11\text{–}5a)$$

We use this image for the object of the second lens. The object distance for the second lens becomes

$$p_2 = d - q_1. \qquad (11\text{–}5b)$$

From this result we find q_2 since

$$q_2 = \frac{p_2 f_2}{p_2 - f_2}. \qquad (11\text{–}5c)$$

This method, using the image from one lens as the object for the next lens, can be extended to several lenses, and is equally valid for negative as well as positive lenses. The algebraic sign conventions explained in Chapter Three must be used.

The above technique gives us no insight concerning the focal lengths and principal planes of lens combinations. To determine these values, we will consider the case of two thin lenses as in Fig. 11-20. Let a ray parallel to the lens axis and distance x from

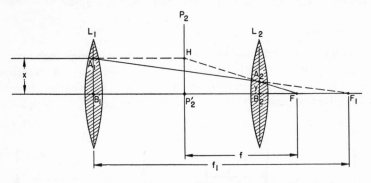

Fig. 11-20. Determination of the principal planes and focal length of a compound lens.

it be incident on the lens element L_1. This element refracts the ray which emerges toward the focal point of L_1. The ray is incident on L_2 at a distance y from the axis. The second lens further refracts ray toward the point F which is the focal point of the lens combination. The extension of the incident ray forward, and the emergent ray backward, forms an intersection which locates the second principal plane P_2. The focal length of the combination is the distance along the lens axis from P'_2 to F. In Fig. 11-20, we see that triangles A_2B_2F and HP'_2F are similar. Thus

$$\frac{y}{x} = \frac{q_2}{f}, \tag{11-6a}$$

where q_2 is the image distance for the second lens and f is the focal length of the lens combination. Also, we have

$$\frac{y}{x} = \frac{f_1 - d}{f_1} \tag{11-6b}$$

from the similar triangles $A_1B_1F_1$ and $A_2B_2F_1$. Thus

$$q_2 = \frac{(f_1 - d)f}{f_1}. \qquad (11\text{–}6c)$$

From Eqs. (11–5b) and (11–5c) we find

$$q_2 = \frac{p_2 f_2}{p_2 - f_2} = \frac{(d - q_1)f_2}{d - q_1 - f_2}. \qquad (11\text{–}6d)$$

However, in the present case, the object is at infinity, so that $q_1 = f_1$, and Eq. (11–6d) becomes

$$q_2 = \frac{(d - f_1)f_2}{d - f_1 - f_2}.$$

Substituting this value into Eq. (11–6c) gives

$$\frac{(d - f_1)f_2}{f(d - f_1 - f_2)} = \frac{f_1 - d}{f_1}$$

which simplifies to

$$\frac{1}{f} = \frac{1}{f_1} + \frac{1}{f_2} - \frac{d}{f_1 f_2}. \qquad (11\text{–}6e)$$

Again, this result is valid for both positive and negative lenses. Notice that when d is small, we can ignore the last term and have the equation for lenses in contact (Eq. 11–2).

The second principal plane is located to the left of L_2 a distance of $f - q_2$. Although Eq. (11–6e) is valid for any separation distance, its interpretation is somewhat difficult whenever d is larger than either f_1 or f_2. Its application in the usual manner to find the equivalent focal length should be restricted to the cases where d is

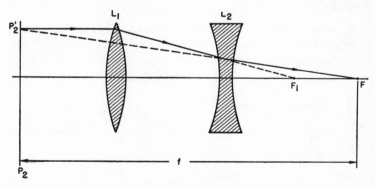

Fig. 11-21. Arrangement of a simple telephoto lens.

smaller than either f_1 or f_2. For large separation, we usually consider one component at a time as previously discussed.

The normal telephoto lens consists of two components, each of which may contain two or three elements. The first component is a positive lens and the second a negative lens as shown in Fig. 11-21. The methods of the previous section can be applied to this combination to find the equivalent focal length and principal planes. The principal planes lie outside the lens system, and a telephoto lens gives a long focal length without excessive distance between the lens and the film.

Equation (11–6e) shows that the focal length can be changed by changing the separation between the components. This principal allows construction of "zoom" type lenses familiar on television and some types of photographic cameras.

Photographic Objectives

We generally use a camera lens for photographing objects at a distance which is large compared with the focal length. As a result, lens designers correct the aberrations for objects at infinity. However, certain lens types, such as enlarger lenses, portrait lenses, and copying lenses, may be corrected for relatively small object distances. The number of lens components separated by a substantial air space determines the class of a photographic objective. So many different lens designs exist that we will limit our discussion to the general classifications.

Singlets

Under this class comes the large variety of objectives for box and other inexpensive cameras. A concavo-convex lens, usually referred to as a meniscus lens, forms the bulk of these photographic objectives. A singlet lens by itself gives considerable curvature of field,

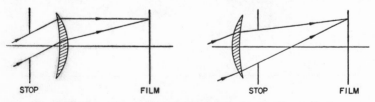

STOP FILM STOP FILM

Fig. 11-22. Common arrangements of a light stop used with a singlet lens.

but a properly designed light stop placed either in front or back of the lens reduces this distortion. Figure 11-22 shows two methods of orienting the lens-stop combination. Apertures wider than $f/11$ are not found with the simple meniscus lens. Furthermore, the edge of the field of view suffers seriously from astigmatism, but the center of the negative is sometimes sharper than that from a more highly corrected lens.

Two-component lenses

Lenses made of two components are called both doublets and duplets. However, the term doublet is frequently limited for application to a two-element telescope objective.

In order to reduce distortion, the two components are frequently arranged in symmetrical form. A typical example of the symmetrical two-component lens is the rectilinear lens discussed earlier in connection with distortion. A rapid rectilinear lens consists of two symmetrical components each of which is achromatic. This arrangement provides apertures of about $f/8$.

An example of the unsymmetrical two-component lens is the Zeiss Protar shown in Fig. 11-23.

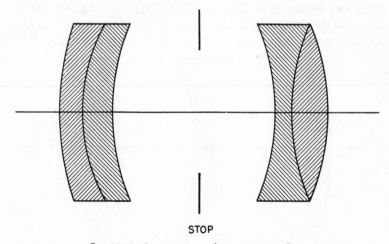

STOP

Fig. 11-23. An unsymmetrical two-component lens.

Wide-angle lenses frequently contain two components. The Goerz Hypergon is an extreme example of this type (Fig. 11-24),

and it gives an undistorted field of view of 130°. The aperture, however, is limited to about $f/40$.

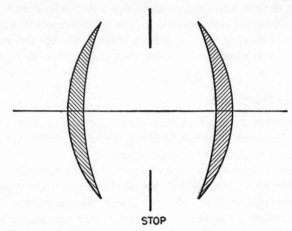

STOP

Fig. 11-24. A wide-angle lens consisting of two components.

Triplets

There are two well-known examples of triplet lenses. The first of these was developed in 1893 by H. D. Taylor in England and is known as the Cooke triplet. Its cross section is illustrated in Fig. 11-25. The negative element, which forms the middle component, is

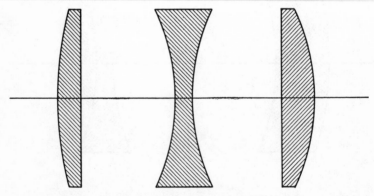

Fig. 11-25. A Cooke triplet lens.

equal in power to the sum of positive components. This arrangement eliminates astigmatism and curvature of field. An ingenious

combination of radii of curvature of the lens surfaces and the dispersion of the negative component almost completely eliminates spherical aberration, coma, and chromatic aberration.

The Tessar series of lenses represents a modification of the Cooke triplet. Originally introduced by Zeiss, this lens design forms the

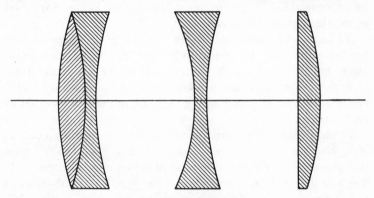

Fig. 11-26. Tessar lens design.

basis for most good $f/4.5$ and faster lenses. Figure 11-26 shows a four-element Tessar lens of Zeiss design.

Resolution

The resolution of a photographic system determines the limit of proximity of two point sources which can still be recognized as two separate images. We must consider not only the optical capabilities of the system but also the characteristics of the film.

Rayleigh limit of resolution

The finite wavelength of light determines the ultimate resolution of a photographic or optical system. Since light propagates with a wave motion, it has all of the usual properties of waves. Two of these important properties are known as interference and diffraction. Interference occurs when two waves travel through the same medium at the same time. The two important cases of interference are (1) constructive interference, when the waves add crest to crest to produce larger waves, and (2) destructive interference, when two waves add crest to trough and cancel each other. Light waves have

these properties. We can add two light waves and produce greater intensity, or we can add them destructively and produce darkness. Ordinary light is such a heterogeneous mixture of wavelengths and relative phases that usually interference is not important, and the observation of interference results from a controlled laboratory experiment. However, interference is important in cameras as well as in other optical instruments.

Diffraction of light results from the ability of waves to bend around obstacles. We generally assume that the shadow of an object has sharp edges if the illuminating source is a point. However, this is not true since all waves bend around obstacles. Ordinarily, such a small percentage of light fills in the shadows that we do not notice it.

Consider now a monochromatic point source imaged by a camera lens. Neglecting the lens aberrations, we would expect the image to be a point. However, the diffraction of light around the edge of the lens and the resulting interference of the light rays produce a disk in the image plane. This image appears as shown in Fig. 11-27

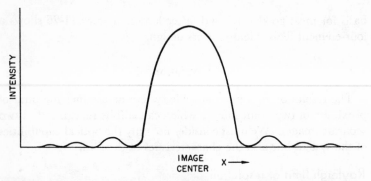

Fig. 11-27. Intensity of the image of a point source as a function of the distance along the focal plane.

where intensity is plotted as the ordinate, and distance along the focal plane is plotted as the abscissa. Thus, the image, instead of being a point, spreads out into a central disk surrounded by concentric rings. The central disk, however, contains most of the light energy.

The central peak in Fig. 11-27 represents light which arrives in phase, that is, crest to crest. On each side of this maximum is a

minimum, which represents light arriving trough to crest under conditions of destructive interference. Figure 11-28 shows the lens

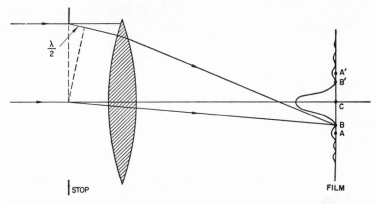

Fig. 11-28. Intensity of the diffraction pattern of the image of a point source.

opening with rays of light incident on it. The first minimum of the diffraction pattern of Fig. 11-27 forms at a position where the ray through the center of the lens and the rays diffracted by the edge of the lens meet with destructive interference. This occurs at point B in Fig. 11-28, where the optical path lengths are one-half wavelength different. The next maximum, point A, occurs when the difference in path length is one full wavelength and the two rays meet crest to crest again. In general, the maxima result from path differences of an integral number of wavelengths, while the minima occur at odd multiples of half-wavelength path differences.

More advanced optical theory shows that the distance from the central maximum to the first minimum is found by

$$\frac{r}{f} = \frac{1.22\lambda}{d} \tag{11-7}$$

where r is the required radius of the central disk, f is the focal length, λ is the wavelength of light, and d is the diameter of the circular opening. In terms of the focal ratio,

$$r = 1.22\lambda(f/\#). \tag{11-8}$$

Lord Rayleigh first established the resolution of a lens on the basis of the diffraction pattern. He concluded that an optical system can just resolve two equally bright point sources when the central maxi-

mum of one image coincides with the first minimum of the other. This limit is known as the Rayleigh criterion of resolution.

If we take the effective wavelength for photographic emulsions as 4100 Angstroms (0.41×10^{-3}mm), Eq. (11-8) becomes

$$r = \frac{(f/\#)}{2000} \quad \text{millimeters.} \tag{11-9}$$

Frequently we desire the angular resolution in radians or degrees. Equation (11-7) gives this value in radians, which, for the effective wavelength just considered, is

$$\rho = \frac{0.5 \times 10^{-3}}{d} \quad \text{radian}$$

$$= \frac{0.03}{d} \quad \text{degree,} \tag{11-10}$$

where ρ is the angular resolution in both image and object space, and d is the aperture of the lens in millimeters.

Equation (11-9) is often inverted, and the resolution given in terms of a series of parallel lines. Thus

$$R = \frac{2000}{(f/\#)} \quad \text{lines per millimeter.} \tag{11-11}$$

We see, for example, that an $f/10$ lens is capable of resolving 200 lines per millimeter in the absence of aberrations.

Resolution limit due to aberrations

Lens designers balance aberrations in order to give as good image quality as possible with a reasonable number of lens elements. In most good camera lenses, the diameter of the circle of confusion is from $\frac{1}{1000}$ to $\frac{1}{2000}$ of the focal length. This diameter is usually considered to be the limit of resolution due to the lens aberrations.

For a miniature camera lens of focal length 50 mm, the image of a point source is spread into a disk whose diameter is about 0.025 mm. The resolution of such a lens is then 40 lines per millimeter. We notice that this resolution is not so good as that based on the Rayleigh criterion until we approach a high f number. In general, the circle of confusion is larger than the diffraction disk, and the lens aberrations limit the resolution obtained.

Film resolution

The resolution of a film is limited by the grain size and by the scattering of light within the film. Measurement of film resolution shows that it is also dependent on the contrast of the subject. Thus any actual values quoted for film resolution must specify not only the type of film and development used, but also the kind of test chart used. Manufacturers generally give the film resolution for a 30:1 object intensity contrast, and optimum development for best resolution. Typical values of film resolution for ASA film ratings are shown in Table 11-2.

TABLE 11-2

Film speed (ASA)	Resolution (lines per mm)
25	60
50	50
100	45
200	40
Microfile	180

We conclude that the resolving power of a camera is about equally degraded by the lens and the film. This statement represents "average" conditions and must be applied with care.

The usual rule of thumb formula for determining the resolving power of a lens-film combination comes from adding the diameters of the smallest images each can produce. For example, if the circle of confusion is 0.02 mm, and the grain size is 0.04 mm, the image of a point source is about 0.06 mm. Thus the resolution is 16 lines per millimeter. This rule is frequently expressed by a reciprocal formula as follows.

$$\frac{1}{\text{resolving power}} = \frac{1}{\text{lens resolving power}} + \frac{1}{\text{film resolving power}},$$

where the resolving powers are in lines per millimeter. Actually, the resolving power due to the diffraction pattern should also be included in this formula, but it is usually so small that it is neglected. The above relation is only an approximate formula and should be used with caution.

Depth of Field

The depth of field is the distance between two critical points in the object space. These two points lie on the optical axis of the lens

and represent the nearest and farthest points between which every-
thing is in satisfactory focus.

Consider a camera focused on an object O as shown in Fig. 11-29.
There exist two points O_1 and O_2, located to either side of O, such

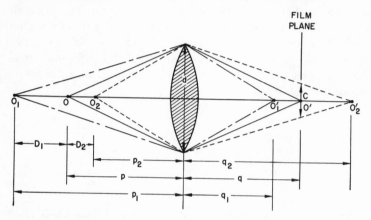

Fig. 11-29. Diagram illustrating the depth of field.

that their images on the film consist of a disk of diameter c. The
diameter of this disk, or circle of confusion, determines the criterion
for "satisfactory focus."

Let p and q be the object and image distances, respectively, for O;
and p_1, q_1 and p_2, q_2 be the respective corresponding values for O_1
and O_2 as shown in Fig. 11-29. From the similarity of triangles in
the image space, we see that

$$\frac{c}{d} = \frac{q - q_1}{q} = \frac{q_2 - q}{q_2}, \tag{11-12}$$

where d is the diameter of the lens aperture. The lens formula gives

$$q = \frac{pf}{p - f}, \tag{11-13}$$

which applies also to q_1 and q_2 provided we put corresponding
subscripts on the p's. Substitution of Eq. (11-13) into Eq. (11-12) to
eliminate the q's gives, after some simplification,

$$\frac{c}{d} = \frac{p_1 f - pf}{p_1 p - p_1 f} = \frac{pf - p_2 f}{p_2 p - p_2 f}.$$

Solving these equations for p_1 and p_2 gives

$$p_1 = \frac{pdf}{df - c(p - f)},$$ (11–15a)

and

$$p_2 = \frac{pdf}{df + c(p - f)}.$$ (11–15b)

By definition, $p_1 - p = D_1$ is the *far depth*, while $p - p_2 = D_2$ is the *near depth*. Also, $p_1 - p_2 = D$, which is the total depth of field. From Eqs. (11–15) we find:

$$\text{far depth } D_1 = p_1 - p = \frac{cp(p - f)}{df - c(p - f)}$$ (11–16a)

$$\text{near depth } D_2 = p - p_2 = \frac{cp(p - f)}{df + c(p - f)}$$ (11–16b)

$$\text{total depth } D = D_1 + D_2 = \frac{2pdfc(p - f)}{d^2f^2 - c^2(p - f)^2}.$$ (11–16c)

The three equations (11–16) give the depth of field in terms of the object distance p, the lens aperture diameter d, the focal length f, and the diameter c, of the allowable circle of confusion.

The depth of field equation can have many forms simply by making use of substitutions from various formulas. For example, the magnification is defined by

$$M = \frac{q}{p} = \frac{f}{p - f}.$$

Equation (11–16c) becomes, in terms of the magnification

$$D = \frac{2p}{dM/c - c/dM}.$$ (11–17)

The form of Eq. (11–7) is interesting since the denominator represents the difference of two terms, one of which is the reciprocal of the other.

Another useful form of the depth of field equation is found by assuming a "relative circle of confusion" in terms of the focal length. Generally, this value is taken as $c = f/1000$ for satisfactory definition. Furthermore, we can use the relation between focal length and $f/\#$ to eliminate the aperture d. Thus

$$d = \frac{f}{(f/\#)}.$$

TABLE 11-3

Depth of Field Tables for Lenses of 2-inch and 6-inch Focal Lengths

$f = 2$ inches Circle of confusion = 0.002 inch

Object distance (feet)	f/4 D_1	D_2	D	f/5.6 D_1	D_2	D	f/8 D_1	D_2	D	f/11 D_1	D_2	D	f/16 D_1	D_2	D
50	∞	27	∞	∞	31	∞	∞	35	∞	∞	38	∞	∞	41	∞
25	38	9.3	47	137	11	148	∞	13	∞	∞	16	∞	∞	18	∞
15	8	4	12	17	5	22	40	6.8	46.8	∞	7.5	∞	∞	9	∞
10	3	1.9	4.9	5	2.5	7.5	8.7	3.2	12	18	3.8	22	∞	5.2	∞
5	0.6	0.5	1.1	0.83	0.66	1.5	1.3	0.83	2.2	1.5	1.1	2.6	3.0	1.5	4.5
3	0.18	0.17	0.35	0.33	0.25	0.58	0.40	0.33	0.73	0.6	0.4	1.0	0.9	0.6	1.5
2	0.08	0.08	0.16	0.10	0.10	0.20	0.14	0.13	0.27	0.21	0.18	0.4	0.33	0.30	0.63

$f = 6$ inches Circle of confusion = 0.006 inch

Object distance (feet)	f/4 D_1	D_2	D	f/5.6 D_1	D_2	D	f/8 D_1	D_2	D	f/11 D_1	D_2	D	f/16 D_1	D_2	D
50	33	14	47	62	18	80	194	22	216	∞	26	∞	∞	31	∞
25	6	4	10	9	5.4	15	16	7	23	29	9	38	93	11	104
15	2	1.6	3.6	3	2.1	5	4.6	2.8	7.4	7.1	3.6	11	13	4.8	18
10	0.82	0.71	1.5	1.2	0.96	2.2	1.8	1.3	3.1	2.7	1.7	4.4	4.4	2.3	6.7
5	0.19	0.17	0.36	0.27	0.24	0.51	0.4	0.34	0.74	0.55	0.45	1.0	0.85	0.63	1.5
3	0.06	0.06	0.12	0.09	0.08	0.17	0.13	0.12	0.25	0.18	0.16	0.34	0.26	0.22	0.48
2	0.02	0.02	0.04	0.03	0.03	0.06	0.05	0.05	0.10	0.07	0.06	0.13	0.10	0.09	0.19

D_1 refers to the far depth, D_2 to the near depth, and D represents the total depth of field.

From these two substitutions, Eq. (11–16c) becomes

$$D = \frac{2000pf(p-f)(f/\#)}{1000^2 f^2 - (p-f)^2 (f/\#)^2}. \qquad (11\text{–}18)$$

Equations (11–16), (11–17), and (11–18) are all forms of the fundamental depth of field equation. They have been derived under the assumption of a perfect lens, that is, a lens with no aberrations. As a result, these equations express the ideal situation and the allowable circle of confusion is not the same as the actual circle of confusion due to the lens aberrations.

Lens manufacturers frequently publish depth of field tables which apply to particular lenses. Lens mounts and focusing adjustments often contain depth of field scales which aid the photographer to estimate the nearest and farthest points in satisfactory focus. If all lenses were equally good, depth of field tables would be identical for all lenses of a given focal length. However, since lenses differ, we find depth of field tables differ also. In general, a large depth of field indicates a poor lens since the assumed circle of confusion is

Fig. 11-30. Photograph showing extreme depth of field. ($\frac{1}{10}$ sec at f/64)

large. A short focal length lens has a larger depth of field than a long focal length lens when both are used at the same relative aperture.

Table 11-3 gives the depth of field for two lenses of focal lengths 2 inches and 6 inches. Notice how the depth of field increases with (1) shorter focal length, (2) larger object distance, (3) higher f number.

Hyperfocal distance

The depth of field concept allows us to focus a camera on some object distance p_h, such that all objects beyond p_h are also in satisfactory focus. This object distance is known as the hyperfocal distance. To find the hyperfocal distance, we return to Eq. (11–15a):

$$p_1 = \frac{pdf}{df - c(p - f)}. \tag{11-15a}$$

When p_1 is infinitely large, p is the required hyperfocal distance. For p_1 to be infinity, the denominator of the right-hand side of the equation must equal zero. Thus

$$df = c(p_h - f).$$

For this particular object distance, p_h is large enough compared with f that we can assume $(p_h - f) = p_h$. From this simplification we find

$$p_h = \frac{fd}{c} \tag{11-19}$$

where p_h is the hyperfocal distance, f is the focal length, d is the lens diameter, and c is the allowable circle of confusion.

When the camera is focused at p_h, some objects between the camera and p_h are also in satisfactory focus. To find the nearest distance of satisfactory focus, we use Eq. (11–15b) and let $p = p_h$, the value of which is shown in Eq. (11–19). Then

$$p_2 = \frac{(fd/c)df}{df + (fd/c)c}$$

provided we again assume that $(p_h - f)$ is approximately equal to p_h. The above relation reduces to

$$p_2 = \tfrac{1}{2}p_h, \tag{11-20}$$

which shows that the nearest distance of satisfactory focus is just half the hyperfocal distance. Table 11-4 gives the hyperfocal distance for the same two lenses of Table 11-3. Notice how this quantity decreases with shorter focal length and higher f numbers.

TABLE 11-4

Hyperfocal Distance (in feet) for Lenses of 2-inch and 6-inch Focal Lengths

	$f/4$	$f/5.6$	$f/8$	$f/11$	$f/16$
$f = 2$ in.	42	30	21	15	10
$f = 6$ in.	125	90	63	45	31

Depth of Focus

Depth of focus refers to the allowable tolerance in the image distance for satisfactory results when the lens is focused on some specific object. Figure 11-31 illustrates the situation. Distance D

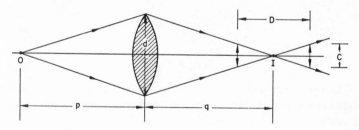

Fig. 11-31. Diagram illustrating depth of focus.

represents the depth of focus for the circle of confusion of diameter c. We see that the near depth and far depth are equal in this case so that

$$\frac{c}{\frac{1}{2}D} = \frac{d}{q},$$

where d and q are the lens diameter and image distance, respectively. Thus

$$D = \frac{2qc}{d} \tag{11-21}$$

For large object distances, q is about equal to f and Eq. (11–21) simplifies to

$$D = \frac{2fc}{d} = 2c(f/\#) \tag{11-22}$$

As an example of the application of Eq. (11–22), consider a miniature camera with a two-inch focal length lens operated at $f/4$. If the circle of confusion is $\frac{1}{1000}$ of the focal length, we have

$$D = \frac{4 \times 2 \times 2}{1000} = 0.016 \text{ inch.}$$

This means that the film must be positioned to within 0.016 of an inch for satisfactory results.

For small object distances, we return to Eq. (11–21) and substitute the value of q taken from the lens equation, $q = pf/(p - f)$. Then

$$D = \frac{2pfc}{d(p - f)}. \tag{11–23}$$

This equation tells us that the shorter the object distance, the larger is the depth of focus for a given f number. Thus we see that as the depth of field decreases, the depth of focus increases. In the previous example, let the camera be focused at 20 inches. Then

$$D = \frac{2 \times 4 \times 20 \times 2}{18 \times 1000} = 0.018 \text{ inch.}$$

Perspective

When photographing most subjects, we obtain two-dimensional images of three-dimensional objects. The two-dimensional result is known as a perspective view.

Consider a three-dimensional subject, such as the building shown in Fig. 11-32. If our eye is placed at point C, then we see rays of

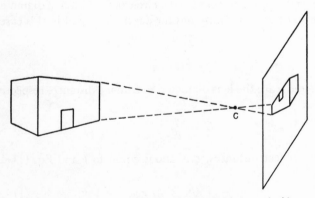

Fig. 11-32. Center of perspective of a scene including a building.

light from the building which pass through C. The point C is known as the center of perspective. If we replace our eye with a camera, the lens of which is at point C as shown, then the camera records the same perspective view that we have seen.

In order to view a picture with the proper perspective, we wish to preserve the angular relationships between the original scene and the picture. As a result, we should view a contact print at a distance equal to the image distance in the camera. This distance is usually about equal to the focal length of the lens. For accurate perspective an enlargement requires a viewing distance equal to the product of the focal length and the enlarging magnification.

The normal position of the human eye is with the lens axis horizontal. As a result, images of vertical patterns, such as building corners, telephone poles, and tree trunks, are essentially parallel. A camera oriented with the film vertical records these vertical patterns correctly also. However, horizontal parallel lines appear to converge as in Fig. 11-33. The convergence of vertical patterns is not a defect since it truly represents what we would see if we looked with

Fig. 11-33. With the film vertical, lines which are vertical remain parallel. Note the convergence of the horizontal lines.

one eye in the same direction as the camera. This convergence is usually more noticeable in a photograph because we make mental allowance for it when actually looking at the scene. See Fig. 11-34.

Fig. 11-34. Convergence of vertical lines is objectionable to some observers and frequently gives the appearance of a building leaning backwards.

Many cameras are equipped with adjustments known as "rising fronts" or "swing backs" to help eliminate convergence. Although the camera looks upward, the film remains vertical and eliminates

the convergence. Horizontal convergence can be removed in a similar manner, although it is usually not so objectional as the vertical. The essential requirement in either case is for the subject and film to be parallel to each other.

The swing-back feature of some cameras can also be used under certain conditions to increase the depth of field, and one of the common uses occurs when we wish to photograph a tall building. The optimum condition for maximum depth of field occurs when the plane of the object, plane of the film, and the plane passing through the lens all meet in a common line. The cross section diagram of this situation appears in Fig. 11-35. Although we obtain

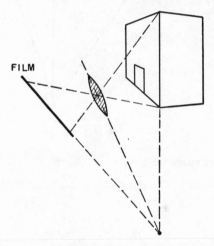

FILM

*Fig. 11-35. Swing-back camera arrangement
for maximum depth of field.*

good depth of field under these conditions, the optical arrangement exaggerates the convergence of the vertical lines. The resulting distortion of perspective can, however, be compensated during enlarging with a similar relative tilt of enlarging easel and negative. Again, for best results, the negative plane, easel plane, and plane through the lens must all pass through a common straight line. Since this condition has frequent applications, the following proof shows its origin.

We begin by assuming a thin lens which forms a plane image of a plane object. Figure 11-36 shows the arrangement of object, lens,

and image with the extension of their respective planes, and the lettering of the various points and distances.

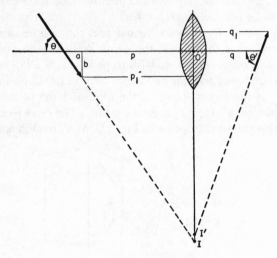

Fig. 11-36.

For the object space we have

$$\tan \theta = \frac{b}{a} = \frac{OI}{p},$$

from which

$$OI = \frac{bp}{a}. \qquad (11\text{--}24)$$

The corresponding relation in the image space is

$$OI' = \frac{b'q}{a'} = \frac{b'(pf)}{a'(p - f)}. \qquad (11\text{--}25)$$

Now $b' = mb$, where m is the lateral magnification from Eq. (3–5). Since $m = q/p = f/(p - f)$ in general, we have

$$b' = \frac{fb}{p_1 - f}.$$

For a' we have

$$a' = q_1 - q = \frac{p_1 f}{(p_1 - f)} - \frac{pf}{(p - f)} = \frac{af^2}{(p_1 - f)(p - f)}$$

since $a = (p_1 - p)$. Substituting these values of a' and b' into Eq. (11–25), we find

$$OI' = \frac{fb/(p_1 - f) \times pf(p - f)}{af^2/[(p_1 - f)(p - f)]} \qquad (11\text{–}26)$$

$$= \frac{bp}{a},$$

which is the same as the value for OI in Eq. (11–24). Thus $OI = OI'$ and the three planes intersect in a common line.

When we correct for convergence of parallel lines in the enlarging process, the optical arrangement in the enlarger should be similar to that of the camera when the picture was taken. For example, a camera without a swing back always maintains the film perpendicular to the lens axis. Resulting convergence should be corrected by tilting the easel, but not the negative. Tilting both the easel and negative results in elongating or shortening the image with respect to its lateral dimensions.

Field of View

The usual camera lens forms an image whose sharpness depends on the distance from the lens axis. The maximum distance from the lens axis where the image still shows satisfactory definition determines the field of view of the lens. In practice, the greatest distance from the lens axis occurs at the corners of the film, and the lens must produce a satisfactory image over a circle whose diameter is equal to the diagonal length of the film. For most camera lenses this

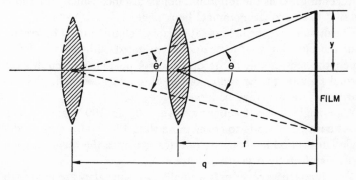

Fig. 11-37. Variation of required angular coverage with image distance.

diagonal length is about equal to the focal length of the lens. In angular units the coverage of the lens is

$$\tan (\tfrac{1}{2}\theta) = \tfrac{1}{2}.$$

Thus the half angle is about 26.5°, or the total angle of satisfactory definition is 53°.

For a given negative size, the angular field of view varies depending on the image distance. Figure 11-37 shows the result when the lens is focused on a near object. Notice that

$$\tan (\tfrac{1}{2}\theta) = q/y, \qquad\qquad (11\text{--}27)$$

where q is the image distance and y is half the film diagonal length.

The problem of determining the correct field of view frequently arises during copying or enlarging. The easiest method of solution is to solve it in terms of the magnification. For example, consider a book page of size 8 by 5 inches which we wish to copy onto a $3\tfrac{1}{4}$ by $4\tfrac{1}{4}$ film. We notice that the required magnification in the short dimension is 0.65 times, while the long dimension requires 0.54. This result shows that the book and negative are not of the same proportion so that we must waste part of the negative width by allowing a maximum magnification of 0.54. If we assume a six-inch focal length lens,

$$m = \frac{q}{p} = \frac{f}{p - f} = 0.54,$$

from which the object distance is

$$p = 17.1 \text{ in.}$$

This result gives us the minimum object distance which still allows the film to record the complete book page.

The diameter of the field of satisfactory definition must be greater than the film diagonal for cameras equipped with a rising front. When the lens is raised, its optical axis no longer occupies the normal position at the center of the film, and good definition requires that the coverage be larger.

Wide-angle lenses frequently cover 90° to 100°, and special lenses have been made to cover more than 180°. However, wide-angle lenses produce noticeable distortion since the magnification varies significantly over the picture.

Telephoto lenses cover only a small angle since they are used with film sizes considerably smaller than the focal lengths. Moving

picture cameras are equipped with lenses which generally cover only 28° to 30°. As a result, these lenses are less expensive than still-camera lenses of comparable focal length and f number.

Stereoscopic Photography

An ordinary photograph reproduces a perspective view as seen by one eye. The normal use of both eyes gives us depth perception which we do not observe in a picture. Our depth perception arises from the fact that each eye sees a slightly different image, and we fuse the two images in our brains to give us a single 3-dimensional image. Stereoscopic photography is a method used to simulate normal binocular vision and the result appears to give three dimensions to a pair of two-dimensional photographs.

The average separation between the human eyes is about $2\frac{1}{2}$ inches. Therefore one eye sees a perspective view in which the center of perspective is displaced $2\frac{1}{2}$ inches from the center of perspective of the other eye. The requirement for stereoscopic pictures, or stereograms, is the production of two pictures of the same subject material with the centers of perspective displaced $2\frac{1}{2}$ inches. Three convenient methods are available for making stereograms. The first and simplest method can be done with any camera. The auxiliary equipment consists of a rack which clamps the camera and allows it to shift the required $2\frac{1}{2}$ inches. First, one picture is taken, the camera is displaced $2\frac{1}{2}$ inches, and then the second picture is taken. Obviously, this system is not applicable to moving objects, but it performs well for still subjects.

The second method for making stereograms consists of using two separate cameras with their lens axes parallel and about $2\frac{1}{2}$ inches apart. Two photographs are taken simultaneously, and the resulting pair forms a stereogram. Early stereo cameras of this type used a long glass plate for the negative material and produced the two pictures on one plate. A modern version of the twin camera arrangement is the Stereo Realist, which uses 35 mm film and takes either color or black and white pictures.

The third stereoscopic camera device consists of a mirror arrangement mounted in front of an ordinary camera as illustrated in Fig. 11-38. Light from the subject material enters at both openings A and B. Mirrors, as shown, reflect the light into the camera lens,

and two images are formed in place of the usual one image. Examples of this system are the Stereoly for Leica cameras, and the Stero-Tach for other cameras.

Fig. 11-38. Arrangement for producing stereograms with an ordinary camera.

The device for viewing a stereogram pair is known as a stereoscope. The necessary requirement for a good stereoscope is that

Fig. 11-39. A simple twin-lens stereoscope.

each picture of the stereogram be viewed with the correct eye and with the proper perspective. So many ingenious stereoscopes have been devised that we will limit our attention to only a few of the more common ones.

Twin-lens magnifier

The stereoscope with which we are most familiar consists of two simple magnifying lenses, one placed in front of each eye. Figure 11-39 illustrates a simple twin-lens stereoscope. This device is often aided by the addition of mirrors, reflecting prisms, or light sources depending on the size and kind of stereograms. For proper stereoscopic viewing, the focal length of the lenses must be the same as the focal length of the camera lenses used for making the pictures. Some of the high-quality stereoscopes of this type contain adjustments for individually focusing each lens as well as a provision for varying the lens separation.

The line screen

The line-screen method of stereoscopic viewing requires a specially prepared positive. Figure 11-40 shows the principle in-

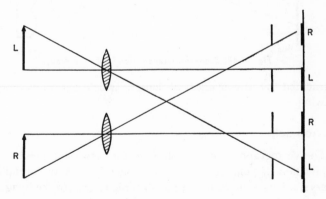

Fig. 11-40. *Principle of the line-screen stereoscope.*

volved. Two stereo negatives are projected through a line screen onto a photographic emulsion. The two images are segmented by the screen, and the image elements of one negative fit in between those of the other. Viewing the composite print requires the use of

the same screen, and the observer's eyes must be situated so that his left eye sees only the left picture and the right eye sees only the right one. The observer's distance from the screen is therefore critical for good results.

Lenticular screen

The lenticular screen method involves the use of a positive film, one side of which is "corrugated" with cylindrical lens elements. Figure 11-41 shows the details of this system. The images are

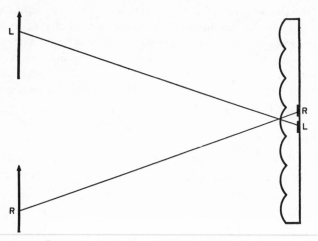

Fig. 11-41. Lenticular screen principle of stereoscopy.

segmented by the cylindrical lenses, which act in reverse for viewing.

Vectographs

The vectograph process of stereoscopic viewing depends on the application of polarized light. (See page 76.) A vectograph appears similar to an ordinary photographic print, but the images are actually made in varying degrees of polarization instead of varying densities. When viewed through a polarizer whose plane of polarization lies parallel to that of the picture, the picture is invisible. However, when the polarizer is rotated 90°, the picture appears. A stereogram pair, polarized at 90° with each other, and mounted on the same sheet, constitutes the vectograph. For view-

ing, the observer wears polarizing glasses, with the angle of polarization of one polarizer set 90° from that of the other. When properly oriented, the left eye sees only the left view, and the right eye sees only the right view. With the vectograph system, several people can simultaneously view the stereographic pair.

Stereoscopic projection

The most common method for viewing projected stereograms consists of another application of polarized light. In this instance, twin projectors form overlapping images of the stereograms on a screen. Each projector contains a polarizer, but the two polarizers have their axes 90° apart, so that the images are polarized 90° apart also. Polarizing viewing glasses eliminate the left image from the right eye, and the right image from the left eye for the 3-dimensional result. This system is easily adaptable to either black and white or color, and to moving pictures as well as slides. Ordinary beaded screens are not satisfactory since they depolarize the reflected light; a special metallic screen is necessary.

Colored anaglyphs

One of the oldest methods for presenting 3-dimensional pictures or drawings is by means of the colored anaglyphs. Anaglyphs usually have one of the stereo pair printed in red and the other in green. Viewing glasses consist of a red filter for one eye and a green filter for the other eye. Thus the green picture is visible through the red filter, but not through the green filter; and the red picture is similarly visible through the green filter. Although this method is easily adaptable to moving pictures, its popularity is diminished because the eyes quickly tire of the red-green confusion.

Stereoscopic distortion

In any stereoscopic system, the image seldom represents a true reproduction of the object. Exact reproduction of size and shape of the original requires a camera with lens separation equal to the interocular separation of the human eyes, and a viewer whose lenses are of the same focal length as the camera lenses. The lack of fidelity of stereoscopic images results from two causes. Whenever the camera lenses have greater separation than the eyes, the 3-dimensional image appears smaller than the original object. This image is

a true miniature representation of the object as long as the viewing device follows the requirements for correct perspective. The second difficulty is caused by lack of proper perspective, which gives a distorted image where the depth dimension is not in the same relative proportion as the lateral dimensions.

Figure 11-42 shows diagrammatic illustrations representing the two causes of unfaithful object representation. Aerial photographs

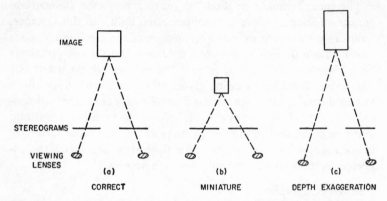

Fig. 11-42. *Types of stereoscope viewing: (a) correct; (b) miniature resulting from incorrect base line; and (c) depth exaggeration resulting from incorrect perspective.*

for surveying or photogrammetry generally show an exaggerated depth dimension. This enhanced depth results not from the long

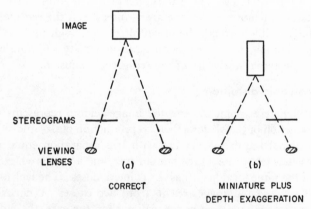

Fig. 11-43. *Combination miniature and depth exaggeration resulting from too long a base line and incorrect viewing perspective.*

base line, which may be several miles, but from the change in perspective produced by the viewing device. The lenses of the viewer are not in the center of the photographs as they should be for correct perspective. This displacement gives rise to the type of distortion shown in Fig. 11-43.

References for Additional Reading

ADVANCED OPTICAL THEORY

Hardy, A. C., and F. H. Perrin, *The Principles of Optics*, McGraw-Hill Book Co., Inc., New York, 1932, Chaps. I-VII.

PHOTOGRAPHIC OBJECTIVES

Greenleaf, A. R., *Photographic Optics*, The Macmillan Co., New York, 1950. In the Appendix is a list of the configurations of most photographic objectives.

DEPTH OF FIELD TABLES

"Lenses," *Kodak Reference Handbook*, Eastman Kodak Co., Rochester, N. Y., 1947.

Lester, H. M., *Photo-Lab-Index*, 10th ed., Morgan and Lester, New York, 1949.

STEREOSCOPIC PHOTOGRAPHY

Greenleaf, A. R., *Photographic Optics*, The Macmillan Co., New York, 1950, Chap. 19.

Norling, J. A., "The Stereoscopic Art—A Reprint," *J. Soc. Motion Picture and Television Engrs.*, vol. 60, 1953, pp. 268-307.

Problems

1. Two thin lenses of focal lengths 15 inches and 10 inches are placed in contact. What is the equivalent focal length of the combination?

2. A thin lens of focal length 20 inches and one of focal length -40 inches are placed in contact. What is the focal length of the combination?

3. A lens of focal length 10 inches and a negative lens of focal length -20 inches are used as a telephoto system. Compute the focal length of the combination when their separation is 6 inches.

4. An object is 12 inches away from a 5-inch focal length lens. A second lens of focal length 10 inches is placed 20 inches away from the first lens and on the opposite side of the lens from the object. Locate the final image formed by the second lens.

5. What is the radius of the diffraction disk formed by an ideal lens of $f/20$?

6. A photographic emulsion can give a resolution of 50 lines per millimeter. What is the f number of an ideal lens which gives an equal resolution as determined by the Rayleigh criterion?

7. A miniature camera lens of two-inch focal length has a circle of confusion of $f/2000$. The film for use with this lens can resolve 45 lines per millimeter. What is the resolution of the lens-film combination?

8. The aberrations of a 10-inch focal length lens limit its resolution to $f/1000$. To what f number must the lens be stopped down before the radius of the diffraction disk is 10% of the aberrational resolution?

9. A 5-inch focal length lens is focused on an object 20 inches away. Compute the total depth of field for the usual $f/1000$ allowable circle of confusion.

10. For better definition, an allowable circle of confusion is sometimes assumed to be $f/1500$. What are the near and far depths of field when using the above criterion? Obtain the results for a 10-inch focal length lens focused on an object 6 feet away.

11. Compute the near and far depths of field for a 20-inch focal length lens when it is copying with unit magnification. (Assume a circle of confusion of $f/1000$.)

12. What is the hyperfocal distance of the lens in Problem 11?

13. Compute the depth of focus for the arrangement described in Problem 11.

14. A 5-inch focal length lens is found to have a depth of focus of 0.001 inch when focused on an object at infinity. Compute (a) the diameter of the allowable circle of confusion; (b) the hyperfocal distance of the lens.

15. A 4 by 5 film has a useful area $3\frac{1}{2}$ by $4\frac{1}{2}$ inches. What is the maximum magnification which can be used for copying a full sheet of $8\frac{1}{2}$ by 13 into paper onto this film?

16. Compute the object to imagine distance for a 4-inch focal length lens under the conditions specified in Problem 15. Is the normal coverage of a 4-inch lens sufficient for this purpose?

COLOR

An understanding of color photography requires not only a knowledge of the basic principles of black and white photography but also a familiarity with colorimetry. Colorimetry is the branch of physics which deals with color matching.

Hue and Purity

Besides the brightness or luminous flux, which we discussed in Chapter Four, two other fundamental quantities appear in the discussion of colorimetry. The first of these quantities is known as *hue*, which refers to the dominant wavelength present in the color. The second quantity describes the amount of white light mixed with the color and the terms *purity* or *saturation* apply to this concept.

An exact definition of hue requires a study of the spectral energy distribution of the particular color sample. For colors generated by monochromatic light, the particular wavelength emitted accurately represents the hue. However, most colors we see are not mono-chromatic, and the color results from selective reflection of the light emitted by a source. The spectral energy distribution of these colors is studied by means of a spectrophotometer. Results of these studies show that two color samples may have the same dominant wavelength but need not have the same hue. For example, Fig. 12-1 shows the reflectance curves of two samples. In both cases the samples appear to be red and the dominant wavelength is 6500 Angstroms. However, the hues of the two samples appear different from each other since their spectral energy distributions are not the

same. The response of the human eye further complicates an attempt to define hue accurately. Two identical color samples do not

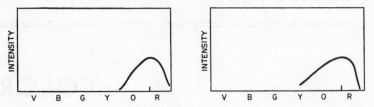

Fig. 12-1. Spectral intensity distribution of two colors with the same dominant wavelength but with slightly different hue.

appear to be of the same hue if they are illuminated by light of different intensities. In general, we say that the hue of a color is the same as the hue of the spectrum color which it matches most closely. Thus, while dominant wavelength and hue are related, they are not identical.

The purity of a color can be defined by

$$p = \frac{C}{W - C}, \tag{12-1}$$

where C is the luminance of the color, W is the luminance of the white light component, and p is the purity. Although Eq. (12-1) seems to express the purity with the necessary accuracy, its interpretation is frequently difficult. For example, various color samples under low illumination exhibit no hue differences. Compare the brilliant colors of a normal landscape under sunlight illumination with the same scene illuminated by the moon. The low-intensity illumination provided by moonlight apparently washes out the colors until we see only varying shades of bluish-gray.

Colorimetry

The science of colorimetry and color photography is based on the following principle: *Any color can be matched by mixing suitable proportions of any three independent colors.* The term "three independent colors" implies that any one of the three cannot be formed by a combination of the other two. The three independent colors are sometimes called *primary colors.* There is no unique set of primary colors, but the three most commonly used for photography are red, green, and blue. In

some cases, color matching requires a negative amount of one or two of the primaries, and the phrase "matched by mixing suitable proportions" must also include negative amounts. Equations for colorimetry take the form

$$X = c_1P_1 + c_2P_2 + c_3P_3, \tag{12-2}$$

where X is the color to be matched, the P's represent the three primary colors, and the c's are the trichromatic coefficients for the particular set of primaries. Notice that the c's may be either positive or negative.

In order that colorimetric measurements all be referred to the same set of standards, the International Commission on Illumination established an idealized set of primary colors. The actual colors of this idealized set do not exist in nature, but the specification for matching spectrum colors in terms of these primaries requires no negative values of their trichromatic coefficients. Figure 12-2 shows

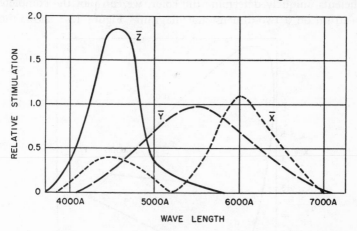

Fig. 12-2. Relative amount of each ICI primary required to match the color of the wavelength indicated.

the relative amount of each primary component required to match a spectrum color at any wavelength. The ordinates are adjusted so that the total area under each curve is the same. Values of $\bar{x}, \bar{y},$ and \bar{z} for any wavelength are known as the *tristimulus values*. For example, green light at 5250 Angstroms shows

$$\bar{x} = 0.1096, \quad \bar{y} = 0.7932, \quad \bar{z} = 0.573.$$

In general, the specification of a color requires the three tristimulus numbers. By setting

$$X = \frac{\bar{x}}{\bar{x} + \bar{y} + \bar{z}}, \quad \Upsilon = \frac{\bar{y}}{\bar{x} + \bar{y} + \bar{z}}, \quad \mathcal{Z} = \frac{\bar{z}}{\bar{x} + \bar{y} + \bar{z}}, \quad (12\text{--}3)$$

we find that $X + \Upsilon + \mathcal{Z} = 1$, and only two numbers are necessary to specify a color. Thus, for the green at 5250 Angstroms,

$$X = \frac{0.1096}{0.9601} = 0.1142$$

$$\Upsilon = \frac{0.7932}{0.9601} = 0.8262$$

$$\mathcal{Z} = \frac{0.0573}{0.9601} = 0.0596$$

The X, Υ, and \mathcal{Z} values are the *trichromatic coefficients* for the standardized set of idealized primaries. Since only two of these coefficients uniquely determine the color, we can plot the complete spectrum on a two-dimensional diagram. Figure 12-3 shows the

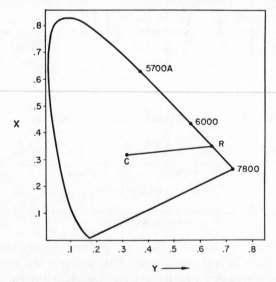

Fig. 12-3. The chromaticity diagram.

spectrum plotted in this fashion using the X and Υ values. The horseshoe-shaped curve is known as the *spectrum locus*, while the

complete diagram forms the chromaticity diagram. Point C, near the center of the diagram, represents white or neutral gray. All points of a line joining C with the spectrum locus represent a color of constant hue. The purity of the color increases from C outward. Thus the purity of the red color represented by line CR is zero at C and 100% at R. The chromaticity diagram shows all hues in the spectrum in all purities.

The idealized set of primaries selected by the ICI do not lie within the horseshoe area of Fig. 12-3 since they do not represent real colors. These three primaries lie at positions $X = 0$, $Y = 0$; $X = 1$, $Y = 0$; and $X = 0$, $Y = 1$.

Color Addition

The realm of real colors contains no combination of three primaries which provide positive trichromatic coefficients for matching all colors. In practice, the widest range of colors can be matched by using primaries consisting of highly saturated red, green, and blue.

Color addition results when two or more colors are superimposed. We can easily demonstrate three methods of color addition. Suppose we have three projection lanterns and filter each of them with one of the three primaries. When the light beams from each lantern are projected separately onto a white screen, we see spots of

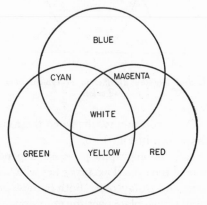

Fig. 12-4. Additive colors formed by green, blue, and red.

blue, green, and red light. If we superimpose the spots, color additive mixtures result. These mixtures form colors as shown in Fig. 12-4. Notice that blue and green give cyan (a bluish-green), red and green give yellow, red and blue give magenta (reddish-purple), while red and green and blue give white.

A second method for producing additive color mixtures is the whirling color disk, which consists of a disk with colored, pie-shaped segments. When the disk rotates rapidly enough, we can no longer distinguish the individual colors, and we see a color additive mixture of the pie-shaped segments. Additive mixtures produced in this manner give the same results as those formed by the three lanterns.

The third method of color addition depends on the limited angular resolution of the eye. Consider a brick building made of alternate red and blue bricks. If we are close enough to the building, we can see the individual bricks. However, when we view the building from a great distance we no longer see the individual bricks, and the building appears as one color which, for this example, is magenta.

Figure 12-5 shows the spectral distribution of typical blue, green,

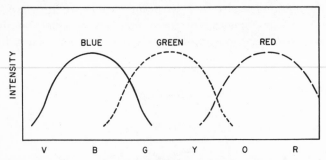

Fig. 12-5. Spectral intensity distribution of typical blue, green, and red colors.

and red colors. Color addition results when these curves are added giving the results shown in Fig. 12-6.

Most additive color photographic processes depend on the limited angular resolution of the eye. Two processes which use this property are Autochrome and Dufaycolor. Both of these processes require the use of a colored screen plate over the emulsion, and the essential difference between the two is in the type of screen plate used. A

screen plate is a transparent, colored mosaic filter consisting of the three primary colors. The screen occupies a position directly in

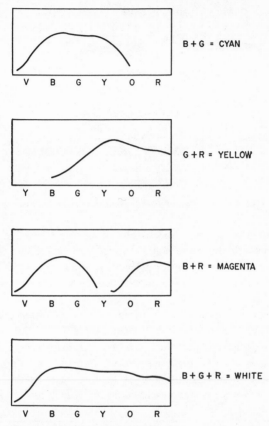

Fig. 12-6. Spectral intensity distribution formed by adding
blue, green, and red.

front of a panchromatic emulsion, so that all light passes through the screen before exposing the sensitive surface. Autochrome employs small grains of starch which are dyed with the primary colors and thoroughly mixed, while Dufaycolor uses a geometrical pattern of the primary colors.

The principle of screen-plate color processes is best discussed with the aid of Fig. 12-7. Part (a) shows a cross section of the emulsion and screen plate. Light of various colors exposes the emulsion as

shown, and the film is developed in the usual manner. Then the film is bleached, exposed to white light, and reversed. The emulsion

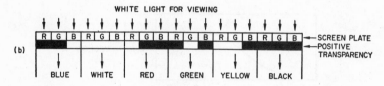

Fig. 12-7. Diagram illustrating the screen-plate color additive process.

now consists of a black and white transparent positive which is viewed through the same colored mosaic filters. Since the screen elements are too small to be resolved by the eye, color addition of the small filters gives the appearance of a colored transparent photograph.

The spectral response of the primaries results from a combination of filters and film sensitivity, but the incident illumination affects the relative response and must also be taken into account. Ideally, the response of the primaries should overlap one another only slightly and their response curves should have as flat a top as possible. Figure 12-8 shows ideal blue, green, and red spectral

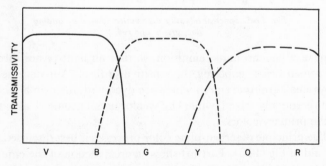

Fig. 12-8. Idealized spectral response curves for color additive process.

response curves for color addition. Compare these curves with the typical curves of Fig. 12-5. Filter-emulsion combinations do not exist which give the ideal curves, and the responses of color primaries in a given color process are adjusted to give the best results.

Additive color prints can be made with the screen plate process by employing the same techniques as those used for transparencies. The only essential difference is that the prints are viewed by reflected light which passes through the screen twice. Color additive results can also be obtained with printing inks. Small dots of ink, printed so there is no overlap, give additive colors as long as the individual dots cannot be resolved by the eye. However, most publications containing color prints employ a color subtractive process.

Color Subtraction

We have seen that the addition of red and green gives yellow, while addition of red, green, and blue gives white. Thus yellow may be considered as white minus blue. In a like manner cyan comes from white minus red, and magenta comes from white minus green. We have,

$$\text{yellow} \quad = W - B = G + R$$
$$\text{cyan} \quad = W - R = B + G$$
$$\text{magenta} = W - G = B + R.$$

Yellow, cyan, and magenta are the three most commonly used primaries in subtractive color photography. (The notion that yellow, blue, and red are *the* primary colors originates from the yellow, cyan, and magenta subtractive primaries.) The term *color subtraction* applies to color mixtures in which the light passes through first one color and then the others in succession. In general, we are more familiar with color subtraction than with color addition. Mixing of color pigments such as paint or ink results in color subtraction. Two pieces of colored glass with one in front of the other also give color subtractive combinations. We can determine the results of subtractive color processes by studying the transmittance or reflectance curves of color samples. Figure 12-9 shows the transmittance curves of magenta and yellow filters. When white light passes through both of these filters in succession, only the light to

which both filters are transparent gets through. The transmittance
of the combination is also shown in Fig. 12-9 and the result appears

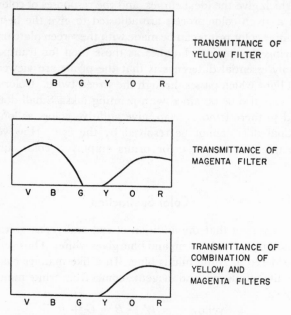

TRANSMITTANCE OF
YELLOW FILTER

V B G Y O R

TRANSMITTANCE OF
MAGENTA FILTER

V B G Y O R

TRANSMITTANCE OF
COMBINATION OF
YELLOW AND
MAGENTA FILTERS

V B G Y O R

Fig. 12-9. Spectral transmittance curves of typical yellow and
magenta filters and their subtractive combination.

as red. Proper combinations of the three subtractive primaries can
give almost any desired color. When all three of the subtractive
primaries are used simultaneously, they transmit no light and the
result is black. Notice that the subtractive primaries represent the
colors complementary to the additive primaries.

Subtractive photographic processes depend on the production of
three separate negatives exposed respectively with the light of the
three additive primaries. Each negative is made into a positive
transparency which is dyed with the complement of the color used
to make the negative. Then the three dyed transparencies are
superimposed to give the final color transparency. Color prints
undergo a similar process, but the dyed transparent positives are
generally fastened to a white backing for viewing. Although the
steps outlined above represent the fundamental procedures neces-
sary for subtractive color processes, the techniques of accomplishing

these steps differ widely. Perhaps the most satisfactory understanding of subtractive color photography comes from discussing some of the various processes in use.

Kodachrome

Kodachrome (Eastman Kodak Co.) film consists of three separate emulsions laid down on a common base. The top emulsion is blue-sensitive, the middle emulsion is blue- and green-sensitive (orthochromatic), and the bottom emulsion is blue-, yellow- and red-sensitive. A thin yellow filter between the first and second emulsions absorbs the blue light. Figure 12-10 shows the arrangement of the

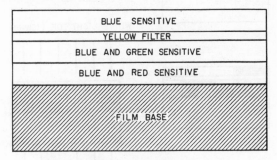

Fig. 12-10. Cross section of Kodachrome film.

layers of Kodachrome film. For illustrative purposes we will consider a subject which includes the colors black, white, red, green, blue, and yellow. Figure 12-11 gives the various steps involved in the exposure and development of Kodachrome. In part (a) we see that none of the emulsions is affected by black, while all three emulsions respond to white. Red light does not expose either the first or second emulsion, but does expose the third, and green light exposes only the second emulsion. Although all emulsions are sensitive to the blue light, only the first emulsion responds to it since the yellow filter absorbs the blue and it cannot reach either the second or third emulsions. Yellow light exposes both the second and bottom emulsion layers, but it does not expose the first since this emulsion is not sensitive to yellow. The emulsion layers of Kodachrome constitute the required three negatives after development since each responds to one of the primary additive colors. Part (a) represents the three developed negatives after exposure.

Kodachrome film is then exposed to red light which renders the undeveloped portion of the third layer developable. The development is done by a special developing agent which incorporates a

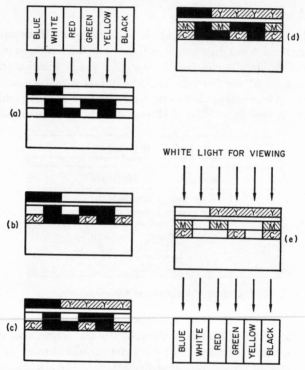

Fig. 12-11. Various steps involved in the Kodachrome process.
(See text.)

cyan dye coupler. A dye coupler is a substance added to the developer so that the combination forms not only a silver image but also a transparent dye image. Of all the developing agents, paraphenylenediamine gives the most satisfactory results for use as a dye coupler. A large group of organic compounds is available to produce the required dye image, and the particular one chosen depends on the requirements of the process. For example, naphthol or phenol compounds give a cyan dye image when they are used with the paraphenylenediamine developing agent. Returning to the Kodachrome film processing, we find that part (b) represents the

film after it has been developed with the cyan-forming coupler. The areas marked with a C contain both the silver deposit and the cyan dye.

The next step requires that the film be exposed to blue light, which renders the rest of the top layer developable. The dye-coupler developer used forms a yellow dye image as shown in part (c). The film is finally developed in a magenta-forming developer and the results appear in part (d). After this development, all of the silver and the yellow filter are bleached out and fixed. The result appears as a three layer transparency shown in part (e). The subtractive primaries in the three layers reproduce the original colors as faithfully as possible under the existing conditions of emulsion sensitivities and dye colors.

Other tripack systems

Kodachrome represents only one of several color subtractive processes employing integral tripacks. This term applies to film consisting of the three emulsion layers all on the same base. Anscochrome and Ektachrome are two types of tripack which can be processed by the photographer. The layers are arranged in the same manner as those of Kodachrome, but the emulsions contain the proper dye couplers. This feature allows the color developing to be done in one step instead of the three required for Kodachrome. Otherwise the systems are similar, and both Anscochrome and Ektachrome give positive color transparencies formed by color subtractive primaries. Ansco Printon contains a similar integral tripack deposited on a white surface for making color prints.

Kodacolor Film and Kodacolor Paper form a color negative-positive process. Kodacolor Film incorporates the dye couplers in the emulsions, but the film is not subjected to reversal during processing. Instead, the first development is done by a color developer which gives a negative silver image and a negative color image. The silver image is bleached, and the remaining color image forms a negative in which the colors are the complements of the original subject colors. This negative is printed onto Kodacolor Paper which contains emulsions similar to the film, and the resulting print shows the colors in their true proportions.

Several other integral tripacks are available in the United States and other countries. The other films are similar to those described,

but may differ in detail.

Polacolor film

In 1963 an entirely new process for producing color photographs was introduced by the Polaroid Corporation. It results from an ingenious combination of the principles of the Polaroid Land black and white process (page 119) with the color subtraction methods used in other color films. However, one significant difference in the Polacolor film occurs as a result of the method of introducing the dyes

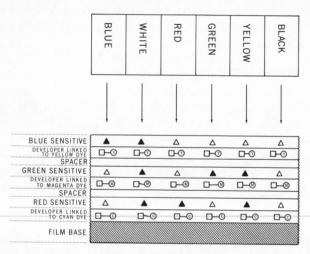

Fig. 12-12. *Arrangement of Polacolor negative material with the reaction to various colors of incident light.*

which make up the color image. In most color film the use of dyecouplers provides the necessary color image. The Polacolor film uses a dye which is linked to the individual developer molecules imbedded in layers of the negative material. Thus, only the linked molecules which are not "eaten up" by an exposed grain of silver halide are free to move toward the paper base and form a positive color image.

The negative material of Polacolor consists of eight layers deposited on a substrate. Figure 12-12 shows a greatly magnified cross section of the arrangement. Note that three layers contain developer molecules linked with the three subtractive primary color dyes labeled Y for yellow, M for magenta, and C for cyan. The silver halides

provide sensitivity to the complementary colors of blue, green, and red. Taking six incident light values as before, we see from the diagram how these colors affect the silver halide layers as illustrated by the black triangles used to represent the exposed halide grains.

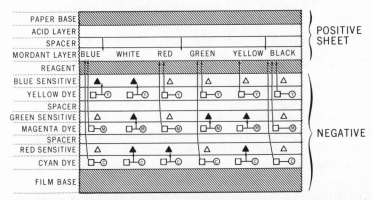

Fig. 12-13. Developing and printing processes of Polacolor after exposure and release of the reagent material.

After exposure, the negative and positive sheets are pulled between a pair of rollers. This action breaks the pod containing a viscous processing reagent in a manner discussed for the Polaroid Land black and white process. The reagent permeates the negative material and activates the developer-dye molecules allowing those closest to the exposed halide grains to be expended by the developing action. The remaining developer-dye molecules, which do not take part in development, diffuse toward the positive sheet. This sheet contains a mordant layer for accepting and holding the dye image plus an acid layer to neutralize the alkaline developer-reagent combination. The result of these actions, as illustrated in Fig. 12–13, produces a positive color image which is deposited on the positive sheet.

Color Prints

Color printing depends on color subtractive processes and several methods exist for producing satisfactory results. In one case we find color printing paper which consists of multilayered coatings deposited in a manner similar to color film. These papers are available in two kinds depending on whether the original transparent image is a color negative or color positive. In the former situation, the resulting

colors formed in the printing process show the complementary colors from those in the negative and give back the original colors of the subject. The latter situation requires that a photographic reversal process be incorporated similar to the reversal described for Kodachrome. In both of these systems the color-temperature (see next section) and spectral distribution of the light source must be very carefully controlled since the photographer has little chance to correct any errors during the processing of the print.

Other methods of color printing depend on the deposition of superimposed color images made from color separation negatives. Usually three separate negatives are made using red, blue, and green filters and special positive prints made from each. The carbro process represents one of several processes in which dyed gelatin layers laid on a white surface form the color print. Another method of producing subtractive color prints depends on transferring dye from the gelatin transparencies to a mordanted paper. (See page 136.) In the Kodak Dye Transfer process, relief images are made from the separation negatives and then the reliefs are soaked in the correct dye. Successive contact between the dyed reliefs and mordanted paper transfers the dye onto the paper. In this manner, several prints can be made from the same set of relief images by continued redying.

Color prints made with printing inks follow roughly the same steps as those used for printing photographically. Printing plates are made from the color separation negatives. These plates print positive images in the correct subtractive colors. When the inks are printed one over the other, subtractive color mixtures result. The cyan, magenta, and yellow inks do not usually give sufficiently black results when they are printed together, and a fourth plate is frequently made to print black ink. The addition of the black image tends to increase the contrast and improve the color balance, and the four-ink combination is known as four-color printing.

Color Temperature

In the early part of the twentieth century, Max Planck developed the law which governs the spectral energy distribution of radiation emitted by luminous solids and liquids. Strictly speaking, his results apply only to "black body" radiation, but most photographic sources approach the black body requirements closely enough that

his formula can be used. The most important light sources for ordinary photography are the sun and incandescent lamps. Figure 12-14 shows the spectral energy distribution for the sun, photoflood

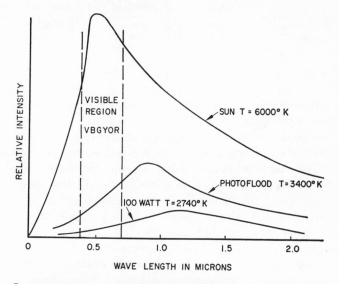

Fig. 12-14. Spectral energy distribution of three illuminating sources of importance in photography.

lamps, and 100-watt lamps. The color balance in color photography depends as much on the spectral energy distribution of the illuminating source as it does on the response of the filter-emulsion combinations. We notice from the curves in Fig. 12-14 that higher temperatures put relatively greater amounts of energy in the short wavelength region of the spectrum. Thus, low temperature sources contain more relative energy in the red than in the blue.

The position of the maximum in the curves determines the color temperature of a luminous source. Wien's displacement law gives the relation between the wavelength at the maximum and the temperature

$$\lambda_m T = 2.89 \times 10^7 \qquad (12-4)$$

where λ_m is the wavelength in Angstroms at maximum energy, and T is the temperature in degrees Kelvin. For the temperatures considered in Fig. 12-14 we have the results in Table 12-1. Notice that

TABLE 12-1

Absolute Temperature and Wavelength of Maximum Energy for Three Important Illuminants

	Sun	Photoflood	100-watt lamp
Temperature	6000°	3400°	2740°
λm	4800 A	8500 A	10,500 A

100-watt lamps radiate only a small fraction of their energy in the visible region, while the maximum energy of photofloods is still in the infrared. The sun radiates its maximum energy in the green portion of the spectrum.

Two methods are in common use to allow for the change in spectral energy distribution due to different source temperatures. The first of these methods requires changing the relative emulsion sensitivities of the three negative materials, or adjusting the relative exposure times. For example, the color balance of indoor tripack film requires that it have greater relative sensitivity in the blue region of the spectrum than does the outdoor type. Some indoor type films (Kodachrome Type A, for example) use a color balance for photoflood lamps at 3400°K. Others (Professional Kodachrome Type B) are balanced for lamps at 3200°K. Presumably tripack film could be color balanced for almost any temperature, but manufacturing complexities limit the available temperature values to only a few, and color balance for other source temperatures is obtained with the use of filters.

The effective color temperature of a source-filter combination is determined by the product, wavelength by wavelength, of the spectral energy distribution of the source and the spectral transmittance of the filter. For example, outdoor Kodachrome used indoors with photofloods requires a blue filter for the proper color balance. The filter can be placed either over the light source or in front of the camera lens. Blue daylight type photoflood lights incorporate the filter in the bulbs, and are especially convenient for use in cases where some daylight comes through windows.

Figure 12-15a shows the results of changing the photoflood color temperature by means of a blue filter to match that of sunlight, while 12-15b gives the reverse situation. When indoor film is used in sunlight, proper color balance requires the use of a pink filter The results shown in Fig. 12-15 represent only two special cases of

the more general problems associated with color temperature. We would like to be able to use any color film with any source.

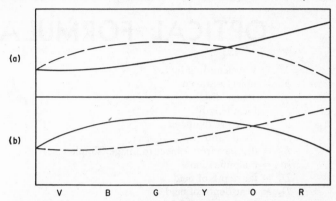

Fig. 12-15. (a) Solid line shows the initial spectral energy distribution of a photoflood lamp and the dashed line shows modification by a daylight correction filter. (b) Solid line shows initial sunlight distribution and the dashed curve shows the modification produced by a correction filter for use of daylight film with photofloods.

Although this ideal cannot be realized in practice, filters are available which alter the spectral energy distribution of most sources so that correct color balance is obtained. In order to use the correction filters, we must know the color temperature of the source and the color balance of the film. Color temperature meters are available for this purpose. They measure the color temperature by allowing the operator to balance the color of the source against the color of a standard within the instrument.

References for Additional Reading

THEORY OF COLOR PHOTOGRAPHY

Evans, R., *An Introduction to Color*, John Wiley & Sons, Inc., New York, 1948.

Evans, R. M., W. T. Hanson, Jr., and W. L. Brewer, *Principles of Color Photography*, John Wiley & Sons, Inc., New York, 1953.

PRACTICAL HINTS ON COLOR PHOTOGRAPHY

Bond, F., *Kodachrome and Kodacolor*, Camera Craft Publishing Co., San Francisco, Calif., 1943.

"Color Films," *Kodak Reference Handbook*, Eastman Kodak Co., Rochester, N. Y.

OPTICAL FORMULAS

λ = wavelength of light
p = object distance
q = image distance
f = focal length
d = aperture diameter
$f/\#$ = focal ratio
L = distance from object to image (simple lens)
m = magnification
D_1 = far depth of field
D_2 = near depth of field
D = total depth of field
c = diameter of allowable circle of confusion
p_h = hyperfocal distance
D' = depth of focus

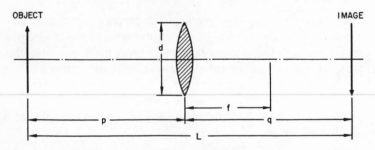

OBJECT IMAGE

Fig. A-1.

In the following formulas, all dimensions must be expressed in the same units.

lens equation

$$\frac{1}{f} = \frac{1}{p} + \frac{1}{q}$$

focal length

$$= f = \frac{pq}{p+q} = \frac{mp}{1+m} = \frac{q}{1+m} = \frac{Lm}{(1+m)^2}$$

image distance

$$= q = \frac{pf}{p-f} = f(1+m) = mp = \frac{Lm}{1+m}$$

object distance

$$= p = \frac{qf}{q-f} = \frac{f(1+m)}{m} = \frac{q}{m} = \frac{L}{1+m}$$

202

focal ratio $\qquad = f/\# = \dfrac{f}{d}$

distance from object
to image* $\qquad = L = p + q = \dfrac{q(1 + m)}{m} = p(1 + m)$

$$= \dfrac{f\,(m + 1)^2}{m}$$

magnification $\qquad = m \quad = \dfrac{q}{p} = \dfrac{f}{p - f} = \dfrac{q - f}{f}$

$$= \dfrac{L - 2f - \sqrt{L^2 - 4fL}}{2f} \text{ for } m \text{ less than unity}$$

$$= \dfrac{L - 2f + \sqrt{L^2 - 4fL}}{2f} \text{ for } m \text{ larger than unity}$$

circle of confusion $\quad = c \quad = \dfrac{f}{1000} \qquad$ for most work

far depth of field $\quad = D_1 \quad = \dfrac{cp(p - f)}{df - c(p - f)}$

$$= \dfrac{(f/\#)p(p - f)}{1000f - (f/\#)(p\text{-}4)} \quad \text{for } c = \dfrac{f}{1000}$$

$$= \dfrac{(f/\#)p^2}{1000f - (f/\#)p} \quad \text{for large values of } p$$

near depth of field $\quad = D_2 \quad = \dfrac{cp(p - f)}{df + c(p - f)}$

$$= \dfrac{(f/\#)p(p - f)}{1000f + (f/\#)(p - f)} \quad \text{for } c = \dfrac{f}{1000}$$

$$= \dfrac{(f/\#)p^2}{1000f + p(f/\#)} \quad \text{for large values of } p$$

total depth of field $\quad = D \quad = \dfrac{2pd\,fc(p - f)}{d^2 f^2 - c^2(p - f)^2}$

$$= \dfrac{2000(f/\#)fp(p - f)}{1,000,000f^2 - (f/\#)^2(p - f)^2} \quad \begin{array}{l}\text{for } c \\ = \dfrac{f}{1000}\end{array}$$

$$= \dfrac{2000(f/\#)fp^2}{1,000,000f^2 - (f/\#)^2 p^2} \quad \begin{array}{l}\text{for large} \\ \text{values of } p\end{array}$$

* Note: These formulas apply to a simple thin lens. Actual object to image distances are larger than L by a distance equal to the distance between the two principal planes of the lens. (See page 148).

hyperfocal distance $= P_h = \dfrac{fd}{c}$

$$= \dfrac{1000\,f}{(f/\#)} \quad \text{for} \quad c = \dfrac{f}{1000}$$

depth of focus $= D' = \dfrac{2qc}{d}$

$$= \dfrac{2p\,fc}{d(p-f)}$$

$$= \dfrac{2\,f(f/\#)}{1000} \quad \text{for} \quad c = \dfrac{f}{1000} \quad \begin{array}{l}\text{and large}\\ \text{object}\\ \text{distances}\end{array}$$

equivalent focal length of two thin lenses in contact

$$\frac{1}{f} = \frac{1}{f_1} + \frac{1}{f_2} \quad \text{or}$$

$$f = \frac{f_1 f_2}{f_1 + f_2}$$

equivalent focal length of two thin lenses separated by distance s

$$\frac{1}{f} = \frac{1}{f_1} + \frac{1}{f_2} - \frac{s}{f_1 f_2}$$

Rayleigh limit of resolution

$$r = 1.22\lambda(f/\#) \quad \text{mm for } \lambda \text{ in millimeters}$$

$$= \frac{(f/\#)}{2000} \quad \text{mm for } \lambda = 4100 \text{ Angstroms}$$

resolution $= R = \dfrac{2000}{(f/\#)}$ lines per millimeter for $\lambda = 4100$ Angstroms

Conversion Table

Pounds	Ounces	Grains	Grams
1	16	7000	454
	1	438	28.3
		15.4	1

Quarts	Fluid ounces	Drams	Cubic centimeters
1	32	256	946
	1	8	29.6
		1	3.7

PROCESSING FORMULAS

Formula No. 1 Film Developer (Kodak D-76)

		Avoirdupois		Metric	
Water, about 125 °F (50 °C)		24	ounces	750	cc
Elon (Metol)		29	grains	2	grams
Sodium sulfite (desiccated)		3	ounces		
			145 grains	100	grams
Hydroquinone		73	grains	5	grams
Borax (granular)		29	grains	2	grams
Water to make		32	ounces	1	liter

Dissolve chemicals in the order given.
Development time is 17 to 25 minutes at 68 °F (20 °C) depending on the contrast desired.

Formula No. 2 Fine Grain Film Developer (Kodak DK-20)

	Avoirdupois		Metric	
Water, about 125 °F (50 °C)	24	ounces	750	cc
Elon (Metol)	73	grains	5	grams
Sodium sulfite (desiccated)	3.25	ounces	100	grams
Kodalk	29	grains	2	grams
Sodium thiocyanate	15	grains	1	gram
Potassium bromide	7	grains	0.5	gram
Water to make	32	ounces	1	liter

Dissolve chemicals in the order given.
Development time is 15 to 20 minutes at 68 °F (20 °C) depending on the contrast desired.

Formula No. 3 High Contrast Film Developer (Kodak D-19)

	Avoirdupois		Metric	
Water, about 125 °F (50 °C)	16	ounces	500	cc
Elon (Metol)	32	grains	2.2	grams
Sodium sulfite (desiccated)	3	ounces		
		90 grains	96	grams
Hydroquinone	128	grains	8.8	grams
Sodium carbonate (monohydrated)	1	ounce		
		380 grains	56	grams
Potassium bromide	73	grains	5	grams
Water to make	32	ounces	1	liter

Dissolve chemicals in the order given.
Development time is 5 to 6 minutes at 68 °F (20 °C) depending on the contrast desired.

Formula No. 4 Universal Developer for Film and Paper (Kodak D-72)

	Avoirdupois		Metric	
Water, about 125 °F (50 °C)	16	ounces	500	cc
Elon (Metol)	45	grains	3.1	grams
Sodium sulfite (desiccated)	1.5	ounces	45	grams
Hydroquinone	175	grains	12	grams
Sodium carbonate (monohydrated)	2	ounces		
	290	grains	80	grams
Potassium bromide	27	grains	1.9	grams
Water to make	32	ounces	1	liter

Dissolve chemicals in the order given.

For film and plate development, dilute 1 part developer with 1 part water and develop 3 to 5 minutes at 68 °F (20 °C) depending on the desired contrast.

For paper development, dilute 1 part developer with 2 parts water and develop 1 to 2 minutes.

Formula No. 5 Warm Tone Paper Developer (Kodak D-52)

	Avoirdupois		Metric	
Water, about 125 °F (50 °C)	16	ounces	500	cc
Elon (Metol)	22	grains	1.5	grams
Sodium sulfite (desiccated)	0.75	ounce	22.5	grams
Hydroquinone	90	grains	6.3	grams
Sodium carbonate (monohydrated)	250	grains	17	grams
Potassium bromide	22	grains	1.5	grams
Water to make	32	ounces	1	liter

Dissolve chemicals in the order given.

For use, dilute 1 part of developer with 1 part water. Develop 1 to 2 minutes at 68 °F (20 °C).

Formula No. 6 Stop Bath for Films and Papers (Kodak SB-1a)

	U. S. Liquid		Metric	
Water	32	ounces	1	liter
Acetic acid (28%)	4	ounces	125	cc

Use this bath as a rinse between the developer and fixer.

To make 28% acetic acid from glacial acetic acid, dilute 3 parts of the glacial acid with 8 parts of water.

Formula No. 7 Hardening Bath (Kodak SB-3)

	Avoirdupois		Metric	
Water	32	ounces	1	liter
Potassium chrome alum	1	ounce	30	grams

Use this bath for hot weather processing.

After development and before fixation, immerse the negatives in this bath for 3 to 5 minutes. Agitate the negatives for a few seconds when first immersed in the hardener.

Formula No. 8 Fixing Bath for Films, Plates, and Papers (Kodak F-5)

	Avoirdupois		Metric	
Water, about 125 °F (50 °C)	20	ounces	600	cc
Sodium thiosulfate (hypo)	8	ounces	240	grams
Sodium sulfite (desiccated)	0.5	ounce	15	grams
Acetic acid (28%)	1.5	ounces	48	cc
Boric acid crystals	0.25	ounce	7.5	grams
Potassium alum	0.5	ounce	15	grams
Water to make	32	ounces	1	liter

Fix films and plates 10 to 20 minutes.
Fix paper 5 to 10 minutes.
To make 28% acetic acid from glacial acetic acid, dilute 3 parts of the glacial acid with 8 parts of water.

Formula No. 9 Subtractive Reducer (Farmer's)

	Avoirdupois		Metric	
Stock Solution A				
Water	8	ounces	250	cc
Potassium ferricyanide	328	grains	20	grams
Stock Solution B				
Water	24	ounces	750	cc
Sodium thiosulfate (hypo)	7.5	ounces	225	grams

Before reducing, harden in Formula No. 12 and fix.
Mix 1 part of A with 3 parts of B, and then add 30 parts of water.
Immerse the negative and watch the reduction process closely so that it may be stopped as desired. Wash thoroughly after the reduction.

Formula No. 10 Proportional Reducer (Farmer's)

Use the same stock solutions as Formula No. 9. Harden in Formula No. 12 and fix. Mix 1 part of A with 10 parts of water, and mix 1 part of B with 1 part of water. Bathe the negative in diluted A for about 2 minutes; then bathe it in diluted B for 5 minutes. Wash thoroughly.

Formula No. 11 Superproportional Reducer (Persulfate Reducer)

	Avoirdupois		Metric	
Water	32	ounces	1	liter
Ammonium persulfate	1	ounce	30	grams
Sulfuric acid (10%)	0.33	fluid oz	10	cc

Before reducing, harden the negative in Formula No. 12 and fix. Watch the reducing action carefully as the rate increases with the degree of reduction. To stop the reduction, immerse the negative in the fixing bath.
To prepare 10% sulfuric acid from concentrated acid, dilute 1 part of the concentrated acid with 10 parts of water. *Caution.* Always pour the acid slowly into the water. *Do not pour water into concentrated sulfuric acid.*

Formula No. 12 Formalin Hardener

	Avoirdupois		Metric	
Water	32	ounces	1	liter
Formalin (37% formaldehyde)	0.33	ounce	10	cc
Sodium carbonate (monohydrated)	73	grains	5	grams

Hardening requires about 3 minutes. Fix the negative before further chemical treatment.

Formula No. 13 Intensifier (bleach)

	Avoirdupois		Metric	
Potassium bichromate	3	ounces	90	grams
Hydrochloric acid C.P.	2	fluid oz	64	cc
Water to make	32	ounces	1	liter

For use, dilute 1 part bleach with 10 parts of water. Before bleaching, harden the negative in Formula No. 12. Bleach the negative 3 to 5 minutes and then wash it thoroughly in water. Redevelop the negative in Formula No. 4. Fixing after the redevelopment is unnecessary.

Formula No. 14 Chemical Reversal

	Avoirdupois		Metric	
Bleach				
Hot water (almost boiling)	5	ounces	150	grams
Potassium bichromate	96	grains	6	grams
Sulfuric acid (concentrated)	3	drams	11	cc
Water to make	44	ounces	1.5	liters
Clearing Bath				
Water	32	ounces	1	liter
Sodium bisulfite	1	ounce	30	grams

After development, rinse the film in water and place it in the bleaching bath. The white light may be turned on after about 1 minute. Bleaching usually takes 5 minutes, but a visual check can be used to determine when bleaching is complete. After bleaching, place the film in the clearing bath until all of the coloring has disappeared. Redevelop the film, leaving the white light on, in Formula No. 4.

Formula No. 15 Monobath Solution for Film

(Boston Univ. Optical Lab. No. 315)

	Avoirdupois		Metric	
Water 110°F (42°C)	32	ounces	1	liter
Elon (Metol)	290	grains	20	grams
Sodium sulfite (desiccated)	3	ounces 145 grains	100	grams
Hydroquinone	2	ounces 290 grains	80	grams
Potassium alum	1	ounce 145 grains	40	grams
Sodium hydroxide	2	ounces 145 grains	70	grams
Sodium thiosulfate (hypo)	7	ounces 145 grains	220	grams

| 0.5% Antifog No. 2 (Kodak) | 1.25 ounces | 40 | cc |
| Water to make | 64 ounces | 2 | liters |

Develop about 6 minutes at 68 °F (20 °C).

Caution. Sodium hydroxide is caustic and should be washed off immediately if it touches the skin.

For best results, prewet the film with a wetting agent such as Kodak Fotoflow and agitate the film constantly during development.

Formula No. 16 Monobath Solution for Paper

(Boston Univ.
Optical Lab.
No. 365)

	Avoirdupois		*Metric*	
Water 110 °F (42 °C)	32	ounces	1	liter
Elon (Metol)	54	grains	3.8	grams
Sodium sulfite (desiccated)	2	ounces	66	grams
		87 grains		
Hydroquinone	1	ounce	34.2	grams
		61 grains		
Potassium alum	1	ounce	40	grams
		145 grains		
Sodium hydroxide	1	ounce	32	grams
		29 grains		
Sodium thiosulfate (hypo)	4	ounces	120	grams
Benzotriazole	29	grains	2	grams
Water to make	64	ounces	2	liters

Develop paper about 3 minutes at 68 °F (20 °C) with constant agitation.

EXPERIMENTS

Experiment No. 1 Focal Length of Lenses

Positive Lenses

Focal lengths of positive lenses can be determined in any one of the following three ways.

1. A distant source such as the sun or moon can be considered as being located at infinity. Form an image of a distant source and measure the distance from the lens to the image. This distance is the focal length of the lens.

Most camera lenses are of short enough focal length that an object distance of a few hundred feet is sufficiently large to be used to measure the focal length by the simple method described above.

2. The focal length can be calculated from the lens formula provided the object and image distances are known. Set the lens up on a bench with the lens axis horizontal. A light bulb or candle flame is a suitable object. Focus the image onto a sheet of white cardboard or a ground glass screen, and measure the object and image distances. The focal length is then found from the lens equation

$$f = \frac{pq}{p + q}$$

where p is the object distance and q the image dista nce.

3. The conjugate foci principle offers a method of determining the focal length which is useful in many instances. This principle results from the symmetry of the lens equation. The object and image distances can be interchanged in the lens equation without changing its form.

Separate the object and screen by a distance equal to about six times the estimated focal length of the lens. Find a position of the lens where the image is in sharp focus. Now move the lens to a new position in which the image is again in sharp focus. In one position, the image is smaller than the object, while in the other position the image is larger. For both positions the lens equation is valid, but the object and image distances have been interchanged. Figure X-1 illustrates the conjugate foci positions. Measure the distance L between the object and image.

Fig. X-1.

Measure the distance x between the two lens positions. Then

$$L = p_1 + q_1 = p_2 + q_2$$

and $\qquad x = L - (p_2 + q_1).$

However $\qquad p_1 = q_2$

and $\qquad q_1 = p_2.$

Therefore $\qquad L = p_1 + q_1 \qquad x = L - 2p_1,$
from which

$$p_1 = \frac{L - x}{2} \qquad q_1 = \frac{L + x}{2}.$$

The lens equation becomes

$$f = \frac{p_1 q_1}{q_1 + p_1} = \frac{(L - x)(L + x)}{4L} = \frac{L^2 - x^2}{4L}.$$

The conjugate foci method for measuring focal length is particularly useful for cases in which the lens is mounted so that measurements to it are difficult. Only the difference between lens positions is required and this distance can be determined by means of any reference mark on the lens mount.

Measure the focal lengths of at least two lenses using all three methods described above.

Negative lenses

A negative, or diverging, lens does not form a real image when used by itself. As a result, the easiest method for determining the focal length of a negative lens is to measure the focal length of the combination of a negative lens and a positive lens.

Put the negative lens in contact with a positive lens whose focal length is small enough so that the combination forms a converging system. Measure the focal length of the combination by one of the three methods mentioned previously. The focal length of the negative lens is then

$$f_2 = \frac{ff_1}{f_1 - f},$$

where f_1 is the focal length of the positive lens (obtained from a previous measurement), and f is the focal length of the combination. Since f is larger than f_1, the value of f_2 will be negative as it should be for a diverging lens.

Telephoto lenses

An interesting study of telephoto lenses can be performed with this same combination of negative and positive lenses. A telephoto system consists of a positive lens in front of a negative lens. Separate the positive and negative lenses by a distance which is about one-half the focal length of the positive lens. With the object distance constant, notice how the image distance changes when the lenses are separated. Vary the lens separation slightly and observe the manner in which the object distance and size change with respect to the separation between the lenses. This principle is used in lenses of the "zoom" type in which the image size can be altered by varying the separation between the lens components.

Experiment No. 2 Magnification

The magnification of a lens setting is defined as the linear size of the image divided by the corresponding size of the object. This ratio, which determines the magnification, is equal to the image distance divided by the object distance, and

$$m = \frac{q}{p}.$$

In normal operation, the magnification of most cameras is a number smaller than unity. However, the magnification of an enlarger is usually greater than unity.

1. Arrange a source, positive lens, and screen in the same manner as Part 2 of Experiment 1. Adjust the system for sharp focus of the image

in such a way that the image is smaller than the object. Measure some particular part of the object normal to the lens axis, and then measure the corresponding part of the image. The magnification is equal to the ratio of the two measurements. Now measure the object and image distances and determine the magnification from these two quantities.

2. Leave the object-to-screen distance constant and find the conjugate focus of the lens. Repeat the measurements of Part 1 and determine the magnification of the lens in the new position. Notice that this magnification is the reciprocal of the value found in Part 1. Check the object and image distances for this position and determine the magnification from the ratio.

3. Repeat Parts 1 and 2, using a lens of different focal length, but with the same distance between the source and screen.

4. Repeat Parts 1, 2, and 3, using a larger distance between the object and screen.

5. Compute the focal length of the lenses used from the formula

$$f = \frac{Lm}{(l + m)^2},$$

where m is the magnification and L is the distance from the object to the image.

Experiment No. 3 Image Brightness Tests

The purpose of this experiment is to demonstrate qualitatively the relations between image brightness and $f/\#$. Furthermore, it shows that the image brightness of an extended object is independent of the object distance. Two methods are available for demonstration of the above principles.

1. Buildings frequently contain long halls lighted with overhead lights. The brightness of the frosted light globes depends on the intensity of the light bulb, but the uniformity of brightness is generally sufficient for a qualitative test.

Set a camera at one end of the hall so that several of the lights are imaged on the film. Photograph the lights several times using exposure ratios of 1:2 by varying the $f/\#$. (Exposures will have to be determined experimentally, but values of $\frac{1}{100}$ sec at $f/11$ are about average.) Develop the negatives in some standard developer such as formula No. 4. Observe how the image blackness varies with the $f/\#$.

2. Pieces of white cardboard in sunlight serve as good white sources. Arrange five or six identical cardboard pieces at distances from the camera varying from about 10 feet to 100 feet. The angle between the cardboards and the sun must be the same for all cardboards or the illuminance will not be identical on each piece. Photograph the cardboards with the same range of exposures as mentioned in Part 1. Develop the films and observe the uniformity of blackness of the images as well as the change of blackness with changing stop opening.

Note: Most white cardboard is not a perfectly diffuse reflector. Some direct reflection may be observed at a particular orientation because of the slick surface of the cardboard. While the cardboard pieces must all be at the same angle with the sun, they can be at almost any desired angle. Arrange them so that any direct reflection is eliminated. If a sunny day is not available, the experiment is equally valid, but exposures will have to be increased about 2 stops.

3. The inverse-square law of illumination can be demonstrated with the aid of the white cardboard pieces. Arrange a 150-watt lamp behind the camera and slightly off to one side. This arrangement must be in a darkened room. Put the cardboard pieces in front of the camera, oriented so that the light rays strike the cardboard pieces perpendicular to the surfaces. Place the first cardboard 10 feet from the lamp and 8 feet from the camera. Arrange the other cardboards at distances from the lamp proportional to $\sqrt{2}$. Thus the second cardboard is 14 feet, the third is 20 feet, the fourth is 28 feet, etc. These distances can be shortened proportionately if the room is not large enough. Now, photograph the cardboard pieces, using several different f numbers which give a series of exposures progressively doubled. Upon development, the blackness of the images on any one film will decrease depending on the object distance from the lamp. The image formed by one cardboard will show the same blackness as the image of the next cardboard away from the lamp shows on the film exposed twice as long. Thus the inverse-square law applies to the distance from the illuminating source to the object, but not to the distance from the object to the camera.

Note: The exposures required for Part 3 will have to be determined experimentally. An average value is about 2 sec at $f/4.5$.

Experiment No. 4 Films and Film Speeds

The following experiment describes two methods of determining the approximate values of relative film speeds.

1. Arrange five pieces of white cardboard, all oriented in the same direction, at various distances from a 150-watt lamp. The ratio of the distances from the lamp to each successive cardboard should be $1:\sqrt{2}$ as described in Part 3 of Experiment 4. The camera should be set up as before so that all cardboards can be photographed simultaneously.

Obtain at least five different kinds of film types. They need not all be of different speeds, but there should be one fast film type and one slow film included. Expose each film type with identical series of exposures starting with an exposure equivalent to 10 sec at $f/4.5$. Cut each successive exposure in half either by increasing the $f/\#$ or by shortening the exposure time. After the films are developed compare them for negatives which appear to have the same blackness for corresponding cardboard images. The ratios of the exposures of these negatives are approximately equal to the ratios of the reciprocals of the film speeds.

2. Satisfactory accuracy for relative film speeds can be obtained by the trial-and-error method of taking pictures outdoors. Using the same five film types as for Part 1, expose each type with a series of exposures starting with $\frac{1}{50}$ sec at $f/4.5$. Again cut successive exposures in half and expose about eight films of each type. Develop the films and visually determine the best negative of each film type. The ratios of exposures of the best negatives of each film type again give the reciprocals of the relative speeds of the films for pictorial purposes. In some cases, the different film types will not all exhibit the same contrast, and the choice of the "best" negative may be uncertain. This uncertainty reflects the more general problem of rating films with speed numbers. The numbers do not necessarily measure relative film speeds which are equally applicable for all photographic purposes.

Experiment No. 5 Exposure and Exposure Tolerance

A correct exposure is one which gives a satisfactory negative. The exposure tolerance depends on the brightness range of the subject material and on the latitude of the film. An exposure meter is useful for determining average exposures under average conditions, but it cannot solve all exposure problems. We frequently resort to trial-and-error methods because of the limitations inherent in meters. The following experiment demonstrates the methods for determining exposure and exposure tolerance.

1. Photograph a typical outdoor scene under full sunlight illumination but including some subjects in shadow. Determine the correct exposure with an exposure meter, exposure chart, or from the results of Experiment 4. Now give the same scene at least six more exposures, three overexposed progressively by one-half stop and three underexposed progressively by one-half stop. Develop the film and determine the exposure tolerance. The exposure tolerance in this case can be estimated by finding the least exposure which still records all the shadow detail, and by finding the greatest exposure which still records detail in the brightest part of the scene.

2. If possible, photograph the same scene on an overcast day and repeat the analysis of Part 1. If this procedure is not feasible, photograph some subjects in the shade of a building. Be careful not to include any objects which are illuminated directly by the sun. Repeat the series of exposures and the analysis as in Part 1. In Part 1, the brightness range of the subject material is much larger than for Part 2. Thus, the exposure tolerance should be greater in the second part of the experiment.

Experiment No. 6 Color Filters

Color filters alter the natural contrast between various colors as reproduced in black and white photography. The particular filter requirement

depends on the desired result which the photographer wishes. This experiment demonstrates two common uses for photographic filters.

1. Photograph a subject which contains several different colors. Suggestions for possible subjects include a landscape, flower garden, colored samples of yarn, or a colored archery target. Obtain at least five photographs of the same subject using four different color filters and one without a filter. If possible, repeat the exposures using film of different spectral response. For example, use panchromatic film for one series of exposures and orthochromatic film for another series. Develop the negatives and compare them for the effects of the filters on various colors included.

2. Prepare a chart which has colored letters on a background color which is approximately complementary to the color of the letters. For example, use orange letters on a blue background or red letters on a green background. Choose two color filters for photographing the chart. One of the filters should produce white letters on a black background while the other filter should produce black letters on a white background. Photograph the chart with the two filters chosen and develop the negatives to prove that your choice is correct.

Experiment No. 7 Polarizing Filters

Polarizing filters find use in photography in connection with natural light which is polarized. Polarized light coming from subjects includes sunlight scattered by the atmosphere and light reflected by a nonmetallic surface. This experiment demonstrates these two principal uses of polarizing filters.

1. For best results, this part of the experiment requires a day when a few scattered clouds are present. However, it can be performed on a perfectly clear day with the aid of a white building for comparison with the sky.

Point the camera for taking a typical landscape scene but at right angles to the direction of the sun. Now, looking through the polarizing filter in the same direction as the camera, rotate the filter until maximum sky darkening is obtained. Place the filter on the camera but keep the orientation of the filter constant. Photograph the scene with about $2\frac{1}{2}$ times the normal exposure. Take the filter off and photograph the same scene with a normal exposure. Develop the films and note the effect of the polarizing filter on the sky. This effect will probably be more noticeable on prints made from the negatives.

2. Light reflected from a nonmetallic surface is partially polarized. The angle of reflection for maximum polarization depends on the index of refraction of the reflecting material. For glass this angle is $57°$, and for water it is $53°$. An ideal situation for examining the effect of a polarizing filter on reflected light is furnished by a store display window. Arrange your camera outdoors so that the angle between the surface of the

glass and the direction which the camera points is 33°. Examine the reflection from the glass by looking through a polarizing filter. By rotating the filter, you will find a position of the filter where the reflected images almost disappear. Keeping the orientation of the filter constant, put it on the camera and take a picture. Now remove the filter and take the same picture. Examine the developed negatives for the effect of the polarizing filter.

3. An experiment similar to Part 2 can be performed using a water surface as the reflecting material. A pond or lake serves this purpose. Repeat the steps of Part 2, using a water surface to test the effect of a polarizing filter for this type of reflection.

Experiment No. 8 Characteristic Curves (Effects of Emulsion and Developer)

The next three experiments concern the study of characteristic curves. Accurate measurements for determining characteristic curves require the use of a good sensitometer and a good densitometer. The sensitometer is the instrument which gives accurate exposures, while the densitometer is used to measure the resulting densities of the photographic film. These instruments are usually expensive to buy or build and they are generally not available in small laboratories. The following paragraph includes the suggestion of a method for obtaining characteristic curves with a minimum of expense.

Both the sensitometer and densitometer can be replaced with a calibrated photographic step wedge. These wedges are obtainable at any good photographic store. The calibrated wedges usually contain a range of densities from values of almost zero to about 2. A light box with opal glass and the step wedge in front serves as a sensitometer. The same wedge used for comparing its density with that of a negative serves as a densitometer. The resulting measurements are sufficiently accurate to show variations in the characteristic curves due to changes in developer, emulsion, or color filter.

1. Photograph the step wedge in front of the light box. Opaque masking tape will probably be a necessary requirement for eliminating stray light. Adjust the exposure by trial and error so that as many of the steps as possible are reproduced. Repeat the process with at least two additional different emulsions, at least one of which is a high-contrast material. Develop all three films identically (at the same time if possible). The image of the step wedge on the negative should be as close to the center as possible. As soon as the negatives dry, cut them along the edge of the step wedge images so that measurements can be made. The densities of the images can now be determined by comparing them with the densities of the calibrated wedge. Plot the image densities as the ordinate values and the logarithm of the exposures as the abscissa. To a first

approximation, the logarithm of the exposure is proportional to the reciprocal of the density of the calibrated wedge. For an even better approximation to the exposure, multiply the exposure as obtained from the step wedge density by the fourth power of the cosine of the angle between the image and the lens axis. From the resulting characteristic curves, compute the value of γ, the contrast factor, for the three films used.

2. Repeat the exposures of Part 1, using three identical films. For best results, the films should be of the usual pancromatic type. Develop the three films, one each in three different developers using formulas 1, 2, and 3. Plot the characteristic curves and determine the contrast for each of the three developers.

Experiment No. 9 Characteristic Curves (Effects of Color Filters)

Most emulsions exhibit changes in contrast with changes in the color to which they are exposed. This experiment is designed to show the variation in contrast with color.

1. Select three different panchromatic emulsions and include at least one of high contrast. Using the step wedge technique described in Experiment No. 8, expose the three emulsions through three color filters, making nine exposures in all. Suggested color filters are blue, green, and red. Develop the like emulsions identically. Measure the densities and plot the nine characteristic curves. The three curves for like emulsions can be plotted on the same graph. Determine the value of gamma for each of the nine curves and note the effect of color on its value.

Experiment No. 10 Characteristic Curves (Effects of Developer Time and Temperature)

The contrast of a negative material increases with the developing time. Since development proceeds at a faster rate with higher temperatures, the contrast is also affected by temperature. This experiment requires eight negatives, all of the same emulsion type and all exposed identically to the step-wedge sensitometer described in Experiment No. 8.

1. After the eight films have been exposed, separate them into two groups of four each. Develop the first four at 65 °F as follows:

 (a) One-half normal time,
 (b) Normal time,
 (c) Twice normal time,
 (d) Four times normal time.

Develop the second group of four at 80 °F, using the same relative times. These will, in general, be about one-half the developing times for

the corresponding films of the first group. Measure the densities, plot the characteristic curves, and determine the value of gamma for each film.

For each of the developing temperatures, make a graph by plotting the value of gamma as the ordinate against the time of development as the abscissa. From the appearance of the two graphs, determine (by estimate) the value of gamma for infinite developing time.

Experiment No. 11 Reversal and Monobath Techniques

The actual time necessary to develop films using these two techniques is very short compared with the time necessary to mix the solutions. A good procedure for most laboratories is to require any one student or student pair to mix either the reversal or the monobath and then exchange solutions.

1. Reversal. Expose ordinary pictorial panchromatic film to a typical outdoor scene using normal exposure. Make at least four more exposures and double the exposure each time. Now repeat the process to obtain another series of identical exposures. Develop both series in formula 4 for the correct time. Fix one series of exposures in the usual manner, and reverse the other series, using formula 14. Compare the negatives and transparencies of the two series. From the graded series of transparencies and the known film speed, estimate the film speed necessary to produce a good transparency.

2. Monobath. Make a series of six graded exposures of a typical outdoor scene on panchromatic film. Start with one-fourth normal exposure and double the exposure each time. Develop the series of exposures in formula 15. Check the results for quality of negative and effective speed of the film.

Experiment No. 12 Resolution Tests

Accurate tests of the resolution of a lens-film combination require the use of elaborate equipment. In the simplest form, however, approximate values can be determined readily. Fairly complete information on determining the resolution of lenses is contained in the National Bureau of Standards Circular No. 533, "Method for Determining the Resolving Power of Photographic Lenses." This circular is available from the Superintendent of Documents, Washington 25, D. C.

A simple resolution test can be made by using a spoked-wheel test chart. Figure X-2 shows a sample test chart which can be used for the determination of resolution. Photograph Figure X-2, or its equivalent, using a magnification of about $\frac{1}{10}$. Make at least three negatives, using three different emulsion types, at least one of which is a slow high-contrast material. Develop the films in a fine grain developer such as formula 2. Examine the processed negatives under a low-power microscope, and determine the distance from the center to the position where the spokes

can just be detected. From the value of the magnification and the size of the test pattern, calculate the resolution of the lens-film combination for

Fig. X-2.

each film used. If the three values of the resolution come out about equal, the resolution is determined by the optics of the system. If the resolution is better for slower films, the grain of the film determines the resolution.

Experiment No. 13 Depth of Field

A series of parallel objects whose distances from the camera continually increase forms a satisfactory test pattern for determining the depth of field of a camera. Ready-made objects for this purpose are represented by the pickets of a fence, telephone poles, fence posts, and bricks of a building. Cross-section graph paper is a satisfactory test pattern for testing the depth of field at near distances. If none of these ready-made test objects is available, suitable objects can be made from white cardboard strips nailed to wooden blocks. The cardboard pieces can be arranged at suitable intervals for the depth of field tests.

1. Photograph the test objects with the center of the series of objects at distances of 3 feet, 10 feet, and 25 feet. Repeat the exposures using two stops greater and two stops smaller. Adjust the time of exposure so that all nine exposures are the same. Some trial and error may be necessary for placing the test objects close enough together and yet have them cover sufficient range for a good depth of field determination. A rule of thumb for these values is to have at least 25 test objects. Compute the total depth of field from the formula (Eq. 11–18) and divide the test objects into equal intervals over a range twice that given by the formula.

However, at large object distances, this range may be too large, and the test will be restricted to the near depth of field measurement. From the appearance of the negatives, determine the limits of satisfactory definition. Often these limits can be more easily obtained from a good enlargement. From the limits and a knowledge of the position of the test objects, determine the depth of field for the nine combinations of relative aperture and object distance. Using Eq. (11–18), compute the ideal depth of field for comparison with your results.

2. Repeat Part 1 with a lens of different focal length.
3. Compute the hyperfocal distance of the two lenses from

$$p_h = \frac{100 \, f}{(f/\#)}.$$

Were all objects beyond 25 feet in focus when the object distance was 25 feet?

Experiment No. 14 Infrared Film

Infrared film is coated with an emulsion which is sensitive in the blue region of the spectrum as well as in the infrared region. Solar radiation contains relatively more blue-violet energy than photographic infrared energy. In addition, the response of the infrared emulsion favors the blue-violet region. Thus, photographs obtained with infrared film and no filter appear very much as they do when taken with blue-sensitive film.

The following experiments are of a qualitative nature, but a little study will reveal many of the useful applications of infrared film when it is used pictorially.

1. Photograph a tpyical landscape scene three times with infrared film. For most spectacular results, include a blue sky and some broad-leaf trees. For the first photograph, use no filter. For the second, use a yellow filter, and for the third, use the very deep red filter made especially for use with infrared film. Also photograph the same scene with ordinary panchromatic film. Develop the four films and make an enlargement of each. Compare the results of the four enlargements.

2. Use infrared film with an infrared flash bulb for photographing a person in a darkened room. Then repeat the picture with panchromatic film and an ordinary flash bulb. Develop the films and make enlargements from the negatives. Compare the two photographs.

Experiment No. 15 Intensification and Reduction

Prepare four negatives of a typical landscape scene under the following conditions:

1. Normal exposure and normal development.
2. Four times normal exposure and normal development.

3. Normal exposure and four times normal development.
4. Normal exposure and one-third normal development.

Negatives 2 and 3 will require reduction, while 4 will require intensification. Subject negative 2 to a subtractive reducer such as Formula 9, and subject negative 3 to a proportional reducer (formula 10). Negative 4 requires intensification by Formula 13. After the reductions and intensification are finished, make the best enlargement possible from each negative by selecting the proper grade of paper for each. Compare the finished enlargements for print quality and detail in the shadows and highlights.

INDEX

INDEX

A CATALOGUE OF SELECTED DOVER BOOKS
IN ALL FIELDS OF INTEREST

A CATALOGUE OF SELECTED DOVER BOOKS
IN ALL FIELDS OF INTEREST

AMERICA'S OLD MASTERS, James T. Flexner. Four men emerged unexpectedly from provincial 18th century America to leadership in European art: Benjamin West, J. S. Copley, C. R. Peale, Gilbert Stuart. Brilliant coverage of lives and contributions. Revised, 1967 edition. 69 plates. 365pp. of text.

21806-6 Paperbound $2.75

FIRST FLOWERS OF OUR WILDERNESS: AMERICAN PAINTING, THE COLONIAL PERIOD, James T. Flexner. Painters, and regional painting traditions from earliest Colonial times up to the emergence of Copley, West and Peale Sr., Foster, Gustavus Hesselius, Feke, John Smibert and many anonymous painters in the primitive manner. Engaging presentation, with 162 illustrations. xxii + 368pp.

22180-6 Paperbound $3.50

THE LIGHT OF DISTANT SKIES: AMERICAN PAINTING, 1760-1835, James T. Flexner. The great generation of early American painters goes to Europe to learn and to teach: West, Copley, Gilbert Stuart and others. Allston, Trumbull, Morse; also contemporary American painters—primitives, derivatives, academics—who remained in America. 102 illustrations. xiii + 306pp. 22179-2 Paperbound $3.00

A HISTORY OF THE RISE AND PROGRESS OF THE ARTS OF DESIGN IN THE UNITED STATES, William Dunlap. Much the richest mine of information on early American painters, sculptors, architects, engravers, miniaturists, etc. The only source of information for scores of artists, the major primary source for many others. Unabridged reprint of rare original 1834 edition, with new introduction by James T. Flexner, and 394 new illustrations. Edited by Rita Weiss. 6⅝ x 9⅝.

21695-0, 21696-9, 21697-7 Three volumes, Paperbound $13.50

EPOCHS OF CHINESE AND JAPANESE ART, Ernest F. Fenollosa. From primitive Chinese art to the 20th century, thorough history, explanation of every important art period and form, including Japanese woodcuts; main stress on China and Japan, but Tibet, Korea also included. Still unexcelled for its detailed, rich coverage of cultural background, aesthetic elements, diffusion studies, particularly of the historical period. 2nd, 1913 edition. 242 illustrations. lii + 439pp. of text.

20364-6, 20365-4 Two volumes, Paperbound $5.00

THE GENTLE ART OF MAKING ENEMIES, James A. M. Whistler. Greatest wit of his day deflates Oscar Wilde, Ruskin, Swinburne; strikes back at inane critics, exhibitions, art journalism; aesthetics of impressionist revolution in most striking form. Highly readable classic by great painter. Reproduction of edition designed by Whistler. Introduction by Alfred Werner. xxxvi + 334pp.

21875-9 Paperbound $2.25

THE ARCHITECTURE OF COUNTRY HOUSES, Andrew J. Downing. Together with Vaux's *Villas and Cottages* this is the basic book for Hudson River Gothic architecture of the middle Victorian period. Full, sound discussions of general aspects of housing, architecture, style, decoration, furnishing, together with scores of detailed house plans, illustrations of specific buildings, accompanied by full text. Perhaps the most influential single American architectural book. 1850 edition. Introduction by J. Stewart Johnson. 321 figures, 34 architectural designs. xvi + 560pp.
22003-6 Paperbound $3.50

LOST EXAMPLES OF COLONIAL ARCHITECTURE, John Mead Howells. Full-page photographs of buildings that have disappeared or been so altered as to be denatured, including many designed by major early American architects. 245 plates. xvii + 248pp. 7⅞ x 10¾.　　21143-6 Paperbound $3.00

DOMESTIC ARCHITECTURE OF THE AMERICAN COLONIES AND OF THE EARLY REPUBLIC, Fiske Kimball. Foremost architect and restorer of Williamsburg and Monticello covers nearly 200 homes between 1620-1825. Architectural details, construction, style features, special fixtures, floor plans, etc. Generally considered finest work in its area. 219 illustrations of houses, doorways, windows, capital mantels. xx + 314pp. 7⅞ x 10¾.　　21743-4 Paperbound $3.50

EARLY AMERICAN ROOMS: 1650-1858, edited by Russell Hawes Kettell. Tour of 12 rooms, each representative of a different era in American history and each furnished, decorated, designed and occupied in the style of the era. 72 plans and elevations, 8-page color section, etc., show fabrics, wall papers, arrangements, etc. Full descriptive text. xvii + 200pp. of text. 8⅜ x 11¼.
21633-0 Paperbound $4.00

THE FITZWILLIAM VIRGINAL BOOK, edited by J. Fuller Maitland and W. B. Squire. Full modern printing of famous early 17th-century ms. volume of 300 works by Morley, Byrd, Bull, Gibbons, etc. For piano or other modern keyboard instrument; easy to read format. xxxvi + 938pp. 8⅜ x 11.
21068-5, 21069-3 Two volumes, Paperbound $8.00

HARPSICHORD MUSIC, Johann Sebastian Bach. Bach Gesellschaft edition. A rich selection of Bach's masterpieces for the harpsichord: the six English Suites, six French Suites, the six Partitas (Clavierübung part I), the Goldberg Variations (Clavierübung part IV), the fifteen Two-Part Inventions and the fifteen Three-Part Sinfonias. Clearly reproduced on large sheets with ample margins; eminently playable. vi + 312pp. 8⅛ x 11.　　22360-4 Paperbound $5.00

THE MUSIC OF BACH: AN INTRODUCTION, Charles Sanford Terry. A fine, nontechnical introduction to Bach's music, both instrumental and vocal. Covers organ music, chamber music, passion music, other types. Analyzes themes, developments, innovations. x + 114pp.　　21075-8 Paperbound $1.25

BEETHOVEN AND HIS NINE SYMPHONIES, Sir George Grove. Noted British musicologist provides best history, analysis, commentary on symphonies. Very thorough, rigorously accurate; necessary to both advanced student and amateur music lover. 436 musical passages. vii + 407 pp.　　20334-4 Paperbound $2.25

A HISTORY OF COSTUME, Carl Köhler. Definitive history, based on surviving pieces of clothing primarily, and paintings, statues, etc. secondarily. Highly readable text, supplemented by 594 illustrations of costumes of the ancient Mediterranean peoples, Greece and Rome, the Teutonic prehistoric period; costumes of the Middle Ages, Renaissance, Baroque, 18th and 19th centuries. Clear, measured patterns are provided for many clothing articles. Approach is practical throughout. Enlarged by Emma von Sichart. 464pp. 21030-8 Paperbound $3.00

ORIENTAL RUGS, ANTIQUE AND MODERN, Walter A. Hawley. A complete and authoritative treatise on the Oriental rug—where they are made, by whom and how, designs and symbols, characteristics in detail of the six major groups, how to distinguish them and how to buy them. Detailed technical data is provided on periods, weaves, warps, wefts, textures, sides, ends and knots, although no technical background is required for an understanding. 11 color plates, 80 halftones, 4 maps. vi + 320pp. 6⅛ x 9⅛. 22366-3 Paperbound $5.00

TEN BOOKS ON ARCHITECTURE, Vitruvius. By any standards the most important book on architecture ever written. Early Roman discussion of aesthetics of building, construction methods, orders, sites, and every other aspect of architecture has inspired, instructed architecture for about 2,000 years. Stands behind Palladio, Michelangelo, Bramante, Wren, countless others. Definitive Morris H. Morgan translation. 68 illustrations. xii + 331pp. 20645-9 Paperbound $2.50

THE FOUR BOOKS OF ARCHITECTURE, Andrea Palladio. Translated into every major Western European language in the two centuries following its publication in 1570, this has been one of the most influential books in the history of architecture. Complete reprint of the 1738 Isaac Ware edition. New introduction by Adolf Placzek, Columbia Univ. 216 plates. xxii + 110pp. of text. 9½ x 12¾. 21308-0 Clothbound $10.00

STICKS AND STONES: A STUDY OF AMERICAN ARCHITECTURE AND CIVILIZATION, Lewis Mumford.One of the great classics of American cultural history. American architecture from the medieval-inspired earliest forms to the early 20th century; evolution of structure and style, and reciprocal influences on environment. 21 photographic illustrations. 238pp. 20202-X Paperbound $2.00

THE AMERICAN BUILDER'S COMPANION, Asher Benjamin. The most widely used early 19th century architectural style and source book, for colonial up into Greek Revival periods. Extensive development of geometry of carpentering, construction of sashes, frames, doors, stairs; plans and elevations of domestic and other buildings. Hundreds of thousands of houses were built according to this book, now invaluable to historians, architects, restorers, etc. 1827 edition. 59 plates. 114pp. 7⅞ x 10¾. 22236-5 Paperbound $3.00

DUTCH HOUSES IN THE HUDSON VALLEY BEFORE 1776, Helen Wilkinson Reynolds. The standard survey of the Dutch colonial house and outbuildings, with constructional features, decoration, and local history associated with individual homesteads. Introduction by Franklin D. Roosevelt. Map. 150 illustrations. 469pp. 6⅝ x 9¼. 21469-9 Paperbound $3.50

ALPHABETS AND ORNAMENTS, Ernst Lehner. Well-known pictorial source for decorative alphabets, script examples, cartouches, frames, decorative title pages, calligraphic initials, borders, similar material. 14th to 19th century, mostly European. Useful in almost any graphic arts designing, varied styles. 750 illustrations. 256pp. 7 x 10. 21905-4 Paperbound $3.50

PAINTING: A CREATIVE APPROACH, Norman Colquhoun. For the beginner simple guide provides an instructive approach to painting: major stumbling blocks for beginner; overcoming them, technical points; paints and pigments; oil painting; watercolor and other media and color. New section on "plastic" paints. Glossary. Formerly *Paint Your Own Pictures*. 221pp. 22000-1 Paperbound $1.75

THE ENJOYMENT AND USE OF COLOR, Walter Sargent. Explanation of the relations between colors themselves and between colors in nature and art, including hundreds of little-known facts about color values, intensities, effects of high and low illumination, complementary colors. Many practical hints for painters, references to great masters. 7 color plates, 29 illustrations. x + 274pp.
20944-X Paperbound $2.50

THE NOTEBOOKS OF LEONARDO DA VINCI, compiled and edited by Jean Paul Richter. 1566 extracts from original manuscripts reveal the full range of Leonardo's versatile genius: all his writings on painting, sculpture, architecture, anatomy, astronomy, geography, topography, physiology, mining, music, etc., in both Italian and English, with 186 plates of manuscript pages and more than 500 additional drawings. Includes studies for the Last Supper, the lost Sforza monument, and other works. Total of xlvii + 866pp. 7⅞ x 10¾.
22572-0, 22573-9 Two volumes, Paperbound $10.00

MONTGOMERY WARD CATALOGUE OF 1895. Tea gowns, yards of flannel and pillow-case lace, stereoscopes, books of gospel hymns, the New Improved Singer Sewing Machine, side saddles, milk skimmers, straight-edged razors, high-button shoes, spittoons, and on and on . . . listing some 25,000 items, practically all illustrated. Essential to the shoppers of the 1890's, it is our truest record of the spirit of the period. Unaltered reprint of Issue No. 57, Spring and Summer 1895. Introduction by Boris Emmet. Innumerable illustrations. xiii + 624pp. 8½ x 11⅝.
22377-9 Paperbound $6.95

THE CRYSTAL PALACE EXHIBITION ILLUSTRATED CATALOGUE (LONDON, 1851). One of the wonders of the modern world—the Crystal Palace Exhibition in which all the nations of the civilized world exhibited their achievements in the arts and sciences—presented in an equally important illustrated catalogue. More than 1700 items pictured with accompanying text—ceramics, textiles, cast-iron work, carpets, pianos, sleds, razors, wall-papers, billiard tables, beehives, silverware and hundreds of other artifacts—represent the focal point of Victorian culture in the Western World. Probably the largest collection of Victorian decorative art ever assembled—indispensable for antiquarians and designers. Unabridged republication of the Art-Journal Catalogue of the Great Exhibition of 1851, with all terminal essays. New introduction by John Gloag, F.S.A. xxxiv + 426pp. 9 x 12.
22503-8 Paperbound $4.50

CATALOGUE OF DOVER BOOKS

THE RED FAIRY BOOK, Andrew Lang. Lang's color fairy books have long been children's favorites. This volume includes Rapunzel, Jack and the Bean-stalk and 35 other stories, familiar and unfamiliar. 4 plates, 93 illustrations x + 367pp.
21673-X Paperbound $1.95

THE BLUE FAIRY BOOK, Andrew Lang. Lang's tales come from all countries and all times. Here are 37 tales from Grimm, the Arabian Nights, Greek Mythology, and other fascinating sources. 8 plates, 130 illustrations. xi + 390pp.
21437-0 Paperbound $1.95

HOUSEHOLD STORIES BY THE BROTHERS GRIMM. Classic English-language edition of the well-known tales — Rumpelstiltskin, Snow White, Hansel and Gretel, The Twelve Brothers, Faithful John, Rapunzel, Tom Thumb (52 stories in all). Translated into simple, straightforward English by Lucy Crane. Ornamented with headpieces, vignettes, elaborate decorative initials and a dozen full-page illustrations by Walter Crane. x + 269pp. 21080-4 Paperbound $1.75

THE MERRY ADVENTURES OF ROBIN HOOD, Howard Pyle. The finest modern versions of the traditional ballads and tales about the great English outlaw. Howard Pyle's complete prose version, with every word, every illustration of the first edition. Do not confuse this facsimile of the original (1883) with modern editions that change text or illustrations. 23 plates plus many page decorations. xxii + 296pp.
22043-5 Paperbound $2.00

THE STORY OF KING ARTHUR AND HIS KNIGHTS, Howard Pyle. The finest children's version of the life of King Arthur; brilliantly retold by Pyle, with 48 of his most imaginative illustrations. xviii + 313pp. 6⅛ x 9¼.
21445-1 Paperbound $2.00

THE WONDERFUL WIZARD OF OZ, L. Frank Baum. America's finest children's book in facsimile of first edition with all Denslow illustrations in full color. The edition a child should have. Introduction by Martin Gardner. 23 color plates, scores of drawings. iv + 267pp. 20691-2 Paperbound $1.95

THE MARVELOUS LAND OF OZ, L. Frank Baum. The second Oz book, every bit as imaginative as the Wizard. The hero is a boy named Tip, but the Scarecrow and the Tin Woodman are back, as is the Oz magic. 16 color plates, 120 drawings by John R. Neill. 287pp. 20692-0 Paperbound $1.75

THE MAGICAL MONARCH OF MO, L. Frank Baum. Remarkable adventures in a land even stranger than Oz. The best of Baum's books not in the Oz series. 15 color plates and dozens of drawings by Frank Verbeck. xviii + 237pp.
21892-9 Paperbound $2.00

THE BAD CHILD'S BOOK OF BEASTS, MORE BEASTS FOR WORSE CHILDREN, A MORAL ALPHABET, Hilaire Belloc. Three complete humor classics in one volume. Be kind to the frog, and do not call him names . . . and 28 other whimsical animals. Familiar favorites and some not so well known. Illustrated by Basil Blackwell. 156pp. (USO) 20749-8 Paperbound $1.25

JOHANN SEBASTIAN BACH, Philipp Spitta. One of the great classics of musicology, this definitive analysis of Bach's music (and life) has never been surpassed. Lucid, nontechnical analyses of hundreds of pieces (30 pages devoted to St. Matthew Passion, 26 to B Minor Mass). Also includes major analysis of 18th-century music. 450 musical examples. 40-page musical supplement. Total of xx + 1799pp.
(EUK) 22278-0, 22279-9 Two volumes, Clothbound $15.00

MOZART AND HIS PIANO CONCERTOS, Cuthbert Girdlestone. The only full-length study of an important area of Mozart's creativity. Provides detailed analyses of all 23 concertos, traces inspirational sources. 417 musical examples. Second edition. 509pp. (USO) 21271-8 Paperbound $2.50

THE PERFECT WAGNERITE: A COMMENTARY ON THE NIBLUNG'S RING, George Bernard Shaw. Brilliant and still relevant criticism in remarkable essays on Wagner's Ring cycle, Shaw's ideas on political and social ideology behind the plots, role of Leitmotifs, vocal requisites, etc. Prefaces. xxi + 136pp.
21707-8 Paperbound $1.50

DON GIOVANNI, W. A. Mozart. Complete libretto, modern English translation; biographies of composer and librettist; accounts of early performances and critical reaction. Lavishly illustrated. All the material you need to understand and appreciate this great work. Dover Opera Guide and Libretto Series; translated and introduced by Ellen Bleiler. 92 illustrations. 209pp.
21134-7 Paperbound $1.50

HIGH FIDELITY SYSTEMS: A LAYMAN'S GUIDE, Roy F. Allison. All the basic information you need for setting up your own audio system: high fidelity and stereo record players, tape records, F.M. Connections, adjusting tone arm, cartridge, checking needle alignment, positioning speakers, phasing speakers, adjusting hums, trouble-shooting, maintenance, and similar topics. Enlarged 1965 edition. More than 50 charts, diagrams, photos. iv + 91pp. 21514-8 Paperbound $1.25

REPRODUCTION OF SOUND, Edgar Villchur. Thorough coverage for laymen of high fidelity systems, reproducing systems in general, needles, amplifiers, preamps, loudspeakers, feedback, explaining physical background. "A rare talent for making technicalities vividly comprehensible," R. Darrell, High Fidelity. 69 figures. iv + 92pp. 21515-6 Paperbound $1.00

HEAR ME TALKIN' TO YA: THE STORY OF JAZZ AS TOLD BY THE MEN WHO MADE IT, Nat Shapiro and Nat Hentoff. Louis Armstrong, Fats Waller, Jo Jones, Clarence Williams, Billy Holiday, Duke Ellington, Jelly Roll Morton and dozens of other jazz greats tell how it was in Chicago's South Side, New Orleans, depression Harlem and the modern West Coast as jazz was born and grew. xvi + 429pp.
21726-4 Paperbound $2.00

FABLES OF AESOP, translated by Sir Roger L'Estrange. A reproduction of the very rare 1931 Paris edition; a selection of the most interesting fables, together with 50 imaginative drawings by Alexander Calder. v + 128pp. 6½x9¼.
21780-9 Paperbound $1.25

CATALOGUE OF DOVER BOOKS

POEMS OF ANNE BRADSTREET, edited with an introduction by Robert Hutchinson. A new selection of poems by America's first poet and perhaps the first significant woman poet in the English language. 48 poems display her development in works of considerable variety—love poems, domestic poems, religious meditations, formal elegies, "quaternions," etc. Notes, bibliography. viii + 222pp.
22160-1 Paperbound $2.00

THREE GOTHIC NOVELS: THE CASTLE OF OTRANTO BY HORACE WALPOLE; VATHEK BY WILLIAM BECKFORD; THE VAMPYRE BY JOHN POLIDORI, WITH FRAGMENT OF A NOVEL BY LORD BYRON, edited by E. F. Bleiler. The first Gothic novel, by Walpole; the finest Oriental tale in English, by Beckford; powerful Romantic supernatural story in versions by Polidori and Byron. All extremely important in history of literature; all still exciting, packed with supernatural thrills, ghosts, haunted castles, magic, etc. xl + 291pp.
21232-7 Paperbound $2.00

THE BEST TALES OF HOFFMANN, E. T. A. Hoffmann. 10 of Hoffmann's most important stories, in modern re-editings of standard translations: Nutcracker and the King of Mice, Signor Formica, Automata, The Sandman, Rath Krespel, The Golden Flowerpot, Master Martin the Cooper, The Mines of Falun, The King's Betrothed, A New Year's Eve Adventure. 7 illustrations by Hoffmann. Edited by E. F. Bleiler. xxxix + 419pp.
21793-0 Paperbound $2.25

GHOST AND HORROR STORIES OF AMBROSE BIERCE, Ambrose Bierce. 23 strikingly modern stories of the horrors latent in the human mind: The Eyes of the Panther, The Damned Thing, An Occurrence at Owl Creek Bridge, An Inhabitant of Carcosa, etc., plus the dream-essay, Visions of the Night. Edited by E. F. Bleiler. xxii + 199pp.
20767-6 Paperbound $1.50

BEST GHOST STORIES OF J. S. LEFANU, J. Sheridan LeFanu. Finest stories by Victorian master often considered greatest supernatural writer of all. Carmilla, Green Tea, The Haunted Baronet, The Familiar, and 12 others. Most never before available in the U. S. A. Edited by E. F. Bleiler. 8 illustrations from Victorian publications. xvii + 467pp.
20415-4 Paperbound $2.50

THE TIME STREAM, THE GREATEST ADVENTURE, AND THE PURPLE SAPPHIRE— THREE SCIENCE FICTION NOVELS, John Taine (Eric Temple Bell). Great American mathematician was also foremost science fiction novelist of the 1920's. *The Time Stream,* one of all-time classics, uses concepts of circular time; *The Greatest Adventure,* incredibly ancient biological experiments from Antarctica threaten to escape; The *Purple Sapphire,* superscience, lost races in Central Tibet, survivors of the Great Race. 4 illustrations by Frank R. Paul. v + 532pp.
21180-0 Paperbound $2.50

SEVEN SCIENCE FICTION NOVELS, H. G. Wells. The standard collection of the great novels. Complete, unabridged. *First Men in the Moon, Island of Dr. Moreau, War of the Worlds, Food of the Gods, Invisible Man, Time Machine, In the Days of the Comet.* Not only science fiction fans, but every educated person owes it to himself to read these novels. 1015pp.
20264-X Clothbound $5.00

LAST AND FIRST MEN AND STAR MAKER, TWO SCIENCE FICTION NOVELS, Olaf Stapledon. Greatest future histories in science fiction. In the first, human intelligence is the "hero," through strange paths of evolution, interplanetary invasions, incredible technologies, near extinctions and reemergences. Star Maker describes the quest of a band of star rovers for intelligence itself, through time and space: weird inhuman civilizations, crustacean minds, symbiotic worlds, etc. Complete, unabridged. v + 438pp. 21962-3 Paperbound $2.00

THREE PROPHETIC NOVELS, H. G. WELLS. Stages of a consistently planned future for mankind. *When the Sleeper Wakes,* and *A Story of the Days to Come,* anticipate *Brave New World* and *1984,* in the 21st Century; *The Time Machine,* only complete version in print, shows farther future and the end of mankind. All show Wells's greatest gifts as storyteller and novelist. Edited by E. F. Bleiler. x + 335pp. (USO) 20605-X Paperbound $2.00

THE DEVIL'S DICTIONARY, Ambrose Bierce. America's own Oscar Wilde— Ambrose Bierce—offers his barbed iconoclastic wisdom in over 1,000 definitions hailed by H. L. Mencken as "some of the most gorgeous witticisms in the English language." 145pp. 20487-1 Paperbound $1.25

MAX AND MORITZ, Wilhelm Busch. Great children's classic, father of comic strip, of two bad boys, Max and Moritz. Also Ker and Plunk (Plisch und Plumm), Cat and Mouse, Deceitful Henry, Ice-Peter, The Boy and the Pipe, and five other pieces. Original German, with English translation. Edited by H. Arthur Klein; translations by various hands and H. Arthur Klein. vi + 216pp.
20181-3 Paperbound $1.50

PIGS IS PIGS AND OTHER FAVORITES, Ellis Parker Butler. The title story is one of the best humor short stories, as Mike Flannery obfuscates biology and English. Also included, That Pup of Murchison's, The Great American Pie Company, and Perkins of Portland. 14 illustrations. v + 109pp. 21532-6 Paperbound $1.00

THE PETERKIN PAPERS, Lucretia P. Hale. It takes genius to be as stupidly mad as the Peterkins, as they decide to become wise, celebrate the "Fourth," keep a cow, and otherwise strain the resources of the Lady from Philadelphia. Basic book of American humor. 153 illustrations. 219pp. 20794-3 Paperbound $1.25

PERRAULT'S FAIRY TALES, translated by A. E. Johnson and S. R. Littlewood, with 34 full-page illustrations by Gustave Doré. All the original Perrault stories— Cinderella, Sleeping Beauty, Bluebeard, Little Red Riding Hood, Puss in Boots, Tom Thumb, etc.—with their witty verse morals and the magnificent illustrations of Doré. One of the five or six great books of European fairy tales. viii + 117pp. 8⅛ x 11. 22311-6 Paperbound $2.00

OLD HUNGARIAN FAIRY TALES, Baroness Orczy. Favorites translated and adapted by author of the *Scarlet Pimpernel.* Eight fairy tales include "The Suitors of Princess Fire-Fly," "The Twin Hunchbacks," "Mr. Cuttlefish's Love Story," and "The Enchanted Cat." This little volume of magic and adventure will captivate children as it has for generations. 90 drawings by Montagu Barstow. 96pp.
(USO) 22293-4 Paperbound $1.95

VISUAL ILLUSIONS: THEIR CAUSES, CHARACTERISTICS, AND APPLICATIONS, Matthew Luckiesh. Thorough description and discussion of optical illusion, geometric and perspective, particularly; size and shape distortions, illusions of color, of motion; natural illusions; use of illusion in art and magic, industry, etc. Most useful today with op art, also for classical art. Scores of effects illustrated. Introduction by William H. Ittleson. 100 illustrations. xxi + 252pp.

21530-X Paperbound $1.50

A HANDBOOK OF ANATOMY FOR ART STUDENTS, Arthur Thomson. Thorough, virtually exhaustive coverage of skeletal structure, musculature, etc. Full text, supplemented by anatomical diagrams and drawings and by photographs of undraped figures. Unique in its comparison of male and female forms, pointing out differences of contour, texture, form. 211 figures, 40 drawings, 86 photographs. xx + 459pp. 5⅜ x 8⅜.

21163-0 Paperbound $3.00

150 MASTERPIECES OF DRAWING, Selected by Anthony Toney. Full page reproductions of drawings from the early 16th to the end of the 18th century, all beautifully reproduced: Rembrandt, Michelangelo, Dürer, Fragonard, Urs, Graf, Wouwerman, many others. First-rate browsing book, model book for artists. xviii + 150pp. 8⅜ x 11¼.

21032-4 Paperbound $2.00

THE LATER WORK OF AUBREY BEARDSLEY, Aubrey Beardsley. Exotic, erotic, ironic masterpieces in full maturity: Comedy Ballet, Venus and Tannhauser, Pierrot, Lysistrata, Rape of the Lock, Savoy material, Ali Baba, Volpone, etc. This material revolutionized the art world, and is still powerful, fresh, brilliant. With *The Early Work*, all Beardsley's finest work. 174 plates, 2 in color. xiv + 176pp. 8⅛ x 11.

21817-1 Paperbound $2.75

DRAWINGS OF REMBRANDT, Rembrandt van Rijn. Complete reproduction of fabulously rare edition by Lippmann and Hofstede de Groot, completely reedited, updated, improved by Prof. Seymour Slive, Fogg Museum. Portraits, Biblical sketches, landscapes, Oriental types, nudes, episodes from classical mythology—All Rembrandt's fertile genius. Also selection of drawings by his pupils and followers. "Stunning volumes," *Saturday Review*. 550 illustrations. lxxviii + 552pp. 9⅛ x 12¼.

21485-0, 21486-9 Two volumes, Paperbound $6.50

THE DISASTERS OF WAR, Francisco Goya. One of the masterpieces of Western civilization—83 etchings that record Goya's shattering, bitter reaction to the Napoleonic war that swept through Spain after the insurrection of 1808 and to war in general. Reprint of the first edition, with three additional plates from Boston's Museum of Fine Arts. All plates facsimile size. Introduction by Philip Hofer, Fogg Museum. v + 97pp. 9⅜ x 8¼.

21872-4 Paperbound $1.75

GRAPHIC WORKS OF ODILON REDON. Largest collection of Redon's graphic works ever assembled: 172 lithographs, 28 etchings and engravings, 9 drawings. These include some of his most famous works. All the plates from *Odilon Redon: oeuvre graphique complet*, plus additional plates. New introduction and caption translations by Alfred Werner. 209 illustrations. xxvii + 209pp. 9⅛ x 12¼.

21966-8 Paperbound $4.00

AGAINST THE GRAIN (A REBOURS), Joris K. Huysmans. Filled with weird images, evidences of a bizarre imagination, exotic experiments with hallucinatory drugs, rich tastes and smells and the diversions of its sybarite hero Duc Jean des Esseintes, this classic novel pushed 19th-century literary decadence to its limits. Full unabridged edition. Do not confuse this with abridged editions generally sold. Introduction by Havelock Ellis. xlix + 206pp. 22190-3 Paperbound $2.00

VARIORUM SHAKESPEARE: HAMLET. Edited by Horace H. Furness; a landmark of American scholarship. Exhaustive footnotes and appendices treat all doubtful words and phrases, as well as suggested critical emendations throughout the play's history. First volume contains editor's own text, collated with all Quartos and Folios. Second volume contains full first Quarto, translations of Shakespeare's sources (Belleforest, and Saxo Grammaticus), Der Bestrafte Brudermord, and many essays on critical and historical points of interest by major authorities of past and present. Includes details of staging and costuming over the years. By far the best edition available for serious students of Shakespeare. Total of xx + 905pp.
21004-9, 21005-7, 2 volumes, Paperbound $5.25

A LIFE OF WILLIAM SHAKESPEARE, Sir Sidney Lee. This is the standard life of Shakespeare, summarizing everything known about Shakespeare and his plays. Incredibly rich in material, broad in coverage, clear and judicious, it has served thousands as the best introduction to Shakespeare. 1931 edition. 9 plates. xxix + 792pp. (USO) 21967-4 Paperbound $3.75

MASTERS OF THE DRAMA, John Gassner. Most comprehensive history of the drama in print, covering every tradition from Greeks to modern Europe and America, including India, Far East, etc. Covers more than 800 dramatists, 2000 plays, with biographical material, plot summaries, theatre history, criticism, etc. "Best of its kind in English," *New Republic*. 77 illustrations. xxii + 890pp.
20100-7 Clothbound $7.50

THE EVOLUTION OF THE ENGLISH LANGUAGE, George McKnight. The growth of English, from the 14th century to the present. Unusual, non-technical account presents basic information in very interesting form: sound shifts, change in grammar and syntax, vocabulary growth, similar topics. Abundantly illustrated with quotations. Formerly *Modern English in the Making*. xii + 590pp.
21932-1 Paperbound $3.50

AN ETYMOLOGICAL DICTIONARY OF MODERN ENGLISH, Ernest Weekley. Fullest, richest work of its sort, by foremost British lexicographer. Detailed word histories, including many colloquial and archaic words; extensive quotations. Do not confuse this with the Concise Etymological Dictionary, which is much abridged. Total of xxvii + 830pp. 6½ x 9¼.
21873-2, 21874-0 Two volumes, Paperbound $5.50

FLATLAND: A ROMANCE OF MANY DIMENSIONS, E. A. Abbott. Classic of science-fiction explores ramifications of life in a two-dimensional world, and what happens when a three-dimensional being intrudes. Amusing reading, but also useful as introduction to thought about hyperspace. Introduction by Banesh Hoffmann. 16 illustrations. xx + 103pp. 20001-9 Paperbound $1.00

DESIGN BY ACCIDENT; A BOOK OF "ACCIDENTAL EFFECTS" FOR ARTISTS AND DESIGNERS, James F. O'Brien. Create your own unique, striking, imaginative effects by "controlled accident" interaction of materials: paints and lacquers, oil and water based paints, splatter, crackling materials, shatter, similar items. Everything you do will be different; first book on this limitless art, so useful to both fine artist and commercial artist. Full instructions. 192 plates showing "accidents," 8 in color. viii + 215pp. 8⅜ x 11¼. 21942-9 Paperbound $3.50

THE BOOK OF SIGNS, Rudolf Koch. Famed German type designer draws 493 beautiful symbols: religious, mystical, alchemical, imperial, property marks, ᴜnes, etc. Remarkable fusion of traditional and modern. Good for suggestions of timelessness, smartness, modernity. Text. vi + 104pp. 6⅛ x 9¼. 20162-7 Paperbound $1.25

HISTORY OF INDIAN AND INDONESIAN ART, Ananda K. Coomaraswamy. An unabridged republication of one of the finest books by a great scholar in Eastern art. Rich in descriptive material, history, social backgrounds; Sunga reliefs, Rajput paintings, Gupta temples, Burmese frescoes, textiles, jewelry, sculpture, etc. 400 photos. viii + 423pp. 6⅜ x 9¾. 21436-2 Paperbound $3.50

PRIMITIVE ART, Franz Boas. America's foremost anthropologist surveys textiles, ceramics, woodcarving, basketry, metalwork, etc.; patterns, technology, creation of symbols, style origins. All areas of world, but very full on Northwest Coast Indians. More than 350 illustrations of baskets, boxes, totem poles, weapons, etc. 378 pp. 20025-6 Paperbound $2.50

THE GENTLEMAN AND CABINET MAKER'S DIRECTOR, Thomas Chippendale. Full reprint (third edition, 1762) of most influential furniture book of all time, by master cabinetmaker. 200 plates, illustrating chairs, sofas, mirrors, tables, cabinets, plus 24 photographs of surviving pieces. Biographical introduction by N. Bienenstock. vi + 249pp. 9⅞ x 12¾. 21601-2 Paperbound $3.50

AMERICAN ANTIQUE FURNITURE, Edgar G. Miller, Jr. The basic coverage of all American furniture before 1840. Individual chapters cover type of furniture—clocks, tables, sideboards, etc.—chronologically, with inexhaustible wealth of data. More than 2100 photographs, all identified, commented on. Essential to all early American collectors. Introduction by H. E. Keyes. vi + 1106pp. 7⅞ x 10¾. 21599-7, 21600-4 Two volumes, Paperbound $7.50

PENNSYLVANIA DUTCH AMERICAN FOLK ART, Henry J. Kauffman. 279 photos, 28 drawings of tulipware, Fraktur script, painted tinware, toys, flowered furniture, quilts, samplers, hex signs, house interiors, etc. Full descriptive text. Excellent for tourist, rewarding for designer, collector. Map. 146pp. 7⅞ x 10¾. 21205-X Paperbound $2.00

EARLY NEW ENGLAND GRAVESTONE RUBBINGS, Edmund V. Gillon, Jr. 43 photographs, 226 carefully reproduced rubbings show heavily symbolic, sometimes macabre early gravestones, up to early 19th century. Remarkable early American primitive art, occasionally strikingly beautiful; always powerful. Text. xxvi + 207pp. 8⅜ x 11¼. 21380-3 Paperbound $3.00

MATHEMATICAL PUZZLES FOR BEGINNERS AND ENTHUSIASTS, Geoffrey Mott-Smith. 189 puzzles from easy to difficult—involving arithmetic, logic, algebra, properties of digits, probability, etc.—for enjoyment and mental stimulus. Explanation of mathematical principles behind the puzzles. 135 illustrations. viii + 248pp.
20198-8 Paperbound $1.25

PAPER FOLDING FOR BEGINNERS, William D. Murray and Francis J. Rigney. Easiest book on the market, clearest instructions on making interesting, beautiful origami. Sail boats, cups, roosters, frogs that move legs, bonbon boxes, standing birds, etc. 40 projects; more than 275 diagrams and photographs. 94pp.
20713-7 Paperbound $1.00

TRICKS AND GAMES ON THE POOL TABLE, Fred Herrmann. 79 tricks and games— some solitaires, some for two or more players, some competitive games—to entertain you between formal games. Mystifying shots and throws, unusual caroms, tricks involving such props as cork, coins, a hat, etc. Formerly *Fun on the Pool Table*. 77 figures. 95pp.
21814-7 Paperbound $1.00

HAND SHADOWS TO BE THROWN UPON THE WALL: A SERIES OF NOVEL AND AMUSING FIGURES FORMED BY THE HAND, Henry Bursill. Delightful picturebook from great-grandfather's day shows how to make 18 different hand shadows: a bird that flies, duck that quacks, dog that wags his tail, camel, goose, deer, boy, turtle, etc. Only book of its sort. vi + 33pp. 6½ x 9¼. 21779-5 Paperbound $1.00

WHITTLING AND WOODCARVING, E. J. Tangerman. 18th printing of best book on market. "If you can cut a potato you can carve" toys and puzzles, chains, chessmen, caricatures, masks, frames, woodcut blocks, surface patterns, much more. Information on tools, woods, techniques. Also goes into serious wood sculpture from Middle Ages to present, East and West. 464 photos, figures. x + 293pp.
20965-2 Paperbound $2.00

HISTORY OF PHILOSOPHY, Julián Marias. Possibly the clearest, most easily followed, best planned, most useful one-volume history of philosophy on the market; neither skimpy nor overfull. Full details on system of every major philosopher and dozens of less important thinkers from pre-Socratics up to Existentialism and later. Strong on many European figures usually omitted. Has gone through dozens of editions in Europe. 1966 edition, translated by Stanley Appelbaum and Clarence Strowbridge. xviii + 505pp. 21739-6 Paperbound $2.75

YOGA: A SCIENTIFIC EVALUATION, Kovoor T. Behanan. Scientific but non-technical study of physiological results of yoga exercises; done under auspices of Yale U. Relations to Indian thought, to psychoanalysis, etc. 16 photos. xxiii + 270pp.
20505-3 Paperbound $2.50

Prices subject to change without notice.
Available at your book dealer or write for free catalogue to Dept. GI, Dover Publications, Inc., 180 Varick St., N. Y., N. Y. 10014. Dover publishes more than 150 books each year on science, elementary and advanced mathematics, biology, music, art, literary history, social sciences and other areas.